*This book is dedicated to my photo assistant and
dear friend, Brad Moore. I'm very grateful for all your help
and advice, for always looking out for me, and even
for all the incredibly corny jokes. You rock!*

Acknowledgments

Although only one name appears on the spine of this book, it takes a team of dedicated and talented people to pull a project like this together. I'm not only delighted to be working with them, but I also get the honor and privilege of thanking them here.

To my amazing wife Kalebra: I don't know how you do it, but each year you somehow get more beautiful, more compassionate, more generous, more fun, and you get me to fall even more madly in love with you than the year before (and so far, you've done this 25 years in a row)! They don't make words to express how I feel about you, and how thankful and blessed I am to have you as my wife, but since all I have here are words—thank you for making me the luckiest man in the world.

To my wonderful, crazy, fun-filled, son Jordan: When I wrote the first version of this book, I wrote that you were the coolest little boy any dad could ever ask for. Now that you're 17 years old, and you're 6'1" and 220 lbs. of muscle (my brother calls you "The Wall"), you're not a little boy by any means, but you are definitely still the coolest! Although I know you don't read these acknowledgments, it means so much to me that I can write it, just to tell you how proud I am of you, how thrilled I am to be your dad, and what a great big brother you've become to your little sister. Your mom and I were truly blessed the day you were born.

To my beautiful daughter Kira: You are a little clone of your mom, and that's the best compliment I could ever give you. You have your mom's sweet nature, her beautiful smile, and like her, you always have a song in your heart. You're already starting to realize that your mom is someone incredibly special, and take it from Dad, you're in for a really fun, exciting, hug-filled, and adventure-filled life. I'm so proud to be your dad.

To my big brother Jeff: A lot of younger brothers look up to their older brother because, well…they're older. But I look up to you because you've been much more than a brother to me. It's like you've been my "other dad" in the way you always looked out for me, gave me wise and thoughtful council, and always put me first—just like Dad put us first. Your boundless generosity, kindness, positive attitude, and humility have been an inspiration to me my entire life, and I'm just so honored to be your brother and lifelong friend.

To my in-house team at KelbyOne: You make coming into work an awful lot of fun for me, and each time I walk in the door, I can feel that infectious buzz of creativity you put out that makes me enjoy what we do so much. I'm still amazed to this day at how we all come together to hit our often impossible deadlines, and as always, you do it with class, poise, and a can-do attitude that is truly inspiring. You guys rock!

To my Photo Assistant Brad Moore: I dedicated this book to you because I wanted you to know how much help you've been to me, not just throughout this book and the updates to this book series, but in everything I'm trying to accomplish as a photographer, businessman, and family man. Your ideas and input have made everything I've done that much better. You're a very valued member of our team, but beyond that, I'm proud to call you my friend.

To "Mega-Intern" Chris Hendrix: Thanks for helping Brad and I with some of the last-minute shoots we had to do for the book. You were a great help (and you've got a great eye—we're expecting big things from you in the future).

To my Editor Kim Doty: I couldn't be any luckier than to have you editing my books and shepherding them along. This one has taken a lot more time and sweat than any of us expected, but you always kept your trademark attitude and a smile on your face. Both of those kept a smile on mine, and I'm

The step-by-step secrets for how to make your photos look like the pros'!

The Digital Photography Book

PHOTO RECIPES

Book

PART 5

Scott Kelby

The Digital Photography Book, Part 5: Photo Recipes

The Digital Photography Book, Part 5 Team

CREATIVE DIRECTOR
Felix Nelson

ART DIRECTOR
Jessica Maldonado

TECHNICAL EDITORS
Kim Doty
Cindy Snyder

PHOTOGRAPHY
Scott Kelby

STUDIO AND
PRODUCTION SHOTS
Brad Moore

PUBLISHED BY

Peachpit Press

©2015 Scott Kelby

Composed in Myriad Pro (Adobe Systems Incorporated) and LCD (Esselte) by Kelby Media Group Inc.

Trademarks
All terms mentioned in this book that are known to be trademarks or service marks have been appropriately capitalized. Peachpit Press cannot attest to the accuracy of this information. Use of a term in the book should not be regarded as affecting the validity of any trademark or service mark.

Photoshop, Elements, and Lightroom are registered trademarks of Adobe Systems, Inc.
Aperture is a trademark of Apple Inc.
Nikon is a registered trademark of Nikon Corporation.
Canon is a registered trademark of Canon Inc.

Warning and Disclaimer
This book is designed to provide information about digital photography. Every effort has been made to make this book as complete and as accurate as possible, but no warranty of fitness is implied.

The information is provided on an as-is basis. The author and Peachpit Press shall have neither the liability nor responsibility to any person or entity with respect to any loss or damages arising from the information contained in this book or from the use of the discs, videos, or programs that may accompany it.

ISBN 13: 978-0-133-85688-0

ISBN 10: 0-133-85688-7

15 14 13 12 11 10 9 8 7 6 5 4 3

Printed and bound in the United States of America

www.peachpit.com
www.kelbyone.com

very grateful. Also, a big thanks to **Cindy Snyder** who tirelessly tech edits, checks, and rechecks everything I write to make sure it works (I keep telling her, "Hey, this stuff actually works," but she still somehow feels compelled to make certain). I'm delighted that you do what you do the way you do it. Thanks again, Cindy!

To Jessica Maldonado (a.k.a. Photoshop Girl): I can't thank you enough for all your hard work on the cover, layout, and on the look of this and all my books. I love the way you design, and all the clever little things you add to everything you do. You're incredibly talented, a joy to work with, and I feel very, very fortunate to have you on my team.

To my friend and Creative Director Felix Nelson: You're the glue that keeps this whole thing together, and not only could I not do this without you—I wouldn't want to. Keep doin' that Felix thing you do!

To my best buddy Dave Moser: Well, we did it! Thanks for everything you did to make this, probably our 60-something book together, come together. I know, I know "Write, Forrest, write!" ;-)

To my dear friend and business partner Jean A. Kendra: Thanks for putting up with me all these years, and for your support for all my crazy ideas. It really means a lot.

I owe a special thanks to my buddy Matt Kloskowski: You really helped me mentally get through a couple of stages of this book where I had kind of hit a wall. Your help and advice really made a difference and helped me create the kind of book I really wanted to make for my readers. I couldn't have done it without you. Thanks, man!

To my Executive Assistant Lynn Miller: Thanks so much for managing my schedule and constantly juggling it so I can actually have time to write. I know I don't make it easy (I'm kind of a moving target), but I really appreciate all your hard work, wrangling, and patience throughout it all. I'm very glad to have you on our team.

To Ted Waitt, my awesome Editor at Peachpit Press: There's nothing like having a serious photographer as your Editor, and while you're a kick-butt Editor, you're an even better friend.

To my publisher Nancy Aldrich-Ruenzel, marketing mavericks Scott Cowlin and Sara Jane Todd (SJ), and the incredibly dedicated team at Peachpit Press: It's a real honor to get to work with people who really just want to make great books.

To all the talented and gifted photographers who've taught me so much over the years: Moose Peterson, Joe McNally, Bill Fortney, George Lepp, Anne Cahill, Vincent Versace, David Ziser, Jim DiVitale, Tim Wallace, Peter Hurley, Cliff Mautner, Dave Black, Helene Glassman, and Monte Zucker.

To my mentors John Graden, Jack Lee, Dave Gales, Judy Farmer, and Douglas Poole: Your wisdom and whip-cracking have helped me immeasurably throughout my life, and I will always be in your debt, and grateful for your friendship and guidance.

Most importantly, I want to thank God, and His Son Jesus Christ, for leading me to the woman of my dreams, for blessing us with such amazing children, for allowing me to make a living doing something I truly love, for always being there when I need Him, for blessing me with a wonderful, fulfilling, and happy life, and such a warm, loving family to share it with.

Other Books by Scott Kelby

Professional Portrait Retouching Techniques for Photographers Using Photoshop

The Digital Photography Book, parts 1, 2, 3 & 4

Light It, Shoot It, Retouch It: Learn Step by Step How to Go from Empty Studio to Finished Image

The Adobe Photoshop Book for Digital Photographers

The Photoshop Elements Book for Digital Photographers

The Adobe Photoshop Lightroom Book for Digital Photographers

The iPhone Book

It's a Jesus Thing: The Book for Wanna Be-lievers

Photoshop for Lightroom Users

Professional Sports Photography Workflow

About the Author

Scott Kelby

Scott is Editor, Publisher, and co-founder of *Photoshop User* magazine and is co-host of the influential weekly photography talk show *The Grid*. He is also President of the online training, education, and publishing firm, KelbyOne.

Scott is a photographer, designer, and an award-winning author of more than 60 books, including *The Digital Photography Book*, parts 1, 2, 3, & 4, *The Adobe Photoshop Book for Digital Photographers*, *Professional Portrait Retouching Techniques for Photographers Using Photoshop*, *The Adobe Photoshop Lightroom Book for Digital Photographers*, and *Light It, Shoot It, Retouch It: Learn Step by Step How to Go from Empty Studio to Finished Image*. The first book in this series, *The Digital Photography Book*, part 1, has become the top-selling book on digital photography in history.

For the past four years, Scott has been honored with the distinction of being the #1 best-selling author of educational books on photography. His books have been translated into dozens of different languages, including Chinese, Russian, Spanish, Korean, Polish, Taiwanese, French, German, Italian, Japanese, Dutch, Swedish, Turkish, and Portuguese, among others.

Scott is Training Director for the Adobe Photoshop Seminar Tour, and Conference Technical Chair for the Photoshop World Conference & Expo. He's featured in a series of online courses (from KelbyOne.com), and has been training photographers and Adobe Photoshop users since 1993. He is also the founder of Scott Kelby's Annual Worldwide Photowalk, the largest global social event for photographers, which brings tens of thousands of photographers together on one day each year to shoot in over a thousand cities worldwide.

For more information on Scott, visit him at:

His daily blog: **http://scottkelby.com**
Twitter: **@scottkelby**
Facebook: **www.facebook.com/skelby**
Google+: **Scottgplus.com**

Chapter Four 73

Hot-Shoe Flash Like a Pro

Quick Lighting Recipes for Using Flash Like a Pro

Chapter Five 97

Shooting Weddings Like a Pro

Recipes for Making the Bride Look Awesome
(Because Nobody Cares About the Groom)

Chapter One

Shooting Natural Light Portraits Like a Pro

Recipes for Making People Look Their Best

I don't know if you've ever walked outside and taken a good long look at the sun, but if you did, you were probably on drugs (at least that's what it said in that instructional film I watched back in 8th grade health class. Frankly, that scared the living daylights out of me, which is an odd phrase to use since we're talking about daylight from the sun, but the whole thing is a bit of a blur to me because I was probably on drugs). Anyway, even if you just take a quick glance at the sun, you'll probably start squinting, then sweating, then eventually your retinas will burst into flames and they'll rush you to the hospital where they'll try to ease your pain by giving you (wait for it… wait for it…)—that's right—drugs. (See? They were right in that film after all.) Anyway, that tiny, harsh ball of light in the sky is what creates "natural light," but that natural light is usually the harshest, most unflattering darn light ever created, and if you want to get even with someone for some injustice or parking space they stole from you at the mall, just take a portrait of them standing outside in this direct sunlight right around 2:00 p.m. and you'll have instantly settled the score. It's because sunlight, by itself, is actually harsh and unflattering, so it's our job (and the focus of this chapter) as photographers (and part-time drug abuse counselors) to take the light from that harsh little circle of hydrogen and helium up in the sky and somehow make it look soft and beautiful. If we can do that, the people we photograph will look soft and beautiful, too, unless of course they didn't actually look soft or beautiful to begin with, which is precisely why God invented Photoshop back during The War of the Spanish Succession in 1701. Now, if you're wondering if the rest of these chapter intros are going to be anything along these lines, the answer is, sadly, "Yes. Most definitely." Don't say I didn't warn you.

Seven Things You'll Wish You Had Known...

(1) Here's how this book works: Basically, it's you and me together at a shoot, and I'm giving you the same tips, the same advice, and sharing the same techniques I've learned over the years from some of the top working pros. When I'm with a friend, I skip all the technical stuff. So, for example, if you turned to me and said, "Hey Scott, I want the light to look really soft and flattering. How far back should I put this softbox?" I wouldn't give you a lecture about lighting ratios or flash modifiers. In real life, I'd just turn to you and say, "Move it in as close as you can to your subject without it actually showing up in the shot. The closer you get, the softer and more wrapping the light gets." I'd tell you short and right to the point. Like that. So that's what I do here.

(2) This is a recipe book. It's based on the most popular chapter in parts 1 through 4 of this book series, which is the last chapter—called "Photo Recipes"—where I show a final image and then explain how to get that kind of shot. Here, I took things up a big notch by adding another page (so now each recipe is a two-page spread) with a behind-the-scenes production shot, so you can see the exact setup that was used to make the shot. Plus, for each recipe I give you four important segments: (1) A detailed explanation of what you're seeing in the production shot. (2) All my camera settings for the shot. (3) The thought process of why we do this a particular way (this part is really important). And, (4) I tell you exactly what I did to the photo after the shoot in Lightroom or Photoshop, or using a plug-in, to get the final look you see on the second page.

...Before Reading This Book!

(3) Sometimes you have to buy stuff. This is not a book to sell you stuff, but before you move forward, understand that to get pro results, sometimes you have to use some accessories that the pros use. I don't get a kickback or promo fee from any companies whose products I recommend (rats!). I'm just giving you the exact same advice I'd give a friend.

(4) I wound up making you a bunch of video tutorials. Some of the post-processing stuff is kind of hard to explain with just text, so I made a number (a bunch) of videos for you that show exactly what was done to certain photos in the book. Some stuff was just "standard portrait retouching" and I did a video for you on what that means to me (so you can do the exact same retouches). For some photos, however, I needed to do more, but luckily none of it is hard—you'll be able to do every single thing I teach you because the videos are all simple, clear, and step by step. I use Lightroom a lot (it's my main tool), but sometimes I have to use Photoshop (nearly everything I show in a video can also be done in Photoshop Elements, so if you're an Elements user you won't get left behind). Also, if you use Photoshop's Camera Raw plug-in (instead of Lightroom), that's okay because Lightroom has Camera Raw built right in (it has the same sliders, in the same order, that do the same exact things). I put up a webpage with all the videos and links to any gear I mentioned, and this was all created expressly for this book, and exclusively for you my awesome, awesome reader and new best friend in the whole wide world. Here's the link: **www.kelbyone.com/books/digphotogv5** (but turn the page, you've still got three more important things to go!).

Two More of Those Things

(5) If you're shooting with a Sony, Olympus, or Fuji digital camera, don't let it throw you that a Canon or Nikon camera is pictured. Since most people are shooting with a Canon or Nikon, you'll see both (although I shoot primarily Canon cameras and lenses these days), but either way, don't sweat it—most of the techniques in this book apply to any digital SLR camera, and even many of the point-and-shoot digital cameras, as well.

(6) WARNING: The intro page at the beginning of each chapter is just designed to give you a quick mental break, and honestly, they have little to do with the chapter. In fact, they have little to do with anything, but writing these quirky, off-the-wall chapter intros is kind of a tradition of mine (I do this in all my books), but if you're one of those really "serious" types, I'm begging you: skip them because they'll just get on your nerves. By the way, if you somehow are into these quirky chapter intros, I made an entire eBook of nothing but my favorites compiled from all my books, and it's called *Buy This Book of Chapter Intros Even Though You Won't Learn Anything*. 100% of the profits from the sale of the eBook goes to support the Springs of Hope Orphanage in Kenya, which is an orphanage built from the ground up with the gracious support of people who read my daily blog and take part in my annual Worldwide Photo Walk. You can find it for the Kindle at Amazon, or in Apple's iBooks Store. You'll really dig it (or hate it with the passion of a thousand burning suns), but either way, you're helping some orphans so you still get lots of good Karma and, in the end, everybody makes out (stop snickering—you know what I meant).

One Last Thing

(7) Keep this in mind: this is a "show me how to do it" book. Again, I'm telling you these tips just like I'd tell a shooting buddy, and that means, oftentimes, it's just which button to push, which setting to change, where to put the light, without all the technical explanations. I figure that once you start getting amazing results from your camera, you'll go out and buy one of those "tell me all about it" camera or lighting books that goes into all that technical stuff and you'll learn terms like "chromatic aberration" and "lens diffraction" and "hyperfocal distance." Also, this is the fifth book in this series. All the books have completely different content, and were designed to pick up where the last book left off, so if this is your first book in this series, you're still okay because of how this one was designed. But, if you like the series (and, of course, I'm hoping you super-dig it), I would recommend starting with part 1, and then going in order. This would be the ideal situation (for us both—sorry, couldn't help myself), and honestly, that's how the series was designed. Well, it wasn't designed that way from the start. When I wrote the first one, it wasn't called part 1, because I never imagined it would become the best-selling book in the history of digital photography. Once it did, I wrote a part 2, then 3, then 4, and this new turn in the series, part 5 (Photo Recipes), which I truly hope ignites your passion for photography by helping you get the kind of results you always hoped you'd get from your photography. Now, pack up your gear, it's time to head out for our first shoot.

For Better Light Outdoors, Shoot in Shade

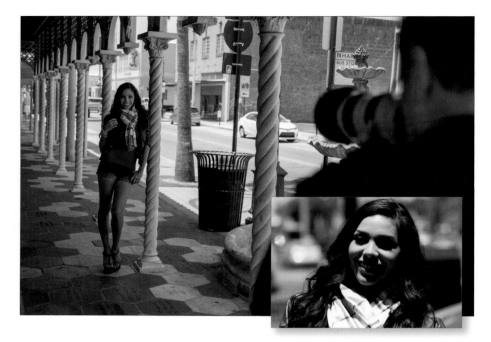

BEHIND THE SCENES: First, look at the small photo in the bottom right here. That's how the light looks on our subject when she's standing just a few feet to the right, out in direct sunlight. Note the harsh shadows, shiny skin and hot spots, and shadows filling her eye sockets. It's just not flattering light at all. In the larger shot here, I've moved her a few feet to her left so now she's standing under a roof awning that blocks all the harsh sun.

CAMERA SETTINGS: For natural light shots, I generally want the background out of focus (to help separate the subject from the background), so I try to shoot at the lowest-numbered f-stop my lens will allow—in this case, it was f/2.8. But, just f-stop alone won't get you that really out-of-focus background; you'll also need to zoom in tight. So, I moved back from my subject (with a 70–200mm f/2.8 lens on my camera) and zoomed in to 130mm. These two things together (f-stop and zooming in) give us that separation and nice soft background you see in the final image. With my f-stop at f/2.8 (which lets in the most light), I was able to use my cleanest, lowest ISO (100 ISO) and still get a shutter speed of 1/320 of a second. So, hand-holding the shot and still having it nice and sharp was not a problem.

Final Image

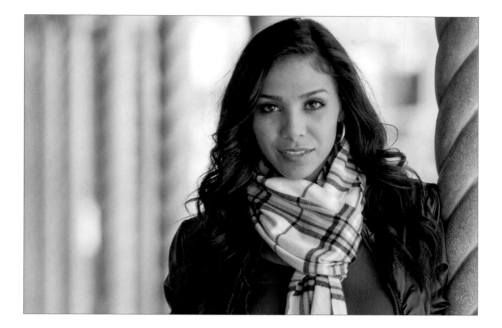

THOUGHT PROCESS: I think a lot of photographers confuse "natural light" with beautiful light, but they are two different things. Natural light usually refers to light coming from the sun, which is the harshest light source in the universe most times of the day because of its brightness, small size, and position in the sky. What makes sunlight beautiful is when something is spreading and diffusing (softening) that natural light, like a frosted window, or a window that's really dirty (those make gorgeous light), or something that blocks most of the light (like a roof or thick tree branches). Our job is to find that diffused, non-direct sunlight. Having the subject stand in the shade, rather than in direct sunlight, is a quick and easy way to use natural light, and since they're in the shade, the light's not harsh—it's soft and flattering. Once you've found some shade, the ideal place to put your subject is near the edge of it. That's where the light will generally be its softest and prettiest (under the shaded area, get as close as you can to the direct sun without any of it actually hitting your subject). So, why didn't I position her to the right more to get her closer to the edge of the shade? Because I wanted that row of columns to appear behind her.

POST-PROCESSING: Nothing much to do here beyond the standard portrait retouching stuff (removing minor blemishes, softening her skin a tiny bit, brightening her eyes a tiny bit, etc.).

Diffusing Harsh Sunlight

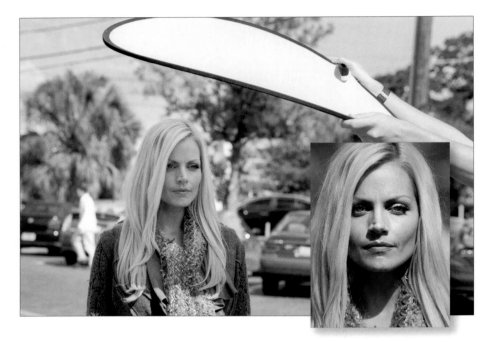

BEHIND THE SCENES: We're in a parking lot here (the light doesn't get much yuckier than this, right?), but to soften and diffuse the harsh, direct sun (you can see what the direct sun shot looks like in the small shot at the bottom right, here) we put a diffuser over our subject's head (as seen above in the large shot). This diffuser is part of the F.J. Westcott 30" 5-in-1 Reflector kit (if you look at the reflector we're using on page 12, that zips open, and inside is this awesome 1-stop diffuser, which is worth the price of the kit alone. I use it 10x more than I do the reflector. It sells for around $39 at B&H Photo).

CAMERA SETTINGS: The final image was taken with my 70–200mm f/2.8 lens at f/2.8, which (when you zoom in tight) puts the background way out of focus (like you see on the facing page). I'm zoomed in tight to 160mm. My ISO is set at 100 and my shutter speed is 1/1000 of a second (I'm shooting in aperture priority mode, so I choose the f-stop and then the camera automatically chooses the shutter speed it needs to make a proper exposure).

Final Image

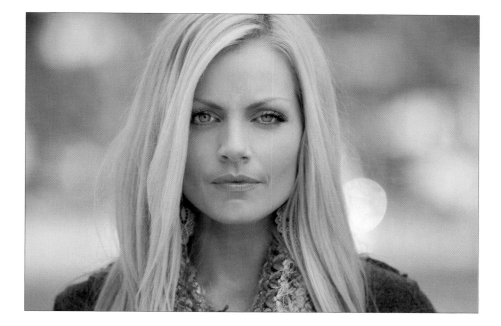

THOUGHT PROCESS: Let's talk about the lighting first. A diffuser is my go-to accessory for shooting outdoors for a number of reasons: (1) you can't always count on there being shade around for soft light, (2) I can use it pretty much anywhere outdoors, (3) it's super-lightweight and collapses into a small flat circle, (4) it's very inexpensive, and (5) it makes people look great! To use one, you literally just have a friend hold it up between the sun and your subject—that's it. If I were to add one tip it would be this: the closer you can get that diffuser to your subject (without actually seeing it in the picture), the softer and more flattering the light becomes. So, I'll have my friend keep lowering and lowering it, bringing it down closer to my subject, until I actually see the edge of it in my view-finder. Then, I have them raise it back up just a couple of inches. Super-simple and you get great results every time. Now, why did I shoot this in an awful-looking parking lot? I thought it would make a great example for how the combination of shooting at a low-numbered f-stop and zooming in tight can be used to blur the background so much you really can't tell what's behind your subject. Can you imagine how handy this is? Now you can make a beautiful portrait anywhere using one lens and a cheap diffuser (if you just want the diffuser, and you don't need the whole 5-in-1 kit, you can get the diffuser alone for around $20 at B&H Photo).

POST-PROCESSING: Just the standard portrait retouching stuff.

Diffusing a Larger Area

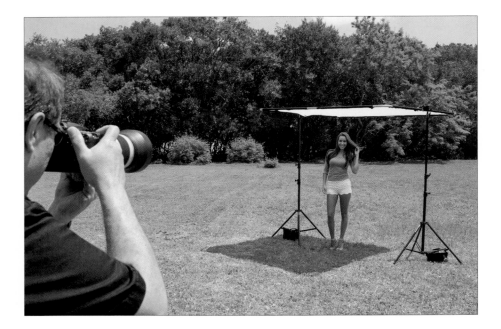

BEHIND THE SCENES: Here, we're in a big empty lot, and we've put up a large diffuser to soften and spread the harsh "high noon" sunlight overhead. This is a 6.6x6.6' Lastolite Large Standard Skylite Rapid Kit, which comes with a 1.25-stop diffusion panel (it's around $399). Plus, you'll need two light stands to support it, and two Lastolite swivel grip heads to angle the diffuser toward the sun. Those swivels run around $54 each. Also note the two sandbags—one on each light stand. Those are very important. Without them, the whole thing can crash over with a small gust of wind. Now, if you're thinking this is getting kinda expensive (you're into about $500 or so at this point), just remember that this rig is less expensive than nearly any lens you might want to buy, and will probably have a bigger impact on how your outdoor portraits look than any $500 lens, so it's worth considering.

CAMERA SETTINGS: This was taken with a 70–200mm f/2.8 lens zoomed in to 135mm. My f-stop is f/2.8 and my shutter speed is 1/1250 of a second at 160 ISO (obviously, I could have lowered my ISO down to 100 and still have had plenty of shutter speed to hand-hold a shot and have it really sharp).

Final Image

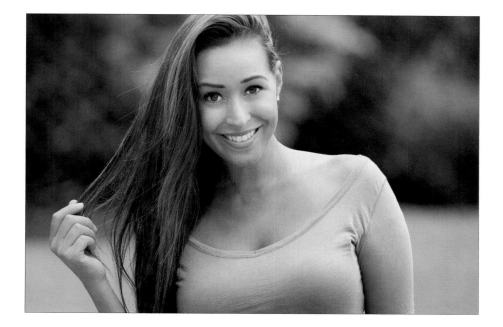

THOUGHT PROCESS: The hand-held Westcott diffuser we used earlier is great for head-shots, but if you need to cover more of your subject (or if you have a couple or a small group), then you'd go to a bigger diffusion panel like this (this larger diffusion panel is sometimes referred to as a "scrim"). With something this big, you could easily do a 2/3-length shot or even full-length—look at the shot on the facing page and you'll see the shadow created by the diffuser covers enough of our subject to do a full-length shot if you wanted to, no problem. Notice the quality of the light here—we're in the middle of a vacant lot, at literally high noon, and the quality of light underneath this diffuser is just beautiful. The diffuser itself is very lightweight, and the frame is made of lightweight aluminum (kind of like those folding lawn chairs). It all fits in a small travel case (it's made for location shoots) and just takes a few minutes to put together. Every time I use this, I think to myself, "I've gotta start using this more." The light is just that gorgeous.

POST-PROCESSING: Nothing much, once again. Standard portrait retouching stuff and darkening the edges all the way around using the Lightroom Develop module's (or Camera Raw's) Post Crop Vignetting Amount slider in the Effects panel. Just drag it to –11 and you're done.

Positioning a Reflector Outdoors

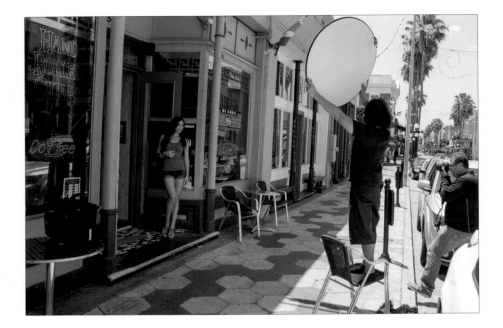

BEHIND THE SCENES: I'm shooting our subject in the doorway of a small cigar bar and, once I took the initial photo, I could see that her face appeared too dark. So, I had my assistant hold a small collapsible reflector (this is the F.J. Westcott 30" 5-in-1 Reflector kit I talked about earlier) up high to bounce some of the sunlight back onto our subject's face. Since we're outdoors, I had him use the gold side of the reflector, so it reflected a warm-colored light onto her, rather than silver (which we use in the studio) or white (which is just too subtle in this case). The reason my assistant is standing on a chair is that: (1) the subject is standing up on a step, (2) the subject is tall, and (3) my assistant John, here…um…isn't.

CAMERA SETTINGS: For this shot, I wanted to put the background behind her really, really out of focus, so I went with an 85mm f/1.8 lens (a fixed-length lens, not a zoom), and, of course, I shot at f/1.8 (if you bought a low-f-stop lens like this, you bought it to shoot at f/1.8, right? If you're not always shooting at that low an f-stop with this lens, you wasted your money). We had been shooting inside the cigar bar, and inside I had set my ISO at 800 so I would have enough shutter speed to hand-hold my shots. When we walked out the front door, I turned back and saw that the entryway looked pretty cool, so I had our subject stand there to catch a few frames, but I forgot to change my ISO back to 100 (for shooting outside). There's a lesson in there somewhere (for me, at least). Anyway, at 800 ISO, my shutter speed was way up there—1/5000 of a second.

Final Image

THOUGHT PROCESS: The key here (and why I included this shot in the book) is to talk about the reflector position. When we light a subject, we're trying to mimic the position of the sun (it's up high, aiming down at us) because that's how we're lit with natural light—from above (heck, that's how we're usually lit with artificial light in our homes and offices—from above, aiming down at us). So, when you use a reflector, don't place it down low to bounce the light up into your subject's face. That's called "up-lighting," and it's used for lighting monsters or linebackers to make them look scary. Mimic the sun. Hold the reflector way up high, so the bounced light comes from up high and reflects down on your subject. That way, it winds up being flattering (instead of scary). As for using the reflector itself, I used it because when I took a test shot, I could see that her face was just too dark. Our eyes are drawn to the brightest thing in the image, so I directed my assistant to angle the reflector so it would mostly brighten her face. You do that by literally tilting the reflector slowly back and forth (toward the subject and away from them), until you can see a large pool of reflected light hit them. Once you see that, then it's easy to position the reflector to move that pool of light where you want it (if you've ever seen sunlight strike the face of your wristwatch and create a bright light on the ceiling, you know what I mean).

POST-PROCESSING: I did standard portrait retouching, but I also had to clone away some stickers on the window to her right (from the camera position). I also used Lightroom's Adjustment Brush to darken the mirror to her left and the windows to her right, so they didn't draw the eye (since our eyes are dawn to the brightest things in the image).

Fix Dappled Light

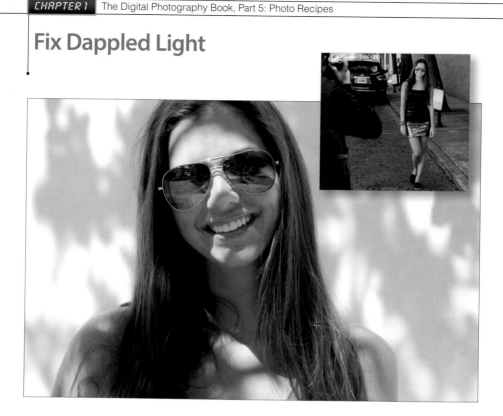

BEHIND THE SCENES: What you're seeing above is a nightmare. You see all those big bright spots of light hitting our subject in different areas (like on the bridge of her nose, her forehead, her upper chest, and her arms)? Those harsh beams of light coming through the tree she's standing under are called "dappled light" and, for the most part, we want to avoid it like the plague (I say "for the most part" because you could possibly make a case for using dappled light in some fine-art piece, but generally, we do our best to avoid it). You see how you can also see individual tree branches (like the one on the left side of her forehead)? Yeah, that's all bad, bad stuff.

CAMERA SETTINGS: For the final image (on the facing page), I'm using a 70–200mm lens zoomed in to 182mm, so I'm pretty tight. I'm at f/2.8 (if your lens doesn't go that low, you can use either f/4 or f/5.6—as long as you're zoomed in tight using the lowest-number f-stop your lens will allow, the background will still be soft). I'm at 400 ISO at a shutter speed of 1/1000 of a second.

Final Image

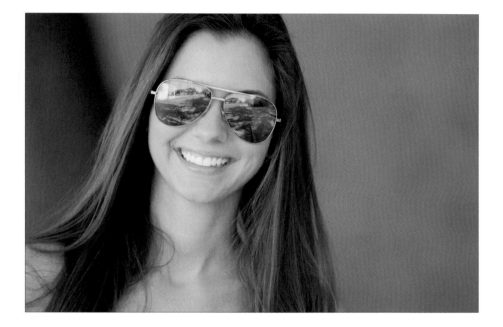

THOUGHT PROCESS: If dappled light is so bad, what is it exactly that we want? We want nice, even shade like you see in the shot above, which was taken literally just a few feet from where the first shot was taken. The next tree on the street had a lot more leaves on it, so there wasn't nearly as much dappled light. There was some at the edges of the shade, so I looked through the viewfinder and had our subject keep taking a step backward, until I could see through the viewfinder that no annoying streams of light were showing through the leaves, and it was just nice, even shade (if you look at the small photo in the top right on the facing page, you can see the behind-the-scenes shot after I moved our subject away from the evil dappled-light tree and over to the more solidly shady tree). Doing this also created a happy accident, in that the background looked more interesting in the second shot than the dull white wall in the dappled light shot.

POST-PROCESSING: Just two things: (1) standard ol' portrait retouching, and (2) in Lightroom's Develop module (or Camera Raw), I dragged the Post Crop Vignetting Amount slider, in the Effects panel, to –11 to darken the edges of the image just a tiny bit (I do this quite a bit for natural light images. It helps draw the eye to your subject by darkening the edges all the way around).

Direct, Contrasty Window Light

BEHIND THE SCENES: Our subject is standing directly in front of a large glass window, so there's nothing there to soften or diffuse the light. The sun is pretty high in the sky (it's around 4:00 p.m.) and the bright sunlight is coming through the window at an angle. I had my subject stand very close to the window because, for this look (which I would generally use with men), I want very sharp, contrasty light (putting him right near the window is the opposite of what I would do if I was shooting a woman and wanted soft, diffused light). So, that's it: direct light streaming in from a tall window. No diffusion—no nuthin'—just direct light. If you look directly behind our subject, you'll see my black laptop bag taped up to the wall with gaffer's tape. We taped it up there because there's a gap between the two black tubes on the wall, and I could see the lighter beige wall area in the shot. I needed something to hide that lighter area, and we didn't have a black cloth or a black shirt, so we kinda had to make do using my laptop bag. It's not pretty, but it worked. Also, having your subject wear a dark-colored shirt makes this look easier.

CAMERA SETTINGS: I'm using a 70–200mm f/2.8 lens and I'm zoomed in to 95mm, with my f-stop at f/4.5. There is plenty of light in the room, so to create this dark, dramatic look, I shot in aperture priority mode (which I always do for natural light portraits), but the trick is to use exposure compensation to darken the scene by around two stops or so (in this case, I darkened it by 1.7 stops). Even though you're darkening the room around him, his face will still be brightly lit by the direct sunlight.

Final Image

THOUGHT PROCESS: I am really drawn to color (it's my "thing"), so I don't shoot a lot of black and white. But, I knew before I pressed the shutter button on this one that I was going to convert it to black and white for the added drama. You might be wondering how I got away with using just harsh, direct sunlight. It's because I wasn't trying to make a soft, beautiful shot. I was intentionally going for a really contrasty look, so this hard light works. This contrasty light (and the post-processing) accentuates his skin texture and facial hair, and brings out detail. For men, that usually looks terrific.

POST-PROCESSING: In Lightroom's Develop module (or Camera Raw), I increased the contrast a lot by dragging the Contrast slider to the right quite a ways. Once the image looked really contrasty, I used a plug-in for Lightroom (or Photoshop, Elements, or Apple Aperture) called Silver Efex Pro, which is part of the Google Nik Collection. Nearly every pro I know uses this plug-in for converting to black and white (yes, it's that good), and I use it in a very simple way: When you open your image in it, on the left, it shows you a bunch of large thumbnail views of your image with different types of black-and-white processing. I just click on the one that looks best to me, and then I click OK. (By the way, the preset that usually looks the best is High Structure [Harsh], as it adds midtone contrast and really brings out the detail, which is what I'm usually after in a black-and-white photo.) The final step was to add a lot of sharpening, using Photoshop's Unsharp Mask filter with these settings: Amount 90, Radius 1.5, Threshold 0.

Softening Window Light

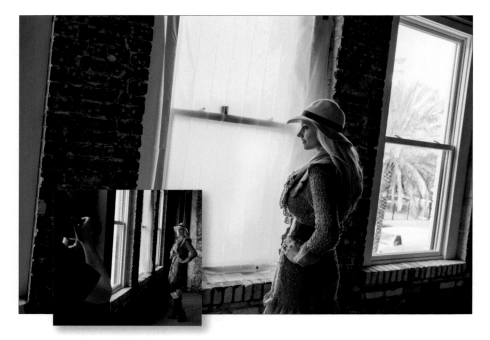

BEHIND THE SCENES: Here, our subject is standing directly in front of a large window, which technically should make a beautiful shot, except for one thing: window light, by nature, is not soft and beautiful. Sometimes it is, but it really depends on the window's location, the time of day, and the angle and position of the sun, because window light can be some of the harshest, nastiest light you've ever seen. That's why we keep a frosted vinyl shower curtain liner with us (literally, just $1.99 at Walmart) to tape up over a window (using gaffer's tape we bought from B&H Photo—gaffer's tape comes off surfaces without leaving any sticky residue, or peeling off paint or finishes, or doing any harm whatsoever. It's amazing stuff. Around $6 a roll). My shooting position is directly to her left along the wall.

CAMERA SETTINGS: I'm using my 70–200mm f/2.8 lens again, and I'm at f/2.8 so I can put the background out of focus, but as you can see on the facing page, it's only a little bit out of focus. Why only a little bit? Wouldn't f/2.8 make it really out of focus? Well, it would if I could zoom in tighter, but to get more of her in the frame than just her head and shoulders, I had to zoom out to 70mm. I couldn't move farther back (to zoom in tighter, but get the same composition with a blurrier background) because the room wasn't that deep. By the way, when you add this frosty diffuser in front of the window, it softens the light big time, but it also cuts the amount of light. So, I had to increase my ISO to 800 to get my shutter speed above my 1/60-of-a-second-minimum hand-holding rule (it actually got it up to 1/320 of a second, so I was in good shape to hand-hold. I actually could have lowered it down to at least 400 ISO and still had a decent shutter speed).

Final Image

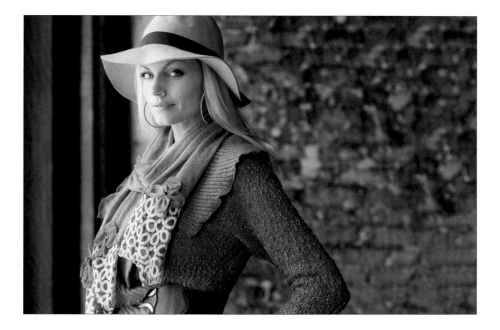

THOUGHT PROCESS: If you want just really soft, wonderful, wrapping light from a window, this trick turns that window into a giant softbox, and the diffused light that comes through now is just absolutely gorgeous (as seen above). By the way, you could get a little softer light by having her take a few steps back from the window. Just know that will lower the amount of light (the farther away you move the light, the darker it gets, right?), so you'd probably have to bump up the ISO a bit more then, because you're already at your lowest possible f-stop (well, I was anyway at f/2.8).

POST-PROCESSING: Not much to do here, just the standard retouching stuff. Also, I used Photoshop's Content-Aware Fill feature to get rid of the edges of two framed pictures you could see on the wall behind her to the far right. I made a short video for you on how Content-Aware Fill works. You can find it on the book's companion webpage (mentioned in the book's introduction).

Shooting in Direct Sun

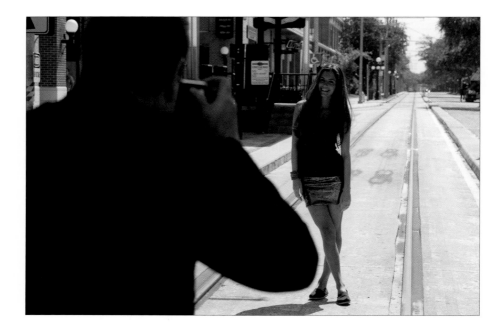

BEHIND THE SCENES: We're shooting in pretty much the harshest sunlight you can imagine—it's nearly "high noon," and we're standing in the middle of a street along some trolley tracks (don't worry, the trolley hadn't started its daily runs yet). I'm not using the tracks as any kind of background element—I'm just trying to avoid seeing parked cars in the background. Not much else going on here, just bright, nasty sunlight, so I positioned my subject with her back to the sun, which almost creates a silhouette of her. But, we're going to address that part with our camera settings.

CAMERA SETTINGS: I'm shooting in aperture priority mode (more on this on the next page), and my f-stop is my standard natural light f-stop of f/2.8. That, coupled with zooming in fairly tight with my 70–200mm f/2.8 lens (I zoomed in all the way to 200mm), created the out-of-focus background behind her. My shutter speed is 1/1000 of a second, and I'm at 400 ISO (I could have shot this at 100 ISO, but I forgot to change the ISO from a previous shot in the shade. Doh! No harm done, but if it's daylight, I generally choose 100 ISO for the cleanest possible results).

Final Image

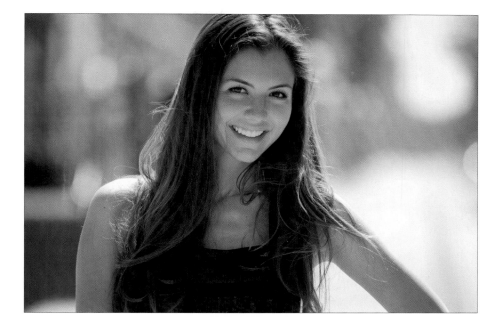

THOUGHT PROCESS: This is a really handy technique to know because there's not always shade around, and you don't always have a way to soften and diffuse the light. Using this technique (which I learned from renowned wedding photographer Cliff Mautner), you can shoot right out in direct sunlight and still have soft, beautiful light on your subject. You start by putting your subject's back to the sun, which creates a nice rim light coming through their hair and along the edges of their shoulders, arms, etc. With the sun now behind your subject, the side of their face facing the camera is dark because it's essentially in the shade. So, the trick is to overexpose (make the entire image intentionally brighter than it should be) by around one full f-stop. So, now they're not in the shadows anymore (compare the light on her face here vs. the behind-the-scenes shot on the previous page). If you shoot natural light portraits in aperture priority mode, like I do (A on the top dial of Nikon or Sony DSLRs, or Av on Canon cameras), then you can use the exposure compensation feature to overexpose the image beyond what the camera thought was the proper exposure. Generally (depending on your camera's make and model), you press a button and then turn a dial or knob to make the exposure the camera took brighter or darker (you can see this in your viewfinder, usually with a + or – sign showing if you made it darker or brighter). If you shoot in manual mode instead, you'd just set your proper exposure, then choose the next brightest full f-stop.

POST-PROCESSING: Just standard portrait retouching stuff—removing blemishes, smoothing skin, brightening eyes, etc.

Better Window Light

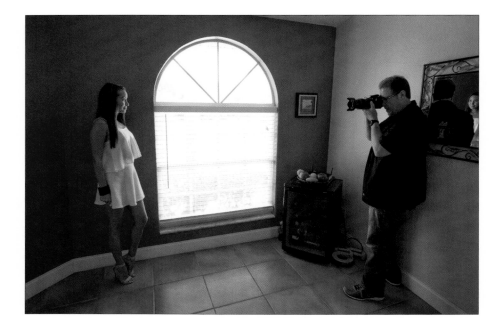

BEHIND THE SCENES: Here, we have our subject in place for a window shot, where she's standing just behind the window. I'm shooting back at an angle toward her (if there had been more room, I probably would have been just to the right of the window—closer to the window itself—so this is also a great tip for making the most of a small space).

CAMERA SETTINGS: In such tight quarters, I'm using a 24–70mm f/2.8 lens at 70mm (certainly not my go-to lens for portraits because it's not tremendously flattering. The 70–200mm f/2.8 zoomed in to around 120mm or more would be a much more flattering choice, but I just didn't have the room). Now, if you look at the image above, you'll see our subject isn't standing directly in front of the window, she's standing behind it, and she's kind of on the edge of the light (no light is hitting her directly). So, I had to crank up the ISO a bit (to 400 ISO) to get my shutter speed up over 1/60 of a second (to 1/100 of a second—enough speed to hand-hold and still get a sharp shot).

Final Image

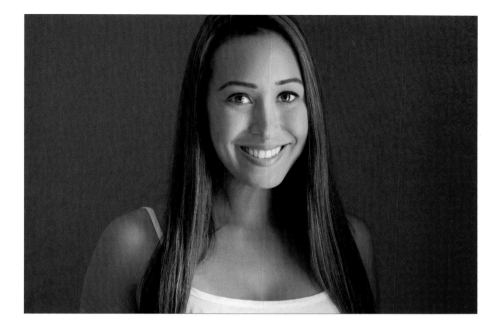

THOUGHT PROCESS: So, why are we placing her behind the window and not in front of it? It's because we don't have any way to diffuse the light (no shower curtain, etc.). So, by putting her just behind the window, she gets the edge of the light, where it's really soft and beautiful, instead of the harsh, direct light. Ideally, to make it even softer, I would have moved her a few feet away from the wall (5 to 6 feet), which helps the light become even softer (again, it's less direct). But, when I tried that, we couldn't make the behind-the-scenes shot you see on the facing page, so I shot it like you see it.

POST-PROCESSING: Just the standard portrait retouching stuff. By the way, if you're wondering, "What's the standard portrait retouching stuff?" I made a video tutorial for you showing what the standard portrait retouching stuff actually is (and how to do it yourself). You'll find it on the book's companion webpage mentioned in "Seven Things You'll Wish You Had Known Before Reading This Book!" at the beginning of this chapter.

Window Light Without Diffusion 2

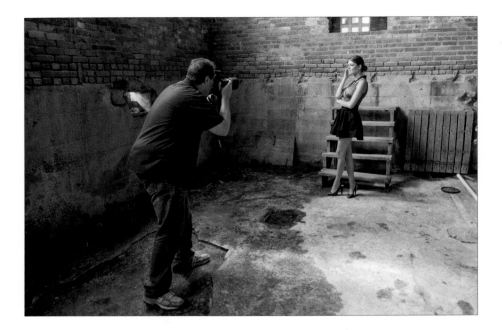

BEHIND THE SCENES: Here, our subject is in an old, abandoned warehouse, and the light is streaming in from the windows up above. Nothing else at work here, but that natural light from the windows.

CAMERA SETTINGS: For the final image on the facing page: to put the background way out of focus, I actually used an 85mm f/1.4 lens for this shot, taken at f/1.4, and that created a very shallow depth of field. My ISO was a bit higher than it needed to be at 800 ISO because that created a shutter speed of 1/500 of a second (way faster than I needed to get above my 1/60-of-a-second rule for hand-held shots), so I probably could have lowered that to at least 200 ISO and still been okay. Maybe even 100 ISO.

Final Image

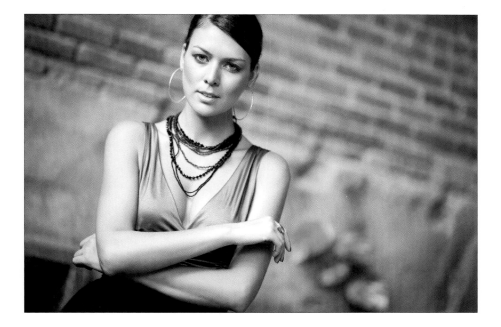

THOUGHT PROCESS: Another way to get softer window light is to move your subject away from the window, so they're not getting a direct beam. Here, I have our subject 8 to 10 feet away from the window, and the light there is much softer and very flattering. You have to move your subject far away enough that the direct beam isn't falling anywhere on them. Once you have them positioned to get that beautiful light, then the rest of the look comes from the extremely shallow depth of field from shooting at f/1.4. One thing to keep in mind about shooting with either an f/1.2, f/1.4, or f/1.8 lens: the focusing technique is a bit different for these lenses than it is with most other lenses. With other lenses, we'd normally aim our camera so the center focus point (inside our viewfinder) is right over our subject's eye, then we'd press-and-hold our shutter button halfway down to lock focus on their eye, then lastly, we'd move the camera however we wanted to compose our shot, and then fire. That doesn't work well with these faster lenses (the f/1.2s, f/1.4s, and f/1.8s) because you're dealing with such a narrow plane of focus. Recomposing after you've focused can get your camera out of the focus plane. So, with these fast lenses, we do just the opposite. We compose the shot *first*, trying to keep the camera parallel to the subject (not tilted up or down). Then, once your shot is composed the way you want it, use the dial on the back of your camera to manually move the center focus point right over your subject's eye, and now you can take the shot.

POST-PROCESSING: Just the regular portrait retouching stuff and darkening the outside edges using the Lightroom Develop module's (or Camera Raw's) Post Crop Vignetting Amount slider in the Effects panel.

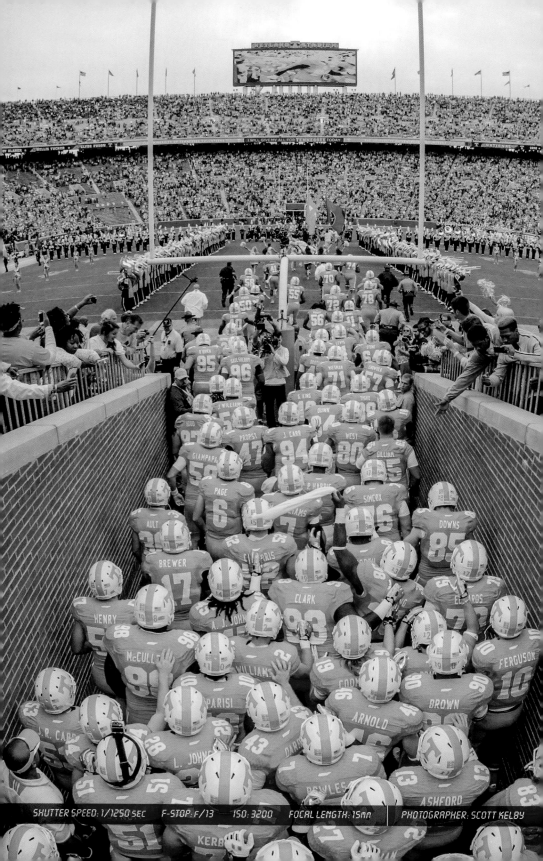

Chapter Two
Using Just One Light Like a Pro
Recipes for Great Results While Still Keeping Things Really Simple

My friend, Dutch fashion and glamour photographer Frank Doorhof, has a great saying about lighting. He says: "If you think you need two lights, use one light. If you think you need three lights, use one light. If you think you need four lights, why are you reading a chapter about using one light?" Okay, he may not have said that last line, but I don't speak Dutch so I can't swear that he didn't, but that's not what's important here. What is important is that you know with every fiber of your being that Frank Doorhof is traveling on a forged passport and by the time you read this, watch out—he'll be in a Swiss jail doing time. I know, this story has a lot of holes in it, and it's kind of cheesy, but does it really matter? (Oh come on, I should get bonus points for sneaking as many Swiss references as I did in just two short sentences. Swiss time? Holes, as in Swiss cheese? Watch, as in a Swiss watch. Matter, as in Matterhorn. Forged passport, as in forged passport, and cheesy, as in Kraft Macaroni & Cheese, which is perhaps the greatest foodstuff ever invented with the possible exception of tater tots, nature's perfect food. Come on, that's gotta be some kind of record.) Anyway, Frank's right: you can do so much with just one light that you really don't need to add more lights (unless, of course, you plan on reading the next chapter, which is about using more than one light, which can actually be a good thing unless, ironically, you live in Switzerland, where it's forbidden due to their Single-Strobe Neutrality law, which has been in place since before WWII [*Wayne's World 2*]). Anyway, there's lots of important stuff to Swatch out for in this chapter—you can bank on it. (Boom! Two bonus points right there!)

One Light Outdoors

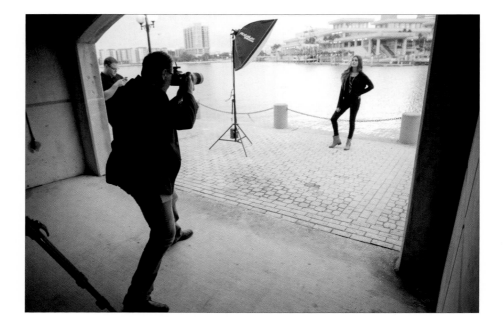

BEHIND THE SCENES: We're actually at the edge of a parking garage with part of the downtown skyline behind us, and it's late in the afternoon. We're using just one light, with a small softbox because my focus is a headshot (well, head and shoulders), so I don't need a very large softbox. We brought a small battery pack, so we didn't have to search for a power outlet at the parking garage (we checked out the location the previous day, so we wouldn't waste time during the shoot trying to find a good background, and when we were there, we didn't see an easily accessible power outlet).

CAMERA SETTINGS: The lens is a 70–200mm f/2.8. I'm zoomed in tight, which will help put my background out of focus, and my f-stop is at f/6.2. Now, to get the background more out of focus, I could have lowered my f-stop to f/4 or f/2.8 and, since my ISO was 400, I definitely could have done that. So why didn't I? I just wasn't thinking about it— I was more concerned with the light, so I missed an opportunity for a better background. It happens. I did wind up lowering my shutter speed from its normal 1/125 of a second to 1/100 of a second to let a little more light appear behind my subject (lowering the shutter speed lets more of the natural existing light into your shot).

Final Image

THOUGHT PROCESS: The idea is to make it look much darker outside than it really is, so the portrait looks more dramatic. Beyond that, for shots like this, you want your subject to be lit solely by the strobe, not by the existing light—that's what lights the background. This was taken about an hour before sunset, so the sky is still pretty bright, but when I shoot with a flash on location like this, I use a three-step process: (1) Place the subject with their back to the setting sun. (2) You'll need to keep your shutter speed at 1/125 to start (so your flash doesn't get out of sync with your camera), and then move your f-stop until you see the meter inside your viewfinder (either at the bottom or along the right side) move to the center. That tells you you've got a proper exposure (it's not under- or overexposed). Once you have the proper exposure (in my case, f/2.8), darken it by a stop or two (don't go by the numbers. Instead, darken the exposure, using a higher-numbered f-stop, until your subject looks like a silhouette. Here, I went from f/2.8 to f/6.2 [2-1/4 stops], and you could barely see her face in the shot). Finally, (3) turn on the flash (with a very low power). If the flash is too bright, just lower its power until you have a nice blend between the light from the flash and the ambient light.

POST-PROCESSING: Nothing much to do here beyond standard portrait retouching stuff: removing minor blemishes, spots, or specks on her shirt, and brightening the existing highlights in her hair using the Adjustment Brush in Lightroom (or Camera Raw).

Dramatic Portrait Lighting

BEHIND THE SCENES: It doesn't get much easier than this when it comes to lighting: just one light with a beauty dish attachment (it sends the light from the flash into the small round dish and then it bounces back out of the dish for some really nice, punchy light). Put this one light straight in front of your subject, up above their head, and aiming back at them at a 45° angle (or sometimes aiming even a little more steeply down). Since this is a photo of a guy, I didn't put a diffusion sock over the front (that's only for portraits of women, children, brides, etc.). To focus the light beam even tighter, I added a metal grid over the front of the beauty dish (you can see the black Velcro straps wrapping around the dish). It just narrows the beam and keeps it from spilling all over.

CAMERA SETTINGS: This couldn't be any more of my standard studio camera settings than it is. The whole thing is textbook for my shooting style: it's my go-to lens (the 70–200mm f/2.8), at my ideal studio f-stop (f/11), at my lowest, cleanest ISO (100 ISO), and my standard shutter speed (1/125 of a second).

Final Image

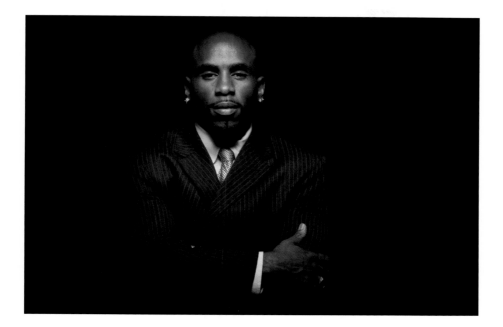

THOUGHT PROCESS: I love the simplicity and drama of this look. I love lighting with a nice falloff of light (his face is the brightest, it's a little darker on his chest, and by the time you get to his crossed arms, it's already starting to fall off to black). I had to tweak the position of the light a little bit so I didn't overlight his bald head—I tipped it a little farther forward than I usually would. Now, if you look over at the production shot, you can see we're shooting on a white background, but the background here is black. How is that? It's because the light is basically aiming straight at the ground, and the white wall is probably 10 or more feet behind him, so none of the light actually makes it back to that wall, making the background go solid black. The only thing you might need to keep an eye on is that your subject's eye sockets don't get too dark, since the light is up above. If you see that happening, just have your subject raise their chin a little bit to get some extra light into their eyes.

POST-PROCESSING: When I'm shooting men, I often do two things to their skin: (1) I add some clarity using the Clarity slider in Lightroom's Develop module (or in Camera Raw), which helps accentuate any texture in their skin and clothes. Then, (2) I desaturate the color of their skin a bit to give it a more modern treatment. You can either lower the Saturation slider in the Basic panel or go to the Hue/Saturation panel and lower the Saturation slider for just the Reds, so it desaturates the skin a bit.

Fashion Lighting

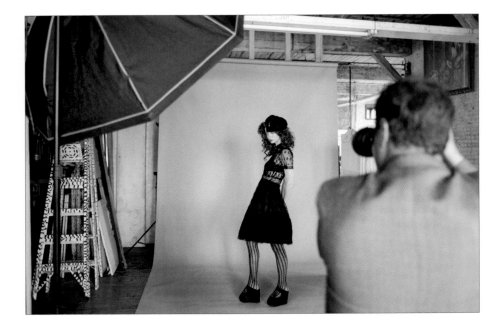

BEHIND THE SCENES: I'm on location here for a shoot at the Metropolitan Building, just across the bridge from New York City, in Long Island City. While I had the models there for the location shoot, I set up a small studio near where the hair, makeup, and styling were being done, so I could shoot on a solid gray background. It's just a roll of gray seamless paper held up by two light stands with a pole in between them. We're using just one large softbox—in this case, a 53" Elinchrom Midi Octa (right around $315)—over our flash. The softbox is big enough to do full-length photos, and I moved it back far enough from our subject to light her evenly pretty much from head to toe. Although I'm standing up here for some close-up shots, to get the proper perspective for the full-length shots, I sit down cross-legged on the floor.

CAMERA SETTINGS: I pretty much wanted everything in focus, so I used a higher numbered f-stop (anywhere from f/8 up to around f/11, usually). For this studio shoot, it's the same basic idea: the lowest ISO (on the camera I took these shots with, it was 200 ISO), and my shutter speed at the standard 1/125 of a second. I once again used my trusty 70–200mm lens, but in this case, I had to zoom all the way to 70mm to get the full-length shot (and I still had to stand 15 feet or so back).

TAKE-AWAYS: Lighting and backgrounds for a fashion shot like this are very simple: one big softbox, a roll of gray seamless, and shooting down low for the right perspective.

Final Image

Styling: Emily Bess
Makeup: Cassi Renee
Wardrobe: at a fete,
Made in Berlin, Han
Walter Steiger

Styling: Emily Bess
Makeup: Cassi Renee
Wardrobe: Fluke Vintage,
Melody's Addiction, Hair
ThePerfect Perfect Vintage

THOUGHT PROCESS: I've always been impressed at how simple most fashion lighting really is. With fashion, the primary focus is on the clothing, and the secondary focus is on the model, and if you really notice the lighting, then the focus isn't where it should be (on numbers 1 and 2). That one big softbox does all the work (including lighting the gray background a bit), and it's far enough back from the subject that the lighting is pretty even from top to bottom. Honestly, what makes a fashion shoot isn't the lighting—like I said, it's usually very simple. What makes it look like "fashion" is really mostly: (1) Having a fashion stylist with the right type of clothing and accessories. The accessories are huge in a shoot like this, and can make or break the image. (2) Having a hairstylist and/or makeup artist—this is another really important aspect and takes the overall look of the shoot up a big notch. You're not going to see a big fashion shoot without both. (3) It takes a model with the right type of posing for fashion, and the reason I'm spending so much time on the clothing, hair, and makeup is because if you have a team putting those three aspects together, your job as photographer is actually very easy. One light. Gray background. Simple and classic, and what will "make" your shoot is the model, styling, hair, and makeup. If you're shooting fashion and you're not really happy with what you're getting, it's probably not because of the lighting or camera settings. It's because of the other stuff (model, styling, hair, and makeup). Yes, it honestly makes that big a difference.

Mixing Natural with Studio Lighting

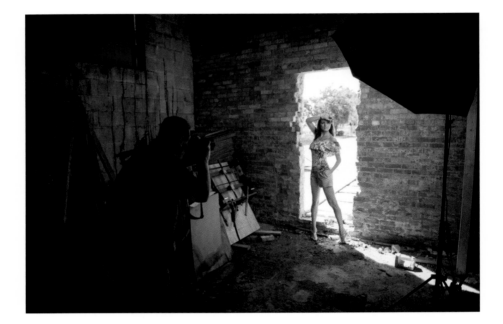

BEHIND THE SCENES: This shot was taken in the doorway of an old abandoned ice factory (we got special permission to shoot in there, and by special permission I mean they charged us a rental fee). This temporary hole in the brick wall was covered with a large wood panel, but they removed it so we could shoot through it like this. It's the middle of the day and there is a ton of light coming in from behind her, so after a few test shots, I decided to just let the background completely blow out to white. With this strong backlighting, she's just about a silhouette standing there, so we brought in a 53" midi-octa softbox to light our subject. So, this is basically a one-light shoot with the sun doing the job of lighting her from behind and creating a rim light around her.

CAMERA SETTINGS: Unless I'm shooting a wedding, I don't reach for this lens very often (I should probably use it more than I do because it is pretty awesome), but it's the 85mm f/1.4 (Nikon's is an f/1.4, Canon's is an f/1.2, but both make an f/1.8 version that is about 30% of the price and you only lose 2/3 of a stop). It's super-sharp, and you can create a super-shallow depth of field with it if you shoot it at or around f/1.4 (which I did—f/1.4). The rest of the settings are the same as always when using flash: the lowest, cleanest ISO (200 ISO on this camera), and the shutter speed at 1/125 of a second.

Final Image

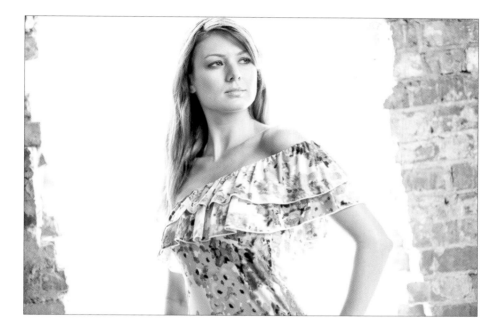

THOUGHT PROCESS: Once I looked through my viewfinder and saw how incredibly bright the light was streaming in from behind her, rather than try to fight it by changing my exposure in-camera or trying to reduce it later in Photoshop, I decided to embrace the light. I shot at f/1.4 and went really bright with the whole look, giving it an overall blown-out look (which I accentuated in Photoshop—more on that in a moment), so it's "high key" to the max.

POST-PROCESSING: I think it's pretty important that, if you're going to try to reproduce the looks that I'm sharing here in the book, you can nail them. But, honestly, you're not going to be able to get this look above with just f-stop, shutter speed, and ISO. It's going to take some Photoshop (or Lightroom). The good news: it takes you literally less than 60 seconds to get this look using the Google Nik Collection's Color Efex Pro. Just open it up, apply the High Key filter with the default settings, and you're done. Easy peasy. If you don't have Color Efex Pro, you can download a free trial copy from: www.google .com/nikcollection/ (click the Try Now button up top). It downloads their whole plug-in collection, but just go to the Color Efex plug-in (it works for Lightroom, Photoshop, Elements, or Apple Aperture).

Big, Beautiful, Wrapping Light

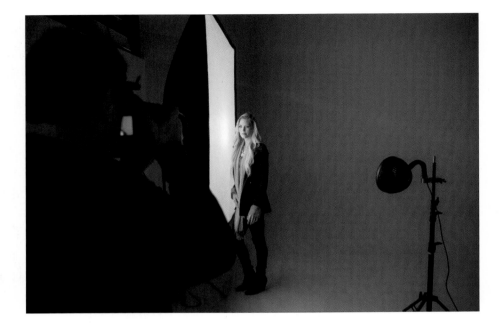

BEHIND THE SCENES: Here you can see the simple one-light setup using a really big softbox. It's a 54x72" shallow softbox made by F.J. Westcott. As big as it is, it's only $350 and, at that size, it creates some gorgeous light. The placement of the light couldn't be any easier. Have your subject face forward, then put the light directly beside them. That's it. Normally, that would put the other side of their face completely in shadow, but you're going to position your subject very close to the softbox and the light will literally wrap around them, lighting the other side. In this case, I had our subject face the light to really light up her hair, but it's really not necessary—they can face mostly toward the camera.

CAMERA SETTINGS: We're in the studio here, and if I had to choose a favorite f-stop for portraits it would probably be f/11. Why f/11? Because, for portraits, it's an f-stop that keeps everything perfectly in focus from front to back. Now that I've told you f/11 is probably my favorite, I actually shot this at f/10. Does that one f-stop make that big a difference? Honestly, no. At f/10, everything's going to be perfectly in focus, too. It's just that at f/11, I thought the lighting looked a little too dark. I could have cranked up the power on the light, but it was just easier (lazier) to lower the f-stop one stop and then the light looked much brighter. I was using my go-to lens: the ol' 70–200mm f/2.8, and I was zoomed in to 100mm. My shutter speed was 1/100 of a second (I probably accidentally moved the dial during the shoot—it would normally be at 1/125 of a second). My ISO was 100.

Final Image

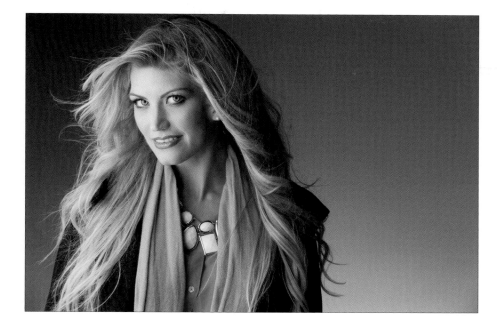

THOUGHT PROCESS: If I could tell you one hands-down, killer secret to getting really beautiful light, it would be to buy a really, really big softbox. The bigger the softbox, the more beautiful and wrapping the light, and it's hard to make anyone look bad with a softbox this big (in fact, I've heard other photographers refer to it as cheating). With a softbox this big, you can literally just put it directly beside your subject, put them right in the center of it (as you see on the previous page), and it does the rest. One posing tip: to help the light wrap around your subject, have them "play" a little toward the light (in other words, don't have them position their body so they are facing away from it—face them either straight ahead or aimed a little bit in the direction of the light). Also remember, whatever is closest to the softbox will be brightest (notice her arm on the left here).

POST-PROCESSING: Just your standard portrait retouching stuff: removing minor blemishes, spots, or specks on her clothes, and brightening the existing highlights in her hair using the Adjustment Brush in Lightroom's Develop module (or Camera Raw).

TAKE-AWAYS: If you want really soft, creamy, luxurious, beautiful, wrapping light, get your hands on a really huge softbox, and the rest will take care of itself. Couple the size (bigger means softer) with getting your subject very close to the softbox (which makes it even softer), and you've got a tough combination to beat.

Entertainment Lighting

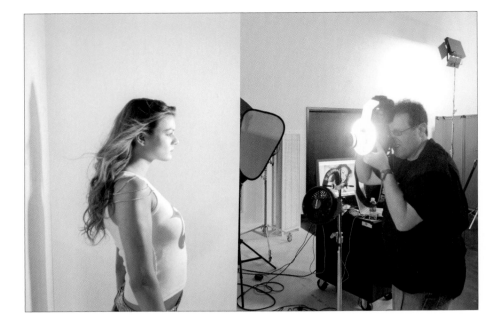

BEHIND THE SCENES: This is another one-flash look, but in this case we're using a special ring light adapter that attaches over your existing hot-shoe flash (the one I'm using here is a Ray Flash adapter from ExpoImaging [www.expoimaging.com]). The ring flash adapter has a hole in the center and your lens extends through that hole, so the ring goes around it. The trademark look of a ring flash is flat, very bright light that creates a dark halo around the edges of your subject when they're against a wall, which is why you usually see ring flash shots taken up against a wall. In this case, the "wall" is actually a studio V-flat (two large 4x8' white reflector cards purchased at a local sign shop and connected to each other with a strip of black gaffer's tape, so they form a "V" and can support themselves). I put her just in front of the V-flat, so you could see some of that dark halo on the wall behind her. I'm also using a small fan mounted on a light stand (the fan is from BLOWiT Fans [blowitfans.com]) to add movement to her hair.

TECH STUFF: I'm using a regular hot-shoe flash, and while normally I'd be at 1/4 power indoors like this, because the Ray Flash adapter eats up a lot of the power of the light as it redistributes it into a circle of light, and because a ring light look is very bright by nature, I powered up the strobe to its full power setting. That means it's going to take a little longer between flashes for the flash to recharge before it can fire again. I'm shooting in manual mode at f/10 with a 1/125 of a second shutter speed at 200 ISO.

Final Image

THOUGHT PROCESS: I call this "entertainment" lighting because that's where I see it most often used—in ads for things like Vegas nightclubs or in print ads for perfume or cologne, where they want the people in the ads to look like they are out clubbing and a photojournalist just happened to catch a shot of them as they were being fabulous. The light is bright and punchy like an on-camera hot-shoe flash, but without the harshness of a direct hot-shoe flash. Also, a lot of photographers like the round catchlights it produces in the subject's eyes (even though only another photographer would ever notice). The Ray Flash I used here is designed to attach over an existing hot-shoe flash, but there are fully self-contained units, as well, my favorite being the Ring Flash 3000 from Elinchrom for their lightweight Ranger Quadra battery packs. It's the lightest, easiest one I've ever worked with.

POST-PROCESSING: The lighting is pretty flat and usually very bright, so you might have some hot spots to deal with in Photoshop. I usually remove them altogether using the Healing Brush in one long stroke, and then I go under the Edit menu, choose Fade Healing Brush, and lower the Opacity so the highlights come back without the sweaty, shiny look.

TAKE-AWAYS: A ring flash is to lighting as a fisheye lens is to lenses. It's a cool look every once in a while, but it can get old fast if you use it too much.

Dramatic Side Lighting

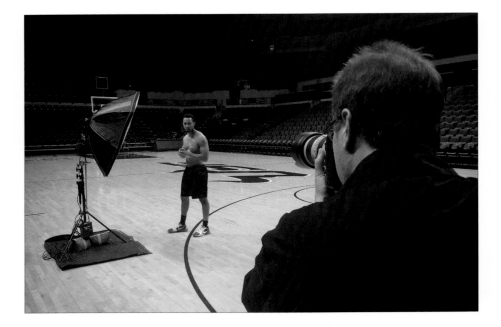

BEHIND THE SCENES: This pretty-large-sized, midi-octa softbox gets around, but the position here is directly beside the subject. It's up a little higher than our subject and aiming down a bit. This is shot on location in a college basketball arena. We're using one strobe with a battery pack (we're using a battery pack, so we won't have to run two 100' extension cords to power the light). The padding underneath the light stand is there so we don't scratch the hardwood court. We have two sandbags on the legs, so the whole thing doesn't topple over (it's pretty unlikely indoors like this, but hey, ya never know, right?).

CAMERA SETTINGS: All the lights on the court are turned on, but we don't want the shot lit with the flat arena lights; we want it lit with our strobe. So, to have the scene kind of "fall off to black" (so the only thing lighting our subject is the strobe), you want to choose a high-number f-stop, like f/11 or higher (I chose f/16). This would mostly kill the arena light. Well, in fact, it did such a great job that I had to lower the shutter speed (it controls the room light) from my standard 1/125 of a second down to just 1/50 of a second just to see that he was still on a basketball court (I want the background to be pretty darn dark, but I do want you to see he's on a court). Now, how did I know that 1/50 was the right amount? I didn't. I did a few test shots at different (slower) shutter speeds (1/100, 1/80, 1/60, 1/50, and 1/30) and the one that looked best to me was 1/50, so I went with that. I'm using a 70–200mm lens and I'm standing quite a ways back to get a 2/3 body shot.

Final Image

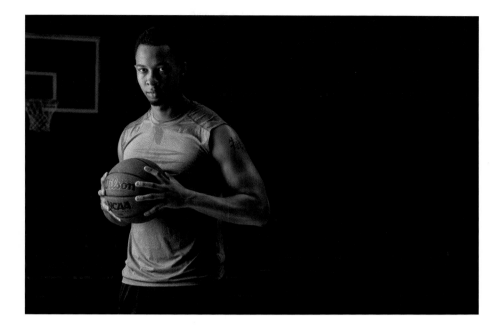

THOUGHT PROCESS: I wanted kind of a dramatic look with subtle lighting, but I didn't want the background to get so dark that you couldn't see the hoop or the stands behind him, so as I mentioned on the facing page, I had to adjust the f-stop up to a higher number (f/16) to make the flash not overlight the scene and fall off to black, and I needed to adjust the shutter speed a bit (slowing it) to see some detail in the background. Since the light is directly to his side, I had him turn his body toward the light (so it's kind of facing the light), but then I had him turn his head a little toward the camera. (*Note:* In the production shot on the facing page, his shirt is off. After the shots with the gray shirt and basketball, I asked him to remove his shirt so I could get a shot of some of his really interesting tattoos— each one has its own fascinating story about his life.) It's really just another simple one-light shoot: the light is directly beside him, his body is angled toward the light, his head is looking back at me—click.

POST-PROCESSING: For portraits of athletes like this, I do two things: (1) In Lightroom's Develop module (or Camera Raw), I increase the Contrast amount (drag the slider way over to the right), and then (2) I add quite a bit of Clarity. That's what makes his skin look shiny and it brings out the texture in his skin, clothes, and the ball. Of course, I sharpened it (like I would any photo), but in the case of an athlete's portrait like this, I added a bit more sharpening than usual.

Filling In Shadows

BEHIND THE SCENES: Here we have one medium-sized softbox, up high and aiming down at our subject. It's a little bit in front of him, aiming back at him. This would pretty much make the shadows on the far side of his face really dark, but we used a silver reflector (held up on a light stand with an A-clamp from Home Depot) to fill it in.

CAMERA SETTINGS: This is getting to be a pretty boring section of this chapter, but my studio settings are pretty consistent for the most part, because some things are constant in a studio environment, like my shutter speed, for example—it's nearly always 1/125 of a second. If it's something different for an indoor shoot, it's probably because I accidentally moved the dial at some point during the shoot. I wouldn't even notice it changed unless I went above 1/200 of a second. Then I'd know, because I'd start to see a dark gradient across at the bottom of the image, otherwise I just would have no way to tell. Another thing that stays the same is my ISO. When using a flash in the studio, it will always be at the lowest, cleanest setting (either 100 or 200 ISO, depending on which camera body I'm using). Lastly, my f-stop is usually around f/11, so everything stays in focus. If you see it drop to f/10, it's either because I needed the light a little brighter and was too lazy to raise the power of the light, or because I (wait for it…wait for it…) accidentally moved the other dial during the shoot.

Final Image

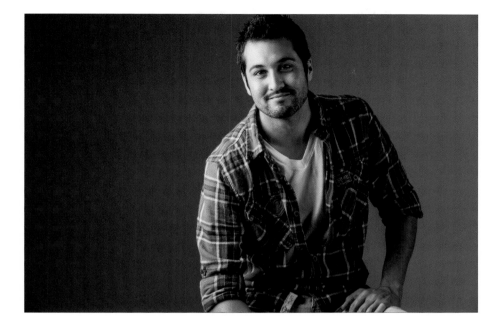

THOUGHT PROCESS: I absolutely love shadows, and I have no problem whatsoever with the shadows on the far side of his face (right side from the camera position) going black. I think it adds drama and dimension, especially in photos of men. So, normally, I wouldn't even mess with it, but I know there are folks who are "shadow adverse" and always want to see detail on that far side of the face, and that's why I included this here in the book. In reality, you're unlikely to see me using a reflector like this unless I am shooting fashion and it's important that the clothing is lit evenly on both sides.

POST-PROCESSING: One thing I love about retouching guys is that you hardly have to do anything. Basically, I remove any major blemishes using the Healing Brush in Photoshop, then I sharpen them to death (accentuating pores and skin texture on guys looks great, as opposed to when we retouch women and children and try to avoid accentuating that texture), and then I just save the file. Why so little retouching for guys? Nobody cares about guys. Well, outside of family members. ;-)

Simple, Flat Lighting

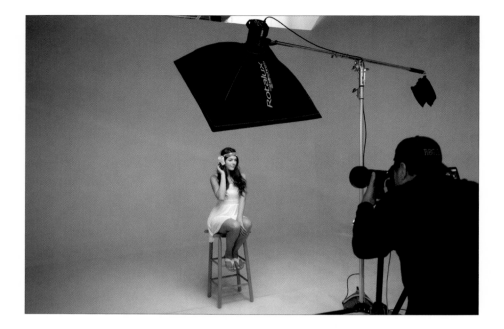

BEHIND THE SCENES: Here, our subject is sitting on a stool with a medium-sized softbox directly in front of her, up above her and aiming back down at her at a 45° angle. The boom stand is kind of important here or you'd have a metal pole right in front of you and you'd have to kind of shoot around it. I've done that, but it's a pain, and you usually have to move a little off-center to make it work.

CAMERA SETTINGS: To keep everything in focus, I'm shooting at f/10, and the rest of my settings are pretty much my standard ones: the lowest ISO (100 on this camera), and the shutter speed at the standard 1/125 of a second. I'm once again using my trusty 70–200mm lens.

Final Image

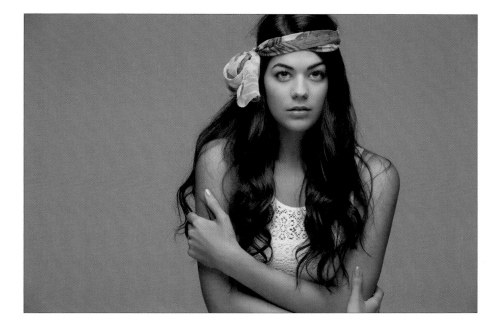

THOUGHT PROCESS: This type of flat, straight-on lighting is somewhat flattering to the skin (it does a good job of minimizing skin blemishes or wrinkles), but what's nice about it is it puts some lovely soft shadows on the neck. One reason the light is so soft is that the softbox is actually pretty large in relation to our subject and that really helps. For subjects with a lot of hair, the direct, straight-on light really brings out the highlights (as seen here).

POST-PROCESSING: Just standard portrait retouching stuff (removing a blemish, brightening the eyes or irises, removing any little wrinkles, etc.) and, of course (I know this goes without saying, but I'm saying it again anyway), sharpening.

Playing Up the Shadow

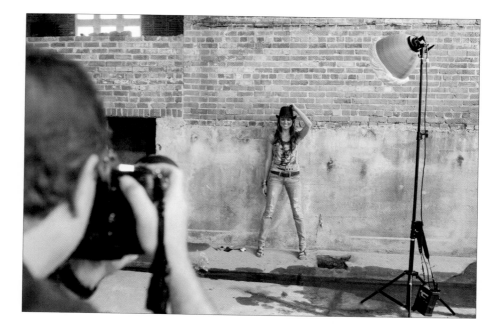

BEHIND THE SCENES: We're shooting on location here, using just one light, up high on a stand, and we put a very large "long throw" reflector on it (so the light reaches farther and is more intense—so intense that we had to put a diffusion sock over the front, so it wasn't so harsh). The reason there's no softbox is because we're trying to bring out the shadow on the wall behind our subject. It's up so high because we're trying to mimic the mid-day sun up high in the sky. We're using a flash with a battery pack because we knew we would have limited access to power outlets at this location.

CAMERA SETTINGS: Pretty much the same as always, even though we're on location: same low ISO (200 ISO), the standard 1/125 of a second shutter speed, and I'm using the 70–200mm lens again, but with an f-stop of f/5.6.

Final Image

THOUGHT PROCESS: If you look at any of the shots in this chapter (or even in my portfolio), you'll notice that you don't see shadows on the wall behind my subjects. We generally don't want to see the shadows, so I position my subjects 8 to 10 feet from the wall. That way, their shadows wind up falling on the floor behind them. However, just for effect, this is one of those cases where I want to see the up-close texture on the wall and the shadow falling on it, and that's why I chose the single light, up high, with that long throw metal reflector on it. That accounts for the semi-harsh look to the light and the shadow on the wall, but that won't get you the final look you see above. That comes courtesy of Photoshop.

POST-PROCESSING: The entire look comes from Nik Software's Color Efex Pro plug-in for Lightroom, Photoshop, or Elements. It's my secret weapon for post-processing effects, but it's not really a secret as tons of photographers use it every day. You can download a free trial copy from www.google.com/nikcollection/ (click the Try Now button up top). The plug-in allows you to apply multiple filters to an image, and I used three to get this particular look: (1) High Key (the default settings), (2) Bleach Bypass (the default settings), and (3) Glamour Glow (I clicked on the icon to the right of Glamour Glow and chose Strong Glow from its presets). Simply click the Add Filter button before selecting another filter, and then click OK. It applies all three to a copy of the layer. Now, lower the Opacity of this layer a bit until it looks good to you (I lowered it to 50%, in this case). I did a step-by-step video tutorial on this on the book's companion webpage, found in the book's introduction.

SHUTTER SPEED: 1/750 SEC F-STOP: F/8 ISO: 800 FOCAL LENGTH: 150mm PHOTOGRAPHER: SCOTT KELBY

Chapter Three

Using Two or More Lights Like a Boss!

Two- and Three-Light Recipes That Are Still Pretty Easy

How come the title of this chapter says "like a boss" instead of "like a pro"? If you're even asking that question, that means that you're Snoop Oldie Old, because if you use that "like a boss" phrase to anyone under the age of 40, they will think you are so cool. But, of course, they don't use that term "cool" because that's "uncool." They use "like a boss!" By the way, if even for a moment you thought that "like a Boss" was some reference to Bruce Springsteen (whose fans call him "The Boss"), then you probably are old enough to be familiar with the phrase "Chairman of the Board" or "Ol' Blue Eyes," which are nicknames of one Mr. Francis Albert Sinatra, but you may refer to him as Mr. Sinatra, or if you're Liza, you can call him "Frank," but don't push it. Now, as I mention Ms. Minnelli, I did what we often do when someone's older and has been out of the spotlight for a while: I wondered aloud, "Is she still alive?" As it turns out, thankfully, she is and she's not that old—she's only 68—and by my saying that Liza's not that old at 68, that should tip you off that perhaps I am no spring chicken myself (despite my silky smooth complexion and otherwise teen-like appearance). My 17-year-old son would say Liza's "ancient," but (and this may come as a surprise to you) my son absolutely loves Frank Sinatra. I am not kidding. He has loads of his songs on his iPod, along with Dino and Sammy (right beside Metallica and Falling in Reverse), but because Liza did a duet with Frankie ("I've Got the World on a String" from Frank's *Duets* album), my son thinks Liza sings "like a boss!" (though if Frank were alive today, he would probably have one of his "fellas" strangle the band members in Metallica and Falling in Reverse for being long-haired punks). Don't mess with Frank. He *is* a boss.

Beauty Look

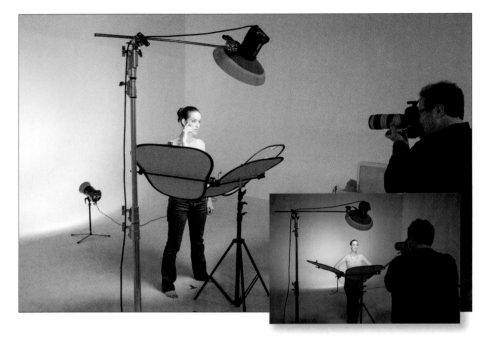

BEHIND THE SCENES: This shot actually uses one light on the subject (a strobe with a 17" white beauty dish with a diffusion cap over it to soften the light). But since, in this case, I wanted a solid white background, I had to use a second strobe to light the white background. (If you don't put a bright light on a white background, it becomes a gray background, and if you don't mind a gray background, then this becomes a one-light shoot.) We are using a special reflector to bounce the light from the beauty dish back onto our subject from below, so it fills in any shadows under her eyes and softens the shadows on her neck. You see this style of lighting a lot in cosmetic ads (hence, the "beauty" name to the look), but it also looks great for just regular headshots of both men and women. The strobe is set at its lowest power setting because it's so close to our subject.

CAMERA SETTINGS: My f-stop is f/13. Now, normally, I like f/11, but the light was a little too bright and the power on the strobe was already turned all the way down to its lowest setting. Raising the f-stop lowers the amount of overall light, though. It's kind of like being able to lower the power of the light below its lowest setting. My shutter speed was 1/200 of a second (no particular reason—I usually use 1/125 of a second, but the dial probably got bumped at some point). I'm in the studio, so I'm using my camera's lowest, cleanest ISO (100 ISO), and I'm using a 70–200mm f/2.8 lens at 100mm.

Final Image

THOUGHT PROCESS: We don't need a second main light on our subject because we're using an incredibly handy reflector system from Lastolite called the Triflector MK II, which is basically three individual reflectors mounted on one stand. The advantage is you can control each of the three reflectors individually, so you can wrap your subject in reflected light. Luckily, it's fairly affordable (B&H Photo has it for $189 at the time of this writing) and, while it's very lightweight, it's well made. Besides the lighting (which is pretty simple— one light directly in front of your subject, and by the way, it does not have to be a beauty dish, as a small softbox will work fine), what really gives you this look is: (1) getting the right subject (not everybody's facial structure works for the beauty look); (2) once you have the right subject, having her hair pulled back in a tight bun behind her head (you don't want to see any of it sticking out the sides); (3) having her apply natural-looking makeup; and often (4) having her shoulders bare, like you see here.

POST-PROCESSING: If you're wondering where the three catch lights from the reflectors are in her eyes, I cloned two of them out in Photoshop using the Clone Stamp tool. (It just looked a little weird to me. Nobody else would probably even notice, but it takes all of two seconds—just two clicks, one over each catch light.) Besides the standard retouching stuff (smoothing skin, removing blemishes, etc.), I did lower the Vibrance amount in Lightroom's Develop module (or Camera Raw) to desaturate her skin a bit, so it looked paler and less brown.

Two-Light Catalog Look (Men)

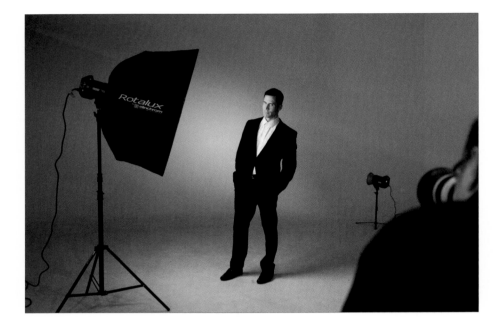

BEHIND THE SCENES: In Chapter 2, you saw how to do a similar look using just one softbox at a 45° angle to the subject, but we let the background be a solid gray color. In this one, we're adding a background light to add some separation and depth from the background. They sell specially made short light stands for background lights (like the one we're using here. It's around $30 at B&H Photo—just go to their site and search for "backlight stands," and you'll find a bunch. I have ones by Impact and Manfrotto). When we use a backlight, we attach the metal reflector that comes with the strobe rather than just using the bare bulb. That way, we can control the beam that hits the gray background somewhat. (The front light is far enough away from the background that it doesn't light the white background, so that falls to gray. Then, we put the background light close enough so it doesn't turn the whole wall white, but just puts a splash of white light over the gray.) The main light has a 39x39" softbox and is on a light stand positioned up a little higher than our subject, in front and to the side a few feet (it's not right next to him, but it's closer to the side of him than normal, so we get lots of dramatic shadows on the far side of his face).

CAMERA SETTINGS: It's my go-to lens (the 70–200mm f/2.8) at 125mm, at my ideal studio f-stop (f/11), at my lowest, cleanest ISO (100 ISO), but for reasons unknown (I bumped the dial on my camera?) my shutter speed is only 1/50 of a second. Shouldn't the photo be blurry at just 1/50? Luckily, the flash freezes any motion. Otherwise, it probably would have been.

Final Image

THOUGHT PROCESS: The lighting here is pretty simple (as you saw, there's just one light on the subject, and one on the background), but the shot on the left is about something more, and it's something I talk about on my live tour: capturing "real" moments instead of just posed shots. When I've shown the shots above to people, they always seem to comment about the shot on the left and they say, "He looks so pensive" or "deep in thought," but in reality what he's doing is looking for a black "X" we put on the floor with gaffer's tape so he'd know where to stand. When I told him that, I still had my eye on my camera's viewfinder, and when he looked down, I took the shot and got the "real" him before he got back to posing. It's my favorite shot from the shoot. There are these moments between poses when you're talking to the subject, or they're distracted, or you're intentionally distracting them, and that's your chance to capture that "moment between the poses."

POST-PROCESSING: There are two things going on here: (1) the standard portrait retouching for guys (removing blemishes, sharpening, etc.), and (2) the "look," which comes from adding a cross-processing effect (kind of like a split-tone effect, where you apply one tint to the shadow areas and a different tint to the highlights). I actually use a wildly popular plug-in for this called Nik Color Efex Pro (part of the Nik Collection from Google). I use their Cross Processing filter and their built-in presets. I created a video tutorial for you on how this is applied, as well as a Photoshop/Lightroom split toning version, which you can find on the book's companion webpage (mentioned in the book's introduction).

Three-Light Catalog Look (Men)

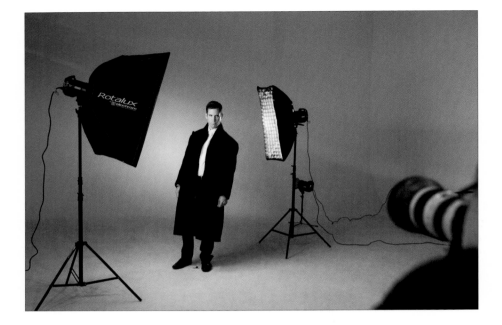

BEHIND THE SCENES: Same exact setup as the previous recipe, but in this case we've added what we call a "kicker light" behind our subject to add a bright rim light along the side of his face that would normally be in shadow. For this kicker light, I used a strip bank, which is just a tall, thin softbox that sends out a taller, thinner beam of light than a big ol' square softbox does. However, it still wasn't as directional as we'd have liked, so we added an egg crate fabric grid (named because it looks like an egg crate) over the front of the softbox (it was just Velcroed into place), and that focused the beam even tighter.

CAMERA SETTINGS: The settings were pretty much the same as the image in the last recipe (they were taken just a few minutes apart): the same lens (the 70–200mm f/2.8— you can see it in the shot above) at 190mm, at f/11, 100 ISO (clean!), and my shutter speed was 1/50 of a second.

Final Image

THOUGHT PROCESS: When you add this second light, make sure you turn off the front light and get just the kicker light looking good all by itself: aim it at the side of his face from behind, take a test shot with just this one light on, and then re-aim if you think you need to. Ideally, it should light his hair, shoulders, and stuff on that side, but when it comes to his face, it should only light the side of his face, as seen here, so don't let it wrap and light his cheek or nose—try to keep it on the side. Once that's looking good, only then do you turn on the front light. My lighting goal for a shot like this is that the left side of his face is well-lit, then it goes a bit shadowy, and then the kicker light kicks in and lights the rest of his face. So, it's well-lit on the left side of his face, then it goes a little dark on the right side of his face, and then it gets very bright. This extra light helps to add a bit more depth and dimension to the shot.

POST-PROCESSING: Not much in the post-production department on this one (no effects or filters), however with shots of men I generally want to emphasize the texture in their face, so I drag the Clarity slider in Lightroom (or Camera Raw) to the right a bit, which does the trick.

Edgy Lighting for Athletes

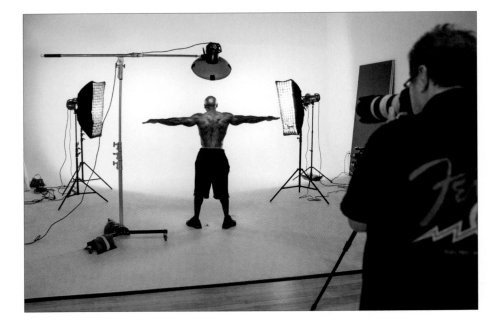

BEHIND THE SCENES: If this looks like a complicated shoot, then good news: it's much, much easier than it looks. There are three lights on your subject, but this is really such an easy setup. There are two lights behind him, using 1x3' strip bank softboxes (pretty inexpensive by photography standards—around $120 each). I also added an egg crate fabric grid that is Velcroed over the front of the softbox to focus the beam from the light, so it's more direct and doesn't spill over too much. Turn off all your lights and then turn on one of these back strip banks and aim it at an angle toward your subject (like you see here). Since there are no lights on in front, it should just look like a bright rim light outlining his body. Now, turn on the second strip bank. It should look the same, but lighting the other side. Try to get both sides looking about even in height and power output. Lastly, you'll turn on the front light—in this case, a beauty dish with a metal grid, but you can also use a small softbox if you don't have a beauty dish. Put it right in front of your subject, up high and aiming back at him at a 45° angle. If you want the background solid white, aim another light at the background with a metal reflector on it (here, I added one on each side, behind the backlights) and turn the power up until the background looks solid white.

CAMERA SETTINGS: I'm using flash, so I'm in manual mode on my camera. I'm using my go-to lens (the 70–200mm f/2.8) at 70mm, at my ideal studio f-stop (f/11), at my lowest, cleanest ISO (100 ISO), and my standard shutter speed of 1/125 of a second. Pretty standard stuff.

Final Image

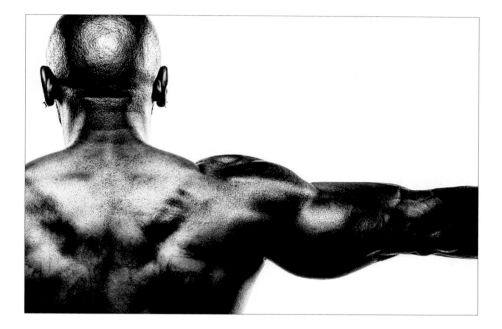

THOUGHT PROCESS: I'm personally not really big on black-and-white images, but I knew I was going to create one when I made this image, because I love how things like muscles and tattoos look in black and white, especially when it's really contrasty (and I'm going to make it really contrasty in Photoshop). But, before you get to that point, if you have a very muscular subject (like we do here), you can have them apply some body oil to help add a shine to their skin that really looks great (make sure you have some on hand before they arrive). By the way, just in case you're feeling kinda creepy over this, you'll be happy to know that applying body oil is pretty common for body builders, especially in competition, so they won't be shocked if you ask (in fact, my subject here came with his own).

POST-PROCESSING: Even if I know I'm going to create a black-and-white image, I always shoot in color and then use a plug-in to convert to black and white. The one I use pretty much everybody uses because it's so simple and looks great: Silver Efex Pro from Google's Nik Collection. Just open your image into it (it works with Lightroom, Photoshop, Elements, and Apple Aperture), and it shows you a bunch of thumbnail previews of different looks (called Presets). Click on the one you like, and then click OK. That's all there is to it. Click on the one you like the best, and then save. How easy is that? I also add a lot of sharpening in Photoshop to give the image a really sharp, crisp look (like this Unsharp Mask setting: Amount 90, Radius 1.5, Threshold 0. If you think that's too much, try: Amount 120, Radius 1.0, Threshold 3).

Beauty Look with Wraparound Light

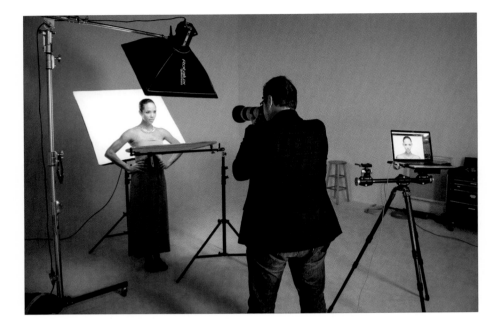

BEHIND THE SCENES: This is a very simple two-light shoot that looks like you used a lot more lights. The first light is a small softbox (it doesn't really matter what size—it can be a large softbox), and it is positioned directly in front of your subject, up higher than her head, and aiming back at her at a 45° angle. Easy enough. Directly in front of your subject, at about chest height, is a pop-up silver reflector that bounces some of that light from the softbox back into your subject's eyes and neck to reduce the shadows there. Usually, I'll just have the subject I'm shooting hold the reflector flat, right out in front of them, for me. Lastly, the second softbox is placed directly behind your subject, aiming up at the ceiling at a 45° angle (that way, the flash inside that softbox isn't aiming straight back at your camera). It's this softbox that gives you the white edge light on both sides of her face, and the brighter you make this light, the farther those edges will extend around her face.

CAMERA SETTINGS: In the studio like this, we generally choose an f-stop that makes everything in focus, from your subject's eyes to the back of their head and everything in between, so something like f/11 is ideal (although I wound up using f/10, probably because I didn't feel like turning up the lights, so I cheated and lowered the f-stop). In the studio, I use the lowest, cleanest ISO I can (in this case, 100 ISO) and I use my standard shutter speed for flash—1/125 of a second. In short, the settings are really simple.

Final Image

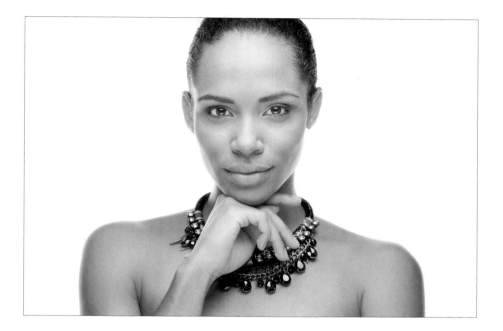

THOUGHT PROCESS: How does this differ from the original one-light beauty shot we did at the beginning of this chapter? Here, we added a 39x39" softbox directly behind her, and that brings light wrapping around both sides of her face (see the image above), along her shoulders, and around her head, as well. The whole thing creates a nice wrapping rim light that adds more dimension to the shot and really emphasizes the highlights. Also, we don't have to light the background with this setup because the softbox directly behind her becomes the background. This lighting setup is great for headshots because it minimizes shadows on the face, which tends to make people with a lot of wrinkles look younger (the reflector fills in all those shadows that make wrinkles look deeper), and that also works to minimize things like blemishes and acne. In someone younger, like we're shooting here, this is a classic beauty-style setup, but as I mentioned in the first shot in this chapter, to get a beauty look takes more than just lighting: her hair in a bun, the natural-looking makeup (think oil-free matte finish), and the bare shoulders all come together to create the look.

POST-PROCESSING: Just standard portrait retouching stuff: removing blemishes, smoothing skin, brightening eyes, etc.

One Main with Two Kickers

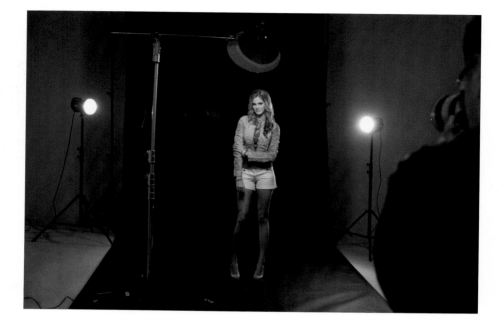

BEHIND THE SCENES: This setup is similar to the one I did on page 56: the main light is a strobe with a 17" beauty dish attachment, but I'm not using the metal grid that I used on that previous shot with the athlete. (The metal grid is designed to focus the light in a much tighter beam, and in this case I didn't just want to light her head, I wanted the clothing lit, as well, so I kept the grid off.) Instead, to soften the light, I added a diffusion sock over the front of the beauty dish. The two lights in back don't have softboxes attached, just the metal reflectors that come with the strobes (these help to focus the light, but without being too tight a beam). We're shooting on a 9' roll of black seamless paper, supported by two light stands with a bar between them.

CAMERA SETTINGS: In the studio like this, I generally try to use an f-stop that keeps everything in focus, and although my goal is usually f/11, in the final image on the facing page, I used f/9, which only means that rather than raising the power of the lights until it looked right at f/11, I went to f/9 to make things brighter (either way works: turning up the strobes or changing your f-stop to make the light brighter). In the studio, I use the lowest, cleanest ISO I can (in this case, 100 ISO), and I used my standard shutter speed for flash—1/125 of a second. I shot with my 70–200mm lens, zoomed in almost all the way at 182mm.

Final Image

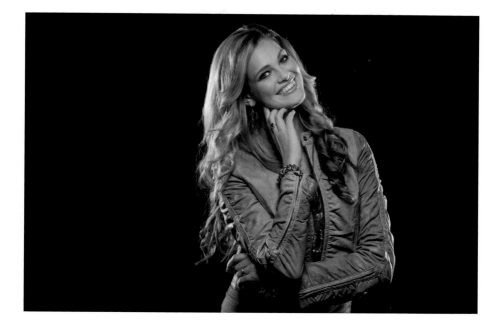

THOUGHT PROCESS: This is a really popular look today—you see it everywhere and it's really great for separating your subject from the background by using light to rim their entire body. You want to build a three-light setup like this in stages: Turn off the front light, then start with just one of the backlights and aim it at the back side of your subject's head, and take a test shot. The power of the strobe will probably have to be pretty high (otherwise, the front light tends to overpower the backlights, and it loses the effect). Once you get one side in back looking good, then turn on the other light. Both lights should be at the same height on the light stands (you don't want one up high and one a lot lower—try to keep them even, so they look consistent), and I generally keep the power setting of both strobes identical. But, I know some folks who like to vary the background lights, having one set at a high power setting and one at a lower setting for added contrast. (Heck, try both and see which you like best.) With just the backlights on, take a test shot and see if everything looks even (height, brightness, etc.), and then turn on the front light. You really want to see those backlights in a shot like this, so don't turn up the strobe in front so bright that it overpowers the backlights. I keep my front light close to its lowest power setting.

POST-PROCESSING: The standard portrait retouching stuff, but I did use Lightroom's Adjustment Brush (also in Camera Raw) to paint increased Clarity over her jacket and jewelry to bring out the texture and make them shinier. That's it.

Simplified Beauty Headshot Variation

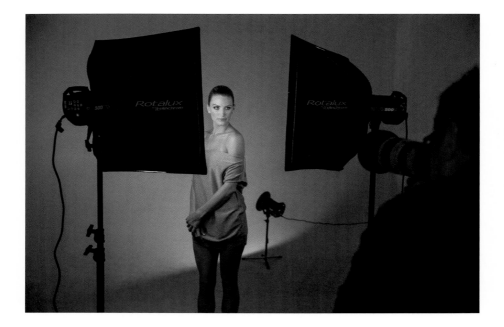

BEHIND THE SCENES: This is a simple three-light shoot, with just two lights on the subject (the third light is lighting the white background to make it actually appear solid white and not just light gray, which means we had to turn the power of the background light up high). We also used a wider metal reflector on the third light, one that's designed for lighting a background. The two lights lighting our subject are two small softboxes (27x27") on standard light stands. They are on either side of the subject with a small space in between for you to shoot through.

CAMERA SETTINGS: To keep everything in focus in the final image, I'm shooting at f/11, and the rest of my settings are pretty much my standard ones: the lowest ISO (100 on this camera), and my shutter speed at 1/125 of a second. I'm once again using my trusty 70–200mm lens, zoomed in to 145mm.

Final Image

THOUGHT PROCESS: I think this is a great setup for a photographer who wants a clean beauty look but maybe doesn't own a beauty dish, and/or doesn't have a big, sturdy boom stand to put the main light up high directly in front of the subject. This just uses two small softboxes—no big boom, no need for a beauty dish—yet it still produces a very nice look. (I learned this setup from awesome fashion/beauty photographer Lindsay Adler. She taught a class at a conference I produced, and I made sure to sit in her audience. As soon as I saw her use this modified beauty setup, I knew I had to try it, and of course it looks great, but without all the hassle of the normal setup. If you're looking for a very simple way to get the beauty look, this is the ticket!)

POST-PROCESSING: Just standard portrait retouching (removing blemishes, skin softening, brightening eyes, etc.).

Fashion Lighting Variation

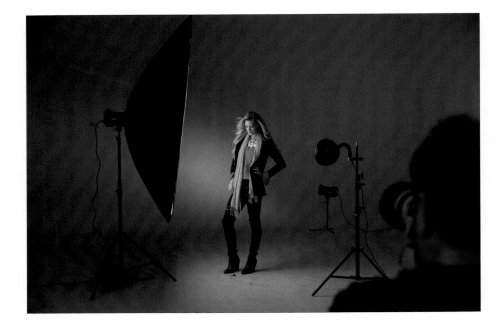

BEHIND THE SCENES: Okay, from the last chapter, you know how much I love a really, really big softbox (it's almost like cheating), and we're using that same big ol' 54x72" shallow softbox from F.J. Westcott, here. It's placed in pretty much the same position—right beside our subject—but I don't have her nearly as close as I did in the head-and-shoulders shot. Plus, we've added a background light to add some dimension to the background, and we're using a small light-stand-mounted fan (which I'm using pretty much just to get her hair off her shoulders) from BLOWiT Fans (blowitfans.com).

CAMERA SETTINGS: The final image was taken in manual mode (I always shoot in manual mode whenever I'm using flash) at f/10 and 100 ISO (the cleanest ISO on the camera I shot it with). My shutter speed was my standard 1/125 of a second.

Final Image

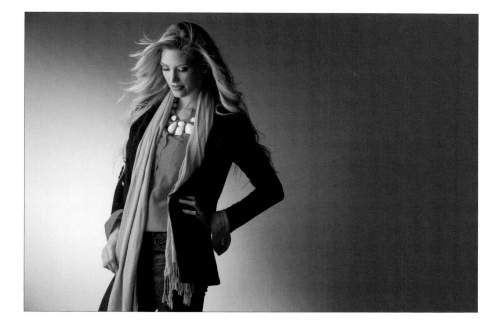

THOUGHT PROCESS: In this case, we're not just using a big softbox so the light is soft and beautiful (although it is), we're using it to light her clothing, as well. That means we need to light more of her than just her head and shoulders, which means we need to use a much bigger softbox (if you're shooting fashion, it's really important that you see the clothing), and this huge softbox does double duty (beautiful light and you can light anything from 3/4-length, like this, to full-length to couples with this one big softbox). The white background looks gray here because we didn't really light the background to make it white, we just used a light close to the background to add a splash of white in the middle of all that gray—that's from the normal metal reflector. If we had used the wider reflector we use when we want a solid white background, then it would have "washed" the whole wall with light and it would appear solid white.

POST-PROCESSING: Just the standard portrait retouching stuff.

Hurley-Look Headshot Lighting

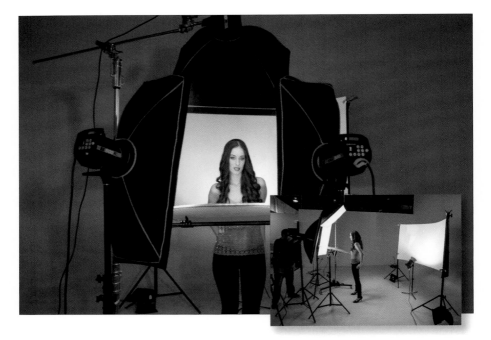

BEHIND THE SCENES: This is actually a four-light shoot, but at least it's a really easy four-light shoot. There are three lights on the subject: two 1x3' strip banks, one on either side of our subject, and then a small softbox overhead. On the bottom is a small silver reflector bouncing some of the light from the three lights back onto her face to minimize any shadows. The fourth light is on a short light stand directly behind her, aiming up at the background to make it solid white. The background is a 4x8' reflective HURLEYPRO Pro-Board, created by famous headshot photographer Peter Hurley (the guy that inspired this lighting look). It's white on one side, black on the other, and makes a perfect background for headshots like this (plus, it rolls up into a tube, so you can take it on location). We have it held up here using two light stands and four A-clamps from Home Depot.

CAMERA SETTINGS: For the final image, I'm using flash, so I'm in manual mode on my camera. I'm using my go-to lens (the 70–200mm f/2.8) at 130mm, at my ideal studio f-stop (f/11), my lowest, cleanest ISO (100 ISO), and my standard shutter speed of 1/125 of a second. Pretty standard stuff.

Final Image

THOUGHT PROCESS: Peter himself uses Kino Flo continuous lights for his front lights, rather than strobes (he uses strobes to light his background), but those Kino Flos are very, very expensive (the four alone would cost around $5,200, so strobes are a much cheaper alternative). He places the four lights to create a square, like a window, but in our example, we're only using three lights and a reflector (you can use a fourth light instead of the reflector, if you have enough lights). Peter's trademark square-of-light look produces a nice, flat, flattering light, but at the same time it's bright and punchy—a wonderful combination for headshots. But, what Peter is famous for isn't just his lighting look (which he'll tell you is very simple—he designed it to replicate natural window light), it's how he works with his subjects to get natural expressions and flattering poses, and he is a master at it. Our lighting setup here is designed to get close to his look without spending close to $5,200 (in fact, if you had to buy all three strobes from scratch and the reflector I used here, it would run around $2,100—well below half the cost). If you want to learn Peter's trick for getting the most out of his subjects, check out his book, *The Headshot* (published by Peachpit Press, and edited and produced by yours truly). Even though I was involved in producing the book, I can tell you without reservation, it rocks (and I learned a lot during the process. The guy's a genius).

POST-PROCESSING: Just your standard portrait retouching stuff.

Working with V-Flats

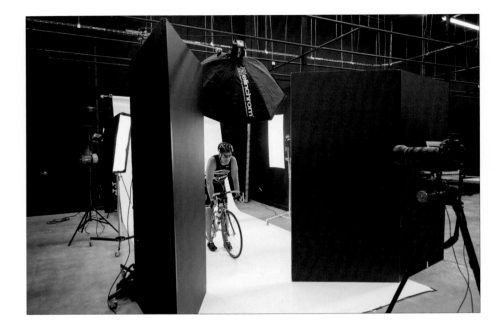

BEHIND THE SCENES: This is essentially the same three-light setup I used for the shot of the athlete from behind in the edgy lighting setup earlier in this chapter, except that because I also wanted to be able to light the entire bike he's on, instead of using a small 17" beauty dish in front, I used a large 54" midi-octa to cover more area. (By the way, we didn't put enough sand bags on the boom light stand at first and the whole thing went crashing over and broke the light inside. Luckily, I had a backup light we could use and we continued on with the shoot with a lot more sandbags.) The other difference in this setup is that I'm using two large V-flats (4x8' reflector boards that are white on one side and black on the other, so although you're seeing the black sides, the sides facing the cyclist are white). I put them there for two reasons: (1) To help block any light from coming back into my lens and causing lens flare. The two strip banks in the back are pretty much aiming right back at me, and I don't have the egg-crate grids on them like I did in the previous shoot (the egg-crate grid's main job is to focus the light, but the happy bonus is that focused light doesn't spill into my lens nearly as much—that's why I didn't need these V-flats blocking the lights in the other shoot). And, (2) the white on the other side of the V-flats (facing the cyclist) bounces some of that light back onto him and the bike.

CAMERA SETTINGS: My settings are pretty much my standard studio settings: my lowest, cleanest ISO (200 ISO) and my shutter speed at 1/160 of a second (probably bumped the dial at some point). I'm once again using my 70–200mm, my go-to lens for portraits, at 200mm.

Final Image

THOUGHT PROCESS: I tried a number of shots with the full bike, including a shot with him carrying it over his shoulder, and riding it straight at me, and a bunch of others, and I just wasn't really digging what I was getting, so we turned the bike sideways and I zoomed in tight with my 70–200mm to make more of a portrait. Then I told him to act like he was screaming and it wound up being my favorite shot from the shoot (for more of an "extreme sports" look, because hopefully you wouldn't be doing a lot of screaming while riding on a Saturday morning with a bunch of friends. If you do wind up screaming a lot, perhaps a portrait shoot shouldn't be your biggest concern. But I digress). You can see the reflection of the softbox in front in his helmet, so you can see we didn't change any of the lighting, just the position of the subject and his bike.

POST-PROCESSING: I did three main things after the fact in Photoshop: (1) I added a bit of a high-contrast effect using the Nik Color Efex Pro plug-in (part of the Nik Collection from Google—very popular with photographers and around $149). The filter I used inside it was Tonal Contrast, and I just used the default settings. (2) Next, I increased the color on the reflection in his sunglasses. It was already there, but I wanted it to be punchier, so using the Adjustment Brush in Lightroom (or Camera Raw), I dragged the Vibrance slider to the right a bit and painted over the lenses on the sunglasses to make them more colorful. And, (3) of course, I sharpened it to death using the Unsharp Mask filter in Photoshop.

Two-Light Catalog Look (Women)

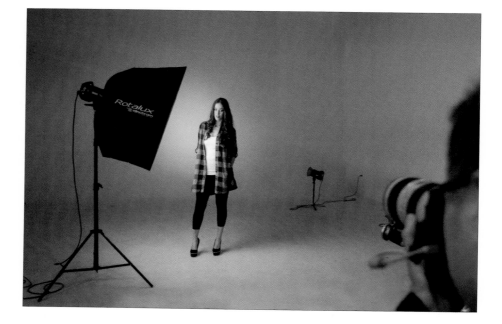

BEHIND THE SCENES: This is pretty much the same lighting setup I used earlier in this chapter to light a man for a catalog shoot (with one important change in the position of the main light, which you'll read about in a moment). It's a main light with a softbox aiming at your subject, and a background light with a reflector aiming at the gray background to add a pool of white light.

CAMERA SETTINGS: It's my go-to lens again (the 70–200mm f/2.8) at 90mm, at f/13, at my lowest, cleanest ISO (100 ISO), and a shutter speed of 1/200 of a second.

Final Image

THOUGHT PROCESS: While this setup does look very similar to the one I used with the man on page 52, I changed the placement of the softbox because it's a woman. Instead of placing it just in front of the subject (like I did with the man), for a woman we don't generally want the shadows on the far side of her face as dark or shadowy, so we moved the softbox forward a bit more, and you can see above that more of her face is lit, so the shadows aren't nearly as prevalent on the right side of her face (from the camera view).

POST-PROCESSING: I did two things: (1) standard portrait retouching for women (removing blemishes, softening skin, brightening eyes, etc.), and (2) gave it a fashion look by adding a cross-processing effect (kind of like a split tone in Lightroom or Camera Raw, where you apply one tint to the shadow areas, and a different tint to the highlights). I used Nik Color Efex Pro's (a plug-in for Lightroom, Photoshop, Elements, or Apple Aperture—part of the Nik Collection from Google) Cross Processing filter with one of the built-in Method presets. Again, see the video tutorial I did on this on the book's companion webpage (mentioned in the book's introduction).

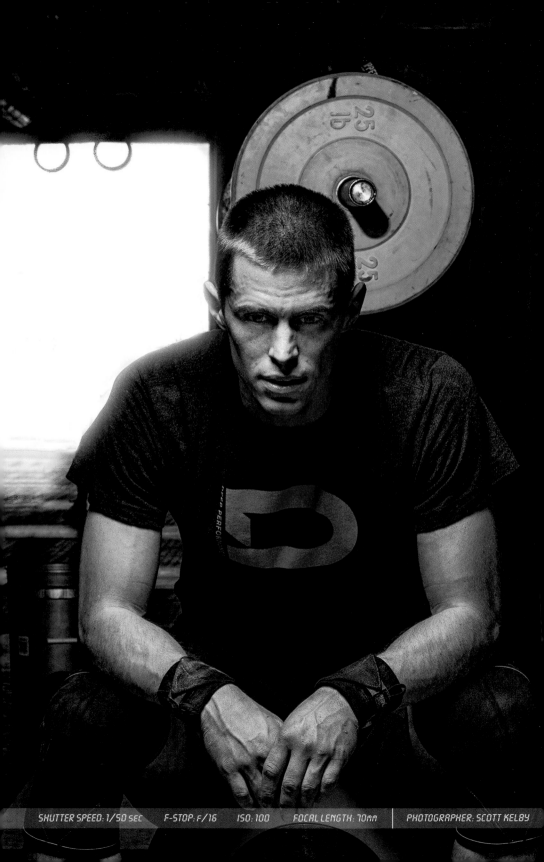

SHUTTER SPEED: 1/50 SEC F-STOP: F/16 ISO: 100 FOCAL LENGTH: 70mm PHOTOGRAPHER: SCOTT KELBY

Chapter Four

Hot-Shoe Flash
Like a Pro

*Quick Lighting Recipes for
Using Flash Like a Pro*

If there's an industry phrase that throws a lot of photographers off, it's "hot-shoe flash." The reason is that you'd have to know, in the first place, that the small metal socket on the top of your camera body is called a "hot shoe." Since so many folks don't know that, before we dive into this chapter, I thought I'd endeavor to make the concept much clearer by breaking it down to its roots. That way, we can analyze the individual words (stop snickering like I just said "Uranus"), and hopefully that will clear things up. The first word, "hot," gets its origin from the Germanic term "hovolklejetstealin," which is roughly translated as "hot wiring a Volkswagen Jetta," or the term "der hund haus," which means "foot-long Coney dog." The second word, "shoe," is actually a modern day term coined by poets Thom McAn and Dr. Scholl's, whose collaboration gave birth to the most influential and acclaimed poem of their time, the graceful and lilting "Odoriferous Insole," in which the term "shoe" was first used to describe a place that smells like Doritos. Lastly, is the word "flash," which quite literally means the bright sudden burst of light you see within seconds of eating a foot-long Coney dog and a bag of Doritos. This bright flash of light lets you know that death can't be too far behind if you keep eating like this, so the entire phrase, "hot-shoe flash," is generally accepted by most scholars as meaning: a small metal socket with electrical contacts, which discharges just enough electrical current to make you drop that Coney dog before the merciful angel of death takes you away toward an even brighter light. You can see why there was so much confusion. Hope that clears things up.

Making the Light Even Softer

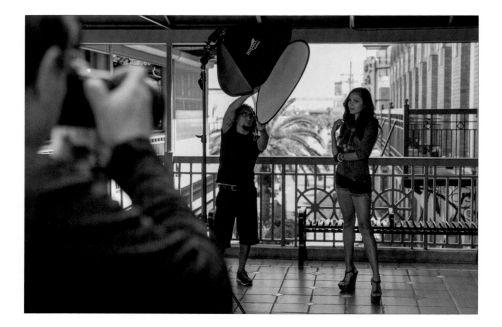

BEHIND THE SCENES: Here, we're using our flash with our go-to softbox, the Impact Quikbox pop-up softbox, but we're also holding a Westcott diffuser (the one that comes inside the 5-in-1 Reflector I talked about in Chapter 1) in front of the softbox, so the light is actually firing through two diffusers before it reaches our subject.

CAMERA SETTINGS: The lens is a 70–200mm f/2.8 and I'm zoomed in tight to around 120mm. My f-stop is f/5.6 but I could have used a lower f-stop (like f/4 or f/2.8), which would have put the background very out of focus. I wanted the background here to be just a little out of focus (to help separate her from the background), but I still wanted you to be able to see the railings behind her (I thought they looked kinda cool, and that's why I positioned her there). We're shooting in the shade, and I was concerned that I wouldn't have enough shutter speed to hand-hold the shot, so I had to increase the ISO to 200 to get my shutter speed up to 1/160 of a second (plenty of shutter speed to hand-hold in this light).

Final Image

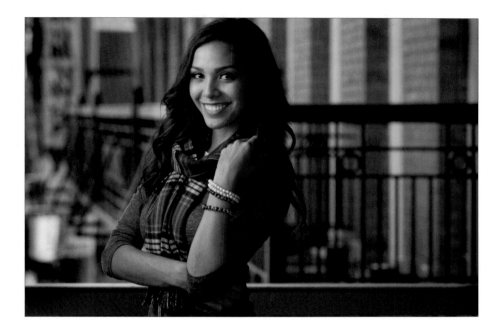

THOUGHT PROCESS: The diffuser on the front of your softbox is designed to spread and soften the light, and it does a pretty darn good job of it, but what if you take a test shot and you don't think it's quite soft enough? Well, the first thing you'd do is move the softbox as close as you possibly can to your subject without actually seeing it in the shot because the closer the softbox is to them, the softer the light will be. Well, what do you do if you move it in as close as you can, and it's still not soft enough? Well, you diffuse it some more by adding another diffuser. It's around $20 to pick up a hand-held diffuser like this and I gotta tell you, it does a beautiful job of creating really soft light (just take a look up above). Now, of course, when you shoot through two diffusers, you're going to have to turn the power of your flash up a bit so the same amount of light gets all the way through both. Here I started with my power setting at 1/4-power (my usual starting place), but once I added the second diffuser, I had to increase the power to 1/2-power to get the same amount of light. A note about the composition: If you look directly behind our subject on the previous page, you can see a lot of bright natural light back there. When I first composed the shot, I could see that behind her and it really drew my eye, so I moved a step or two to the left and recomposed the shot so I wouldn't see those distracting bright areas. Something to keep in mind: the background matters.

POST-PROCESSING: Nothing much to do here beyond the standard portrait retouching stuff (removing minor blemishes, brightening eyes, etc.).

Two-Light Location Setup

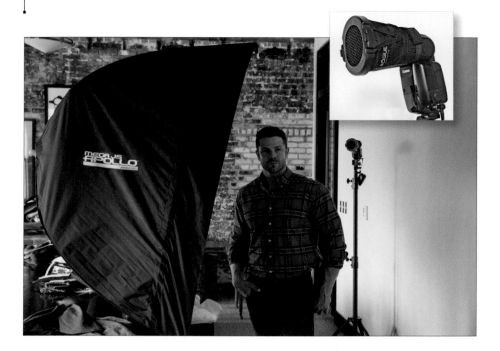

BEHIND THE SCENES: We're on location, and we're using a very large Westcott Mega JS Apollo softbox (we go big like this to create very soft light or to light more of the subject, or both). So, that big Apollo is the main light, and behind our subject (directly opposite that big softbox) is a second flash on a light stand with a Rogue 3-in-1 Honeycomb Grid made by ExpoImaging. This grid focuses the light from that second flash into a direct beam, so it doesn't spill everywhere (you can see a close-up of the second flash grid setup above in the upper right). We're firing these flashes using PocketWizard's PlusX model wireless transmitters, and you can see one hanging from the second flash (it's connected to the flash using a cable that comes with the PocketWizard).

CAMERA SETTINGS: It's my go-to lens (the 70–200mm f/2.8), but I'm only zoomed in to around 135mm. I'm at f/4.5, so the background is reasonably out of focus. My ISO is 400 and my shutter speed is just 1/25 of a second. I know what you're thinking, "Isn't that a little low for a shutter speed for hand-holding?" That would be correct if (wait for it… wait for it…) I wasn't using a flash. The flash does a great job of freezing any movement, so you can get away with lower shutter speeds.

Final Image

THOUGHT PROCESS: I've already talked about how zooming in tight and using a low-numbered f-stop puts the background out of focus, which helps separate your subject from the background (well, you read that if you read Chapter 1, anyway). Another way to separate your subject from the background is to use a second light, like we did here. It really adds a sense of depth to the image and makes the lighting look more interesting, which makes the entire image look more professional. So, there are a number of legitimate reasons for using more than one light. When I do two flashes like this, I like for one light to be really soft (usually the front light), then I like the other flash to be more hard-edged so it creates a nice contrast between the two lights. I also try to position the front light so I get a little area of shadows on the subject's face between where the soft light ends and the hard light begins. You can see this in our subjects' faces above. Look from left to right: first, you see the soft light on the left side and part of the right side of their faces; then as you move to the right, you see an area of shadows on the right side of their faces; then you see the hard light on his right cheek and the right side of his head and her hair. *Tip:* The key to making two lights work like this is to start with only the back flash on. Get that aimed and looking good all on its own, then turn on the front flash.

POST-PROCESSING: Two things: (1) standard portrait retouching, and (2) in Lightroom's Develop module (or Camera Raw), in the Effects panel, under Post Crop Vignetting, drag the Amount slider to –11 to darken the edges of the image just a tiny bit.

One-Flash Environmental Portrait

BEHIND THE SCENES: We're backstage at a classic old theater and the dressing rooms are to my left (this place just might be ready for a makeover, eh? But honestly, that's what drew me to doing a backstage shoot here—it's got "character"). I'm using my go-to lighting setup, which I talked about earlier in this chapter (the Impact QuikBox). I'm using a very-wide-angle lens, and I'm getting the camera really low to the ground to get a low perspective. To have the shot stay in focus, I hold the camera up to my eye, press the shutter button halfway down to lock the focus, then I lower the camera straight down to ground level while still holding the shutter button, and I take the shot (hey, it beats lying down on the dirty floor). It takes a little trial-and-error using this method, but again, it beats lying on the floor. Also, it's not as bright backstage as this image makes it appear—I brightened this behind-the-scenes shot, so you could clearly see the setup.

CAMERA SETTINGS: I'm using a super-wide-angle 16–35mm lens on a full-frame camera body with my f-stop at f/3.5. It was pretty dark down there (lit only by some dim factory lamps from above), so I had to crank up the ISO to 400. For an environmental portrait like this, it's really important to see the environment, so I had to lower the shutter speed from my normal 1/125 of a second down to 1/60 of a second to let more of the room light into the shot. The final image (facing page) was actually taken at 16mm, so it was wider than what you see here. I cropped it in tighter, so you could see the musician better.

Final Image

THOUGHT PROCESS: Environmental portraits aren't just about the subject, they're about the subject in that particular setting (maybe it's taken where they work, like a guitar player backstage, or in their home, or art studio, etc.). The surroundings tell a story about the subject. For portraits where I want to see a lot of the surroundings like this, I generally use a wide-angle lens (usually either a 24–70mm or, in this case, my widest lens, a 16–35mm). While I love how the wide-angle lens takes in a lot more of the environment, there are three things to remember: (1) Be careful about stretching your subject wide. If you get your subject close to the left or right edges of your frame, it will distort and stretch their body, generally making them look heavier, which will definitely not make you any friends. (2) Know that shooting anyone up close with a wide-angle lens isn't generally going to give you as flattering a look for your subject as zooming in tight with a long lens because you lose that flattering lens compression. That's why I made sure I wasn't up close when I was shooting this wide—look how far my subject is from me in the frame (and I already cropped it in a bit). And, (3) even if you're at f/3.5 like this, when you shoot with a wide-angle, everything will pretty much be in focus in the background.

POST-PROCESSING: In Lightroom's Develop module (or Camera Raw), I increased the Contrast amount by 1/3, added a little bit of Clarity (around 10%), and darkened the edges all the way around by going under Post Crop Vignetting in the Effects panel and dragging the Amount slider to –22. Lastly, I applied the Nik Color Efex Pro plug-in's Tonal Contrast filter. That's it.

The Advantages of Using a Larger Softbox

BEHIND THE SCENES: If I think I might want to light more than just my subject's head and shoulders (as the softbox does in the setup shot above), I'm going to go for a much larger softbox, and if I'm using hot-shoe flash like this, I go with the really huge F.J. West- cott Apollo softbox. Technically, it's not a softbox, it's a pop-up umbrella that looks and acts like a softbox, but the advantage is that it's very portable and pops right up, so it's really quick to set up and tear down. They are made to use with hot-shoe flash and there's a zippered slot where your flash fits right through. They're really pretty clever (and very popular). The one I'm using here is a 50" Recessed Mega JS Apollo. It's a big-un, but if you need to do fashion or full-length, this will surely do the trick.

CAMERA SETTINGS: Once again, I'm using my trusty 70–200mm. I tried a number of different focal lengths: for full-length shots, I had to stand way back and shoot at 70mm; for 2/3-length body shots, I could zoom in to around 100mm; and for the final shot you see on the facing page, I zoomed in to 120mm. I wanted the background behind her to be out of focus, so I shot at f/2.8 and 800 ISO, with a shutter speed of 1/30 of a second. The reason I lowered the shutter speed to 1/30 was so I could see more of the available room light in the shot. The lower your shutter speed, the more room light you see, and our job is to find the right balance between the two so it looks natural. We do this by doing a test shot, looking at the room light, then lowering or raising the shutter speed until the blend looks good. It's a bit of trial and error, but at least the film is free, right?

Final Image

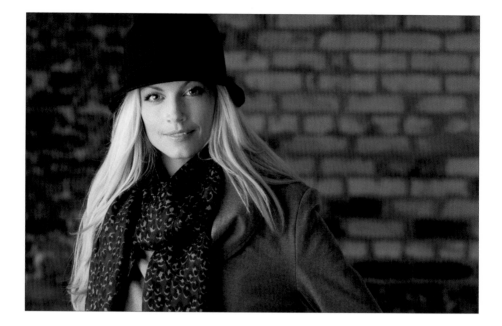

THOUGHT PROCESS: First, let's talk about the lens selection, because you might think that if you wanted to be able to shoot full-length, you'd use a 50mm lens or a wide-angle lens (and a lot of people do shoot full-length with a 50mm lens). So, why did I go with a 70–200mm? Because if I stand back far enough, I can zoom in a bit and make the background out of focus. That's a lot harder to do with a 50mm lens from far away—chances are, even at a low-numbered f-stop, the background is going to be fairly in focus—so by using this lens, I can get that background fairly out of focus just by zooming in. Of course, in the final shot (above), I zoomed in to 120mm, so I had no problem getting the background out of focus at f/2.8. Now, for full- and 2/3-length shots to look right, you really need a perspective. I often sit in a chair or on the ground to get an even lower perspective. Lower is better. Next, let's look at the falloff of the light (how quickly the light fades away to black). There is none—that's the beauty of the big softbox. If lighting the clothing is important (like it is in fashion), then you want your subject evenly lit without the falloff-to-black lighting like we do in standard portraiture, and a big softbox like this really does the trick. Lastly, the other reason to use a really big softbox like this is just the sheer softness of the lighting. The bigger the softbox, the softer, more beautiful, and more wrapping the light will be.

POST-PROCESSING: Just standard portrait retouching.

Simple One-Light Outdoor Flash

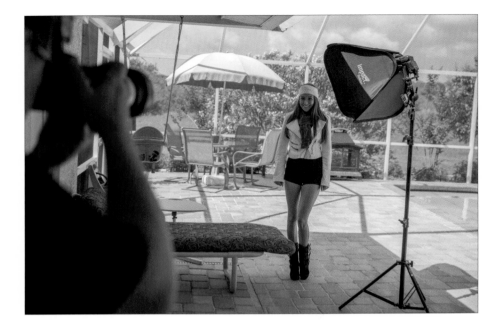

BEHIND THE SCENES: We're in kind of a busy scene here, a pool area, and we placed our subject in direct shade (to get away from the harsh, direct sun). We're lighting her with kind of my go-to kit for hot-shoe flash. It's a 24x24" pop-up collapsible softbox from Impact called a QuikBox. It folds up flat and literally pops up into place. So, we have our flash on a light stand with the Quikbox in front to spread and diffuse the light from the flash. I fire my flash using a wireless transmitter from PocketWizard (more on this on the next page). What I love about this rig is that it's: (a) very lightweight and portable, (b) it sets up in no time, but most importantly, (c) it's pretty darn inexpensive. The Impact QuikBox Softbox Kit (from B&H Photo), which comes with the softbox, an 8' light stand, a hot-shoe flash mount that goes on top of the light stand, and a tilt bracket, is just $149. That's pretty screamin' cheap for a setup that works this well.

CAMERA SETTINGS: When I do location flash, I shoot in manual mode with these settings as my starting place: f/5.6 at 1/125 of a second shutter speed and 100 ISO. That's exactly what I used here. Easy peasy. I'm using my 70–20mm f/2.8 lens zoomed in to 125mm.

Final Image

THOUGHT PROCESS: I always (always!) use a real wireless transmitter to trigger the flash, rather than using the pop-up flash on my camera to trigger the other flash, because I got tired of the flash not firing consistently. It would work a lot of the time, or some of the time, but it never fired all of the time. So, I finally switched to real wireless transmitters and my stress level on shoots has come down by a factor of 10. I use PocketWizard's PlusX model transmitters (they are $99 each and you need two—one sits on top of your camera in the hot-shoe flash mount, and the other one attaches to the flash with a short cord that comes with the PocketWizard transmitter). A cheaper alternative are Cactus Triggers, which are only around $60 for a set of two and they work pretty well (and they're $140 cheaper). I also use my flash in manual mode, rather than TTL mode, which means if the flash is too bright, I just walk over to the back of the flash and turn the power down a notch and try another test shot. I stopped using TTL for the same reason I stopped triggering my flash with my pop-up: I want it to work consistently, and with TTL, sometimes it works great, and sometimes it's a disaster. Now it just works. If I need the flash brighter, I turn it up. If I need it less bright, I turn it down. Don't overthink it.

POST-PROCESSING: The standard portrait retouching stuff, but I also darkened the edges a bit by going in Lightroom's Develop module (or Camera Raw), in the Effects panel, under Post Crop Vignetting, and dragging the Amount slider to –11.

Softening Flash with a Hand-Held Diffuser

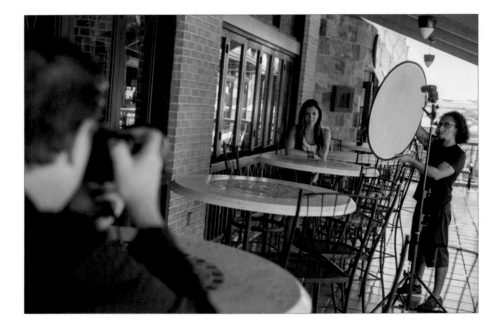

BEHIND THE SCENES: Here, we're on location, and in the shade (as we are here) the lighting is pretty flat, so we're using a flash. To soften the light, we're using the diffuser that comes inside F.J. Westcott's 5-in-1 Reflector (it's around $29). Our flash is on a light stand, and it's sitting on a tilt bracket so we can aim it where we want it. I'm standing back pretty far from our subject so I can zoom in tight to get a more flattering look, and it also helps me put the background out of focus a bit.

CAMERA SETTINGS: I was using my go-to lens—the 70–200mm f/2.8—but my f-stop was at f/5.6 (which is why the background is a bit out of focus, but you can still make out some details). I was zoomed in to 142mm. My shutter speed was 1/30 of a second (more on this on the next page), and my ISO was at 100 (my lowest, cleanest setting).

Final Image

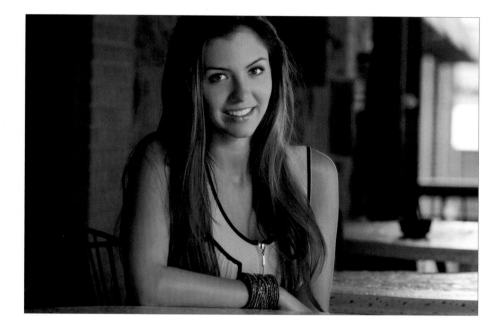

THOUGHT PROCESS: If you don't want to spend the money for a softbox, you can still do something to spread and soften the light, and this super-lightweight collapsible diffuser does a great job of just that (plus, it's really inexpensive). It's collapsible (so it folds up flat) and all you have to do is have a friend hold it between the flash and your subject. If you want the light to be really soft, move the diffuser farther away from the flash (so it can spread the light out more, which makes it softer), or move it closer to the flash (like we did here) so it's not quite as soft and is a bit punchier. Also, although we have our flash on a light stand here, you could just have the person holding the diffuser hold the flash in one hand and the diffuser in the other. The only downside is that they won't be able to get the diffuser quite as far away as you'd be able to with a light stand (they can only move it as far away as they can reach out their arm). Now, on to why I lowered my shutter speed to 1/30 of a second (from my normal 1/125 of a second). On a location shoot like this, your shutter speed controls the amount of natural light in your image, so when I did my first test shot at 1/125 of a second, it was very dark around her and you could barely see the location where we were shooting. By lowering the shutter speed, you can now see the brick walls behind her and other tables and stuff.

POST-PROCESSING: Just your standard portrait retouching stuff.

Using Sunlight as Your Second Light

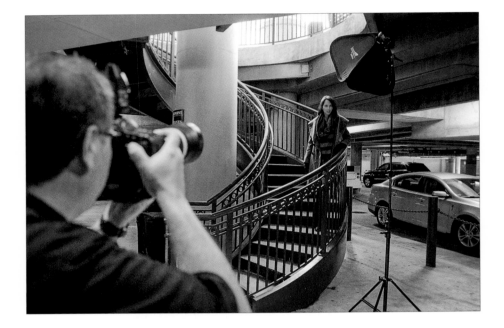

BEHIND THE SCENES: Believe it or not, we're in a multi-level underground parking garage and we're using our go-to setup for hot-shoe flash: the Impact Quikbox kit. We have our subject standing on a circular staircase that leads to an office building above, and there's natural light coming in from directly above, so we're going to add the natural sunlight to what we're doing with our hot-shoe flash.

CAMERA SETTINGS: I'm using my 70–200mm f/2.8 lens (as usual) zoomed in to 160mm at f/2.8 (so the background will be out of focus, which will help hide the fact that we're in a parking garage). I'm at 100 ISO with a shutter speed of just 1/25 of a second. I lowered it from 1/125 of a second, my standard starting-point shutter speed, so I could get more of the existing light into my background. Without lowering the shutter speed, it was just solid black around her.

Final Image

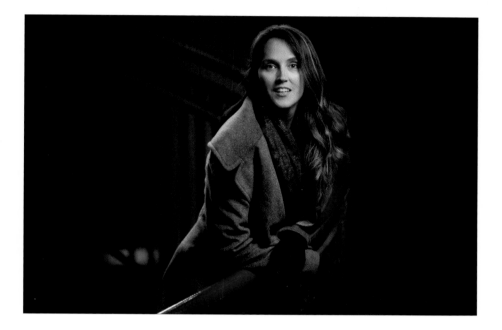

THOUGHT PROCESS: We had actually parked in this underground garage just to use it as a staging area for us to do a shoot outside along the waterfront. But, as we were setting up, I turned around and saw this spiral staircase with natural light streaming in from above and thought we could use that overhead natural light as a rim light on her hair and along her arms, and it worked out really well. That bright light you see along her left side and on top of her hair is that natural light. It's just a touch of light, not enough to fully light her face, but that's okay—that's what our flash with a softbox is for. My standard flash settings would be f/5.6 at 1/125 of a second, but since I knew I wanted the background way out of focus (so you wouldn't see that we were in a parking garage), I started by lowering my f-stop to f/2.8 (by the way, I can use this low of an f-stop because we're already in a low-lighting situation under a roof. Outside in the direct sun, it would be a lot harder to shoot at f/2.8 and not have the photo overexposed by a ton). I took a test shot and I could hardly see any of the existing light, so I lowered the shutter speed (it controls the amount of existing light in the photo) to 1/25 of a second to let in more light. (I didn't just instinctively know that 1/25 of a second was the right amount. I did a few test shots, starting at 1/100, then 1/80, then 1/60, and so on, until I settled at 1/25.)

POST-PROCESSING: Just the standard retouching stuff, and I darkened the outside edges all the way around by going to Lightroom's Develop module (or Camera Raw) and, under Post Crop Vignetting in the Effects panel, dragging the Amount slider to the left to –11.

The "Instant Black Background"

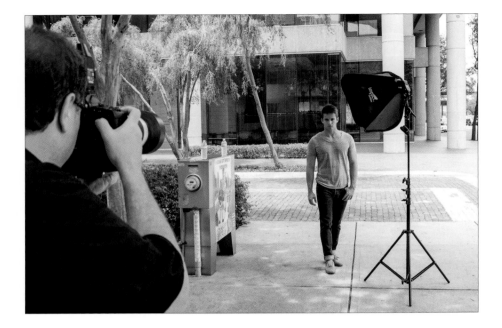

BEHIND THE SCENES: We're out on the street in downtown and we've set up my go-to flash lighting setup, the Impact QuikBox.

CAMERA SETTINGS: The settings for this particular outdoor shoot are very different than usual because we're trying to do something very different: make a regular daylight background turn solid black. I'm shooting my 70–200mm f/2.8 lens (that part is pretty much the same as always), but my f-stop is set to f/22. My ISO is set to 100 and my shutter speed is 1/250 of a second. More on the "why" of these settings on the facing page.

Final Image

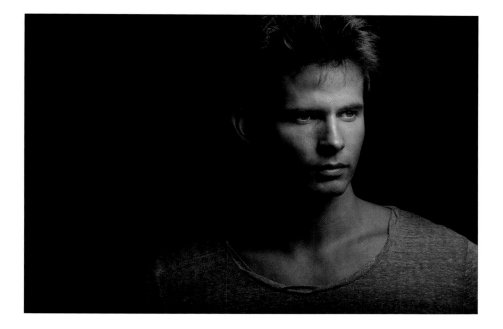

THOUGHT PROCESS: The name and idea for this technique comes from my buddy, UK-based photographer and trainer Glyn Dewis. The idea is you set your camera's settings so that so little light comes into the camera that when you take a shot, all you get is a solid black image. Then, when you turn on your flash at full power, the only thing you'll see in your image is whatever is lit with the light from that full-power flash—that's all that lights your subject. There are three things we can do to limit the light that reaches our sensor: (1) Raise the f-stop. In my case, my lens only goes to f/22, but there are plenty of lenses that go to f/32. The higher the number, the darker your scene will be. (2) Lower your ISO to its lowest setting. The lower the number, the less your camera is sensitive to light. (3) Raise your shutter speed to 1/250 of a second (that's the highest normal sync speed for most hot-shoe flashes, but at that speed it lets in the least amount of existing light. Now, you may not need to do all three of these to create a solid black image. It may only take #1, or #1 and #2, but you'll know it's right when you take a photo and there's no image, it's just solid black. That's your cue to turn your flash on at full power, and now you've created the "Instant Black Background." Thanks to Glyn for this awesome technique.

POST-PROCESSING: Just standard portrait retouching stuff (removing blemishes, brightening the eyes, and so on) and, of course, sharpening with the Unsharp Mask filter in Photoshop (I used: Amount 120%, Radius 1, Threshold 3).

Using Gels with Flash

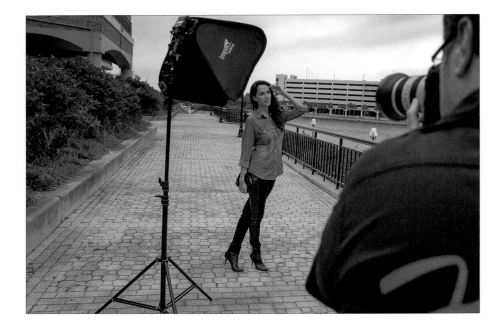

BEHIND THE SCENES: We're on location with my standard location one-flash lighting setup, but what you can't see from this shot is that there is a piece of orange gel taped over the front of the flash.

CAMERA SETTINGS: For location flash, I shoot in manual mode with these settings as my starting place: f/5.6 at 1/125 of a second shutter speed at 100 ISO, and that's exactly what I used here. I start with my flash power set at 1/4-power and I do a test shot and look at the shot on the back of my camera. If the flash isn't bright enough, I turn up the power on the flash to 1/2-power and do another test shot. If it's too bright, I turn the power down on the flash to 1/8-power and do another test shot to see how it looks (and so on). I'm using a 70–200mm lens zoomed in to 165mm.

Final Image

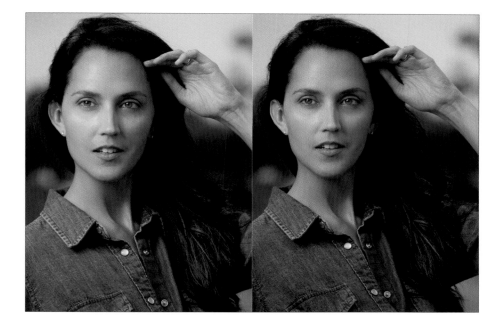

THOUGHT PROCESS: When you're using flash on location like this, the flash is going to create bluish-white light. That white light looks fine in a studio environment, with a solid white, black, or gray background, but when you're on location, having that white light from the flash not only doesn't look natural, but people also just look better with a warmer skin tone. So, we tape a thin orange gel over the front of the flash and that gives you a warmer, more natural-looking light from your location flash (take a look above: the shot on the left has no gel, while the shot on the right used an orange gel). These gels come in different thicknesses called "cuts." (The orange gels themselves are called "CTO" gels. CTO stands for Color Temperature Orange.) A 1/4-cut is a small amount of orange, so you can leave it taped on your flash any time you go out on location, either indoors or outdoors. A 1/2-cut is twice as much orange and you'd switch to this later in the day when the sun is much lower in the sky and getting close to sunset. Right around sunset, to make the light from your flash look more like the setting sun, you'd switch to a full-cut of CTO (by the way, you can buy these gels in 24x20" sheets from B&H Photo for around $6.50 a sheet).

POST-PROCESSING: Just the standard portrait retouching stuff.

Dramatic Sunset Portrait

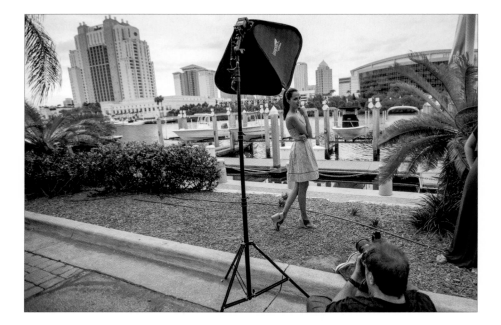

BEHIND THE SCENES: Okay, the dramatic part is here, I'm just not quite sure the sunset part is. It was too cloudy for the sun to actually make an appearance, but this is the technique I use for sunset portraits (it's really based on the settings, which I'll go over below and on the next page). If you're thinking, "Gosh, he's using that same 24x24" softbox again," it's because that's pretty much what I use on location—that and the big Westcott Apollo I used earlier in this chapter. Those are my two go-to softboxes, so that's what I use (no sense in me pulling out a bunch of stuff I don't really use or wouldn't recommend, right?). As far as setting up this shot, we are just across the river from downtown, and there's a lot of distracting stuff already in the scene, so to eliminate all of it from view, I generally get down really low and shoot upward. In this case, I sat down on the ground and aimed upward to compose the shot so you would see some of the downtown buildings, but you wouldn't see the distracting palm trees creeping in from the sides (although I did have to have a friend hold back the palm fronds on the right—that's why her foot is making a cameo appearance), and this angle hid all the shrubs and most of the pylons and ropes and such.

CAMERA SETTINGS: For the final image on the facing page, I'm using a 16–35mm super-wide-angle lens (on a full-frame camera), zoomed in to 29mm. Notice that I kept our subject from getting too close to the edges where she'd get stretched and distorted. My shutter speed is my standard 1/125 of a second, but my f-stop is f/5.6 (more on why on the facing page). My ISO is 100.

Final Image

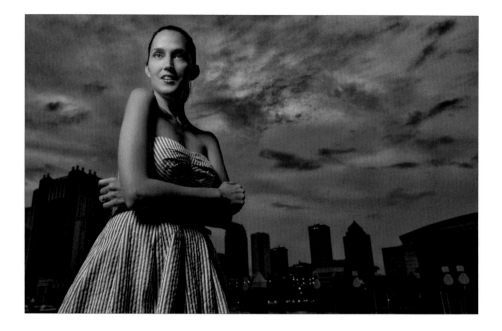

THOUGHT PROCESS: When it gets late in the day like this, I use a technique that makes the sky much darker and more dramatic. It starts with putting your subject with their back to the setting sun (as I did here). Next, you're going to intentionally underexpose the shot by about 2 stops or so (making the sky much darker than it really is). You need to do this in manual mode: Start with your shutter speed set to 1/125 of a second, then don't touch it again. Move your f-stop until you get a proper exposure reading. Look at the little meter inside your viewfinder (it's either along the bottom or the right side) and get it to the center position by moving just your f-stop. When you get the proper exposure (let's say it was f/2.8, for example), then you'd raise your f-stop to around f/8 (two full stops darker) or so and take a test shot. If your subject now looks like a silhouette against the sunset sky, then just turn on the flash with a low power setting (like 1/4-power) and you're good to go. If they don't look like a silhouette, you need to darken the scene even more (try f/9 or f/10) and do a test shot again until you see they finally do look like a silhouette. That's your goal: to get them black against a dark sky. Then, turn on the flash.

POST-PROCESSING: Just a few things: (1) I increased the Contrast in Lightroom's Develop module (or Camera Raw), (2) I did standard portrait retouching, and (3) I applied the Nik Color Efex Pro plug-in's Tonal Contrast filter *twice* in a row to make the clouds in the sky have all that detail. Then, I added a layer mask in Photoshop and painted over our subject with a soft brush to remove the effect from her, leaving it just on the sky.

Using a Spot Grid for a Focused Beam

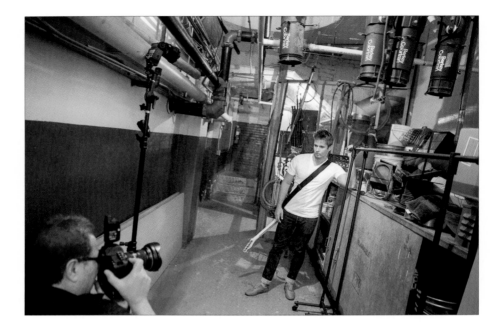

BEHIND THE SCENES: We're backstage in the theater again (at the other end of the hall), and we're using just one bare-bulb flash, but we've put a grid over the end of the flash that turns this bright bare-bulb flash that just kind of goes everywhere (lighting his shirt, and guitar, and pants, and everything around him on either side) into a precise beam of light that we can aim right where we want it—on just his face. I'm down low, sitting in a chair, shooting up at him because the stuff above him and behind his head and shoulders is a lot more interesting than the boring-looking floor and cabinets. So, I composed the shot to hide the boring stuff and show more of the interesting stuff around him.

CAMERA SETTINGS: For the final image on the facing page, I'm using a 16–35mm super-wide-angle lens (on a full-frame camera), zoomed in to 27mm. I lowered my shutter speed down to 1/40 of a second, so I could see the yellow room light.

Final Image

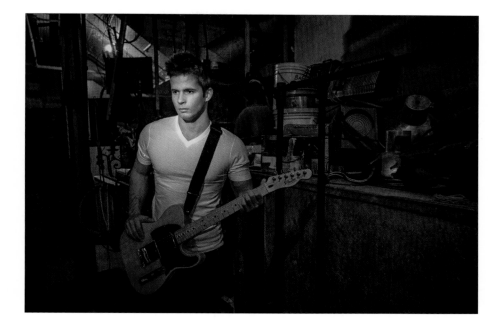

THOUGHT PROCESS: One reason I wanted to use a grid is because he's wearing a white shirt, so if I use a regular softbox, his white shirt is going to be super-bright because it's reflecting all that light. Another reason is that I like the drama of just having a small beam hit our subject. I also didn't use the softbox because, with the grid, the light will be edgier. The particular grid we used is a Rogue 3-in-1 Honeycomb Grid made by Expolmaging. It just attaches right over the head of your flash (it takes all of 20 seconds to put in place), and then creates this very defined narrow beam of light. The street price is around $50.

POST-PROCESSING: The standard portrait retouching stuff (very minor with him), and then I applied the Nik Color Efex Pro plug-in's Tonal Contrast filter to the entire image. If this had been a photo of a woman, I would have added a layer mask to erase the effect from her skin (it isn't very flattering to women's skin), but since this is a guy, it actually looked pretty good so I just left it applied to the entire image (which is easier than having to mask your subject's skin away).

Chapter Five
Shooting Weddings Like a Pro

*Recipes for Making the Bride Look Awesome
(Because Nobody Cares About the Groom)*

Okay, that last part about nobody caring about the groom isn't really true. There are people who care very much about photos of the groom, like the groom's mom, and…and…wait, just give me a minute on this one. Ummmm. I'm almost certain there's someone else…. Anyway, what I was trying to say was your job at a wedding is to get amazing pictures of the bride, her bridesmaids, the maid of honor, the bride's mother, and really, beyond that it's okay to pretty much ignore everybody else, especially the groom and groomsmen because by and large they are loud and grotesque, but more importantly, they are not the bride. If you get a stunning shot of the bride, it really doesn't matter what else you do that day, so this chapter is focused on how to do just that. Here we go: Tip #1 is only shoot beautiful brides. If you show up for an interview with the engaged couple and that bride-to-be doesn't look like Scarlett Johansson or Rihanna, it's time to bail. I don't care what kind of fancy Profoto lights you have, or if your softbox is the size of a NASA radar dish, if your bride is ugly, you're going to have the most beautifully lit ugly shots you've ever seen. So, bail now while the getting's good. Tip #2: If the groom is ugly, who cares? His mom? Yes, but she knows he's ugly. Tip #3: If you're ugly, keep the camera up to your face as much as possible so it doesn't scare the bride. Tip #4: If your second shooter is ugly, hire a professional model as a stand-in. Doesn't matter if they even know how to turn on a camera because he/she is just there to distract the bridesmaids/groomsmen from how hideously ugly you are. Tip #5: What if you're not ugly? Look, I've seen you. Trust me, you're a troll. I'm sorry. Somebody had to say it. This is called "tough love," but love is what weddings are all about.

Controlling Light Outdoors

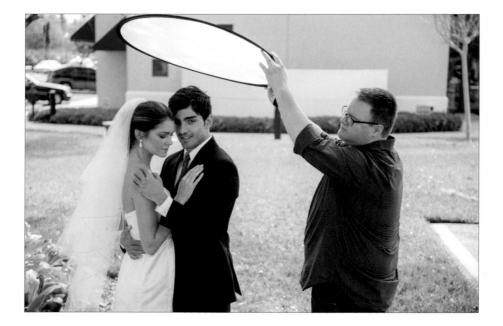

BEHIND THE SCENES: The photographer doesn't usually get to determine when in the day the wedding will be held, so you can almost bet that whenever it is, the light will be pretty harsh and crappy. That's why it's so worth investing around $19 in a Westcott 1-stop collapsible diffuser. You just put this diffuser between your subjects and the harsh, direct sun. It will spread and soften the direct sunlight, creating gorgeous natural light anywhere you need it (and since it's collapsible, it'll hardly take up any room in your camera bag). This is my #1 go-to solution in direct sunlight. As far as placement goes, you want this down as close to your subjects as possible without it actually appearing in the photo (the closer you can get that diffuser to your subjects, the softer and more wrapping the light will be). So, I have the person holding the diffuser for me bring it closer and closer to my subjects until I can see the edge of it in my frame. At that point, I ask them to raise it just a little—just enough to where it's out of my view—and then I take the photo, knowing the diffuser's positioned in its most soft and beautiful place.

CAMERA SETTINGS: I shot this with my 70–200mm f/2.8 lens (my go-to lens) zoomed in to 195mm and at f/2.8 to blur the background. My shutter speed was 1/2500 of a second (I was in aperture priority mode, where I choose the f-stop and the camera automatically chooses the shutter speed it needs to make a proper exposure), and my ISO was at 1600 (I could've lowered it, but we'd been shooting inside and I forgot).

Final Image

THOUGHT PROCESS: Our goal is soft, beautiful, natural light outdoors and you normally won't need to add any fill-in light with flash—there should be plenty of sunlight coming through that diffuser to light your bride and groom. Remember, the diffuser isn't blocking out the sun, it's just spreading and softening the sunlight so it's not harsh. If the sun isn't out, you don't need the diffuser, because the clouds will act as a natural diffuser.

POST-PROCESSING: I often add a big, soft glow. If you have Photoshop and the Nik Collection (software plug-ins that are very popular with photographers—around $149 bought direct from Google, who bought out Nik a while back), then you can use the Glamour Glow filter inside the Nik Color Efex Pro plug-in. The default preset setting is nice, and the Stronger Glow preset works well, too (it's just a stronger amount of glow). Those are the only two presets I use, but they work great. If you don't have the Nik Collection, then you can do this in either Photoshop or Elements: (1) Duplicate the Background layer. (2) Go under the Filter menu, under Blur, and choose Gaussian Blur. When the filter's dialog appears, enter 50 pixels and click OK. Now, in the Layers panel, change the blend mode (the pop-up menu at the top left of the panel) from Normal to Soft Light (to add contrast), then lower this top layer's Opacity to around 50%. That should do the trick. In this case, I also converted the image to black and white using Nik's Silver Efex Pro plug-in (also part of the collection), but you can use Photoshop and convert the image from RGB to Grayscale under Mode on the Image menu.

Close-Up Detail Shots

PETE COLLINS

BEHIND THE SCENES: The bouquet had just been delivered, and I wanted to get a few tight shots while it was at its freshest. I went out to the hotel room's balcony so I could use natural light, and I was careful to place the bouquet in the shade so the natural light would be soft. I also went and borrowed the bride's engagement ring for the shot and placed it inside the petals of one of the roses.

CAMERA SETTINGS: I'm using a macro lens here (and also for stuff like close-ups of the groom's cuff links, or the invitation with both rings sitting on it, etc.). They have a ridiculously shallow depth of field, so any camera movement at all and the whole shot will be out of focus—you really need to be on a tripod. I'm shooting here in aperture priority mode and, since the depth of field is so shallow, I try to shoot at f/16 or f/22 to squeeze another 1/16" that's in focus. On a tripod, I use my lowest ISO (as always) and it doesn't matter what my shutter speed is because (wait for it…) I'm on a tripod.

Final Image

70-200mm | Macro

THOUGHT PROCESS: The 70–200mm lens is a staple of many wedding photographers, but you're not going to be able to get in as tight as you'd like because they usually have a minimum focusing distance. So, if you start to get too close to the ring, everything goes out of focus and you can't get in really close (and if you try to get as close as you can and then crop it tight, you won't get that super-crisp detail and mega-shallow depth of field that is the trademark of a macro shot. The shot at left is as close as I can get with a 70–200mm before it goes out of focus). That's where a macro lens comes in (or better yet, use my handy tip from part 2 of this book below). A macro lens lets you zoom in and get crazy close (like you see above on the right), and create a level of detail that has real impact. Plus, look at how amazingly shallow the depth of field is for the image on the right. The diamond and mount are in focus, and just 1/16 of an inch behind that, it all goes blurry and out of focus, which really makes the diamond stand out.

TIP: DON'T BUY A MACRO LENS, GET A CLOSE-UP LENS INSTEAD
Whether you shoot Nikon or Canon, you can use Canon's brilliant screw-on close-up lens, which is only about 3/4" thick, super-lightweight, and pretty inexpensive (starting at around $72, but it's based on the size of your glass in mm). You just throw it in your camera bag and screw it on to your zoom lens when you need it. Super handy!

Mixing Natural Light with Strobes

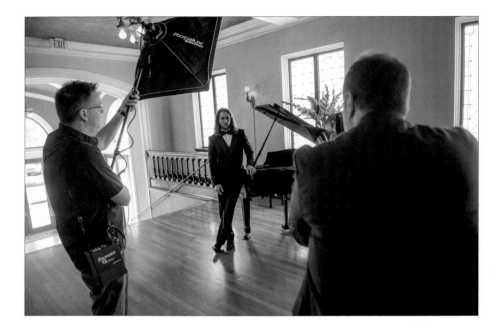

BEHIND THE SCENES: Here, we're mixing the little bit of natural light coming in through the windows (camera right) with the light from our single flash (mounted here on a mono-pod with a small 24x24" softbox—one of my favorite sizes for weddings, where most of the shots I take with flash will be from the waist up). The light is in the standard position: at a 45° angle to the subject, up high, and aiming down at him.

CAMERA SETTINGS: I'm using a flash, so I'm always going to be in manual mode on my camera, and my shutter speed was set to 1/125 of a second (my safe, standard starting point). My f-stop was f/8, which pretty much kept everything in focus, front to back. I used an 85mm lens—a little wider than I normally go, but I wanted to include enough of the piano in the shot that you could instantly tell it was a piano. The power setting on my flash was very low (I didn't want the flash to look like I used flash. I like to keep it subtle).

Final Image

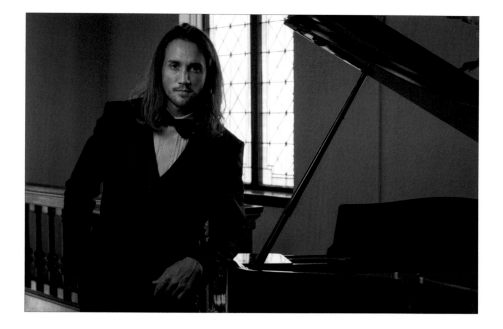

THOUGHT PROCESS: The idea here is to use the little bit of light coming in through the stained glass window as our second light (a kicker light, if you will), just adding a bit of light to the camera-right side of his face and hair, and then letting the flash be the main source of light that actually lights him. You don't want to let the light spill too much onto the camera-right side of his face or it will overpower that light coming in from the window, and I think that window light adds a nice bit of depth, dimension, and separation. The way to keep that flash from overpowering the window light is to move the light farther away from the camera position (toward camera left), so more of the shadows fall on the right side of his face. Just a note: you're not actually going to move the light to the left. You're going to rotate around him like he's at the center of a clock, so if you're shooting directly in front of him (at the 6:00 position) and the light was at 7:30, you'd move it to closer to the 8:00 position to create more shadows on the right side of his face (the 9:00 position would have the right side of his face fully in shadow). At this point, our job is to balance the power of the light with the existing room light. I keep the power of the flash low, and adjust the shutter speed to a slower speed than my starting point of 1/125 of a second to add in more room light. The slower the shutter speed, the more natural room light you get. Think of your shutter speed dial as a dimmer switch for the light in the room. Just like in real life, lowering the dimmer switch for the lights in the room wouldn't affect the power setting of your flash—it stays the same throughout.

Reception Flash

BEHIND THE SCENES: Here, we're in a hotel ballroom and you can see the room's lit with colored lights from the DJ/band and constantly changing colored LEDs on the walls provided by the hotel for the reception. I'm using one single speedlight flash on my camera's hot-shoe mount, and I've aimed it straight upward toward the ceiling. Even though I'm aimed straight upward, some of the light from the flash still goes forward to light the bride and her father (in this case) on the dance floor, and it's just enough to add a little light on them while still blending in with the existing room light.

CAMERA SETTINGS: Since the flash is aiming straight up at the ceiling (it's not bouncing off the ceiling back down to the subject—the ceiling is too high for that—I'm only interested in the tiny bit of flash that comes out of the front), I have it set to full power. When using flash, my camera's always in manual mode. My shutter speed is set to 1/250 of a second, here (making the room appear darker than it really is). My f-stop is f/1.4, which lets me hand-hold in a low-light situation like this, but to do that I had to raise my ISO to 640. I used an 85mm lens so I could shoot at that fast aperture, and it's wide enough to let me include some of the reception hall in the shots.

TAKE-AWAYS: In low-light situations like this, you need a fast lens (like an f/1.4) to keep your ISO from getting too high. Aiming your flash straight upward toward the ceiling can send a little bit of light toward your subjects without overpowering the existing light.

Final Image

THOUGHT PROCESS: My goal here is to add just a little bit of light to the scene, and not to overpower the existing light in the reception hall. The lighting was very colorful, which is what the bride and groom wanted, so if I turned up the flash and aimed it directly at them (even if I added a diffuser or small softbox), you'd see mostly flash, and most of the color will have been overpowered. Notice how you can still see a magenta light on the bride's dress and along her arm, and on her dad's head. Also, using such a low f-stop (like f/1.4) puts the background a bit out of focus, separating them from the background, even though we're not zoomed-in tight. By the way, to give you an example of how important having a fast lens is in a low-light situation like this, I was able to take the shot above at 640 ISO to give me a shutter speed of 1/250 of a second (enough to freeze their motion while dancing, and eliminate any movement from me hand-holding the camera). The production shot of me shooting on the previous page was taken at a slower (higher-numbered) f-stop of f/2.8. To get the shutter speed to 1/125 of a second (just fast enough for a non-blurry hand-held photo), my assistant Brad needed to use an ISO of (wait for it…wait for it…) 16000. That's not 1600 ISO. That's sixteen *thousand* ISO! It looks really clean because he uses a camera that performs really great at high ISOs like this (a Canon 1D X), but what I wanted to demonstrate is that those really fast f-stops (like f/1.4) really do make a difference.

Be the Second Shooter

BEHIND THE SCENES: We're shooting with just available light and a long lens here, so we're kind of "out of sight, out of mind." I'm standing at the foot of a stairway (after coming down the stairs), and I saw the bridesmaids and bride standing around the piano talking, so I was ready. The moment I saw the maid of honor wrap her arms around the bride, I started firing.

CAMERA SETTINGS: You don't need a super-fast shutter speed to freeze the action, but it needs to be fast enough to where you don't come back with a blurry shot. So, you don't want to let your shutter speed fall below around 1/125 of a second for a hand-held, "run-and-gun" shot like this (there is nothing worse than capturing a magical moment and finding the shot is out of focus). That means shooting at a wide-open aperture (like f/2.8 or f/4), and then bumping up the ISO until you reach that 1/125 of a second mark or faster. This is also an ideal time to use your camera's Auto ISO feature, where you can tell it not to let your shutter speed fall below 1/125 of a second and, from that moment on, it raises the ISO just enough so that never happens. Ever. So if you miss the shot now, it won't be because you didn't have enough shutter speed to hand-hold a shot and keep it sharp.

Final Image

THOUGHT PROCESS: The idea here (which I got from pro wedding photographer Joe Buissink) is to blend into the background and let the first shooter handle the official stuff (like dealing with the parents of the bride/groom and staging shoots with the grooms-men and bridesmaids), so your main job is to capture special moments—the moments you would have missed while arranging groomsmen in a row and tracking down Aunt Helen. As second shooter, you shoot with available light (so, high ISO stuff) and stay kind of off to the side watching and waiting to capture the images that will thrill the bride and groom (trust me, the shots that thrill them will not be the formals).

POST-PROCESSING: Because you'll be shooting at high ISOs, you'll probably wind up with some noise in your shots, but don't worry, they will look great when you convert them to black and white or to a duotone (like you see above). I provided a short video for you on how to create duotones in Lightroom or Photoshop/Elements on the book's companion webpage (you can find the link to it in the book's introduction up front). When you convert to black and white, or duotone, that noise is now seen as film grain, and it goes from a negative to a positive really quickly.

Dramatic Lighting

BEHIND THE SCENES: Here, you can see the simple one-light setup (it's a 24" softbox on a lightweight light stand). It's to the left of the camera, a few feet in front of our subject, up high, and aiming down. All the lights are on in the church.

CAMERA SETTINGS: I'm shooting in manual mode on my camera, but to create the drama, I'm shooting with a higher shutter speed than my normal 1/125 of a second. In this case, to intentionally darken the area around my subject, I raised the shutter speed to 1/200 of a second (that's about as high as I can go with a studio strobe, which is what I'm using here with an Elinchrom Ranger Quadra flash head and its portable battery pack. If you're using a Canon or Nikon speedlight, then you can go up to 1/250 of a second before you have a flash sync problem, where you see a dark gradient across the bottom of the image). I stood way back from our bride and used a 70–200mm f/2.8 lens at f/6.3 zoomed out to around 82mm to capture some of the pews and the stained glass windows behind her in the shot.

Final Image

THOUGHT PROCESS: The idea for this look is to keep the light really soft and subtle, and let the background pretty much fall to black, which is why I raised the shutter speed to 1/200 of a second. Beside the light, what makes this shot look so elegant is the pose. First, her body is turned away from the light. When the bride tilts her head toward her back shoulder, it's a more casual look. When she tilts her head to the front shoulder (as seen here), it gives a more elegant look.

POST-PROCESSING: To make the light appear more focused, add a dark edge vignette around the edges of the image. You can do this in the Effects panel in Lightroom's Develop module (or Camera Raw), under Post Crop Vignetting: drag the Amount slider to the left and, if it doesn't extend inward far enough, drag the Midpoint slider to the left, as well (the farther to the left you drag it, the farther in the edge darkening extends).

Using Natural Light Indoors

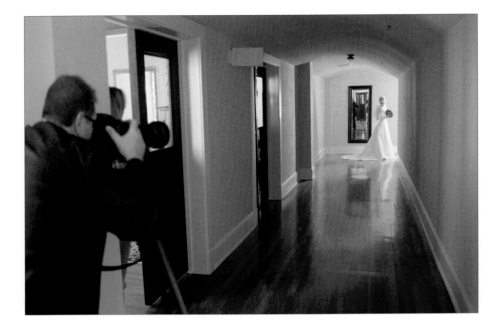

BEHIND THE SCENES: This hallway is in the reception hall. I noticed the natural light at the end of the hall, so I positioned the bride there so she'd be lit with the natural light.

CAMERA SETTINGS: Although it looks like there's a lot of light here, when I held up my camera I could see that I wouldn't be able to get a sharp shot hand-holding (my shutter speed fell below 1/60 of a second), so I put the camera on a tripod to keep it steady in the low light. The lens is a 70–200mm f/2.8 and my f-stop is at f/11. Since I'm on a tripod, I can use the cleanest possible ISO (on this camera, it was 100 ISO).

Final Image

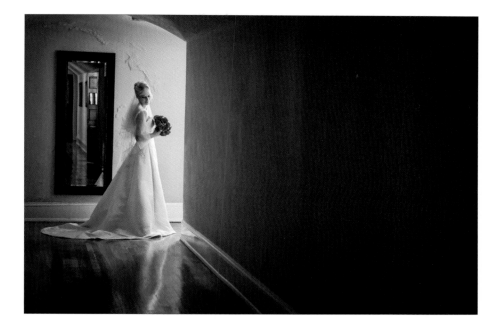

THOUGHT PROCESS: Getting a shot like this is actually very easy: it's just natural light and there are no special camera settings or anything else that make it unique from a shooting perspective. The only hard part is finding a great hallway like this, and not every church or reception hall has one. It's something we don't talk about a lot as photographers, but it's a very real part of our lives, and that's luck. In this case, I got lucky that this reception hall had this great hallway, and the end of the hallway happened to be lit with natural light. If it hadn't been lit with natural light, I could have put a flash down there to light the bride (as long as I was using a wireless radio transmitter, because you don't want to use a flash to light that hallway you're shooting down—that would take away all the mystery and drama).

POST-PROCESSING: There was very little to do here, but the yellow color on the walls was kind of overpowering, so I desaturated the overall color in the photo using Photoshop's Hue/Saturation adjustment (just drag the Saturation slider to the left, but don't drag too far or the red roses will turn brown). I also added a darkening around the edges (edge vignetting). You can do this in the Effects panel in Lightroom's Develop module (or in Camera Raw), under Post Crop Vignetting: drag the Amount slider to the left and, if it doesn't extend inward far enough, drag the Midpoint slider to the left, as well (the farther to the left you drag it, the farther in the edge darkening extends).

Dramatic Edge Lighting with One Light

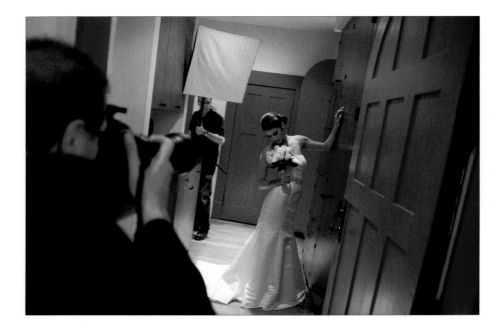

BEHIND THE SCENES: You only need one flash for this look, and we place it behind the bride and at a 45° angle (so it's behind her and off to the side). The softbox is just a small softbox (24x24") on a light stand held up by an assistant. That's pretty much it—just a flash with a small softbox behind her to the side. Simple.

CAMERA SETTINGS: Since we're shooting with a flash, we're in manual mode on the camera (that way we can dial in the exact settings we need). My f-stop is f/5, and my shutter speed is 1/60 of a second (anything under 1/200 of a second will work. If you go much higher than that, you'll probably see a dark gradient start to appear across the bottom of your image). I'm shooting with a 70–200mm lens zoomed all the way out to 70mm, and I'm at 100 ISO (my lowest, cleanest ISO).

TIP: THE ADVANTAGE OF A LIGHT STAND VS. A MONOPOD
Mounting your flash on the end of a monopod is super-convenient, because it's very lightweight, there are no legs hanging off, etc., but holding up a light stand does have one big advantage over a monopod: when your helper holding the flash gets tired, they can simply extend the legs of the light stand, put it down, and take a rest (or just use the light stand, in some cases). With the monopod, when they need to take a rest, they have to find a place to put the light where it won't tip over and crash to the ground (I've seen it happen. When it does, the flash is usually dead). Just a heads up.

Final Image

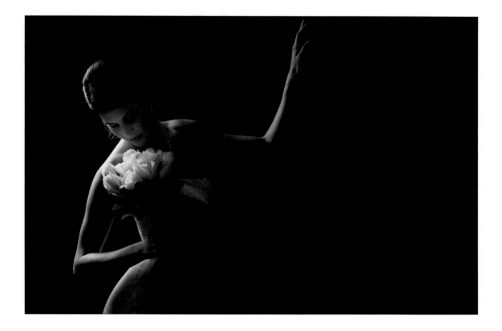

THOUGHT PROCESS: Light bounces off whatever it hits and if it hits something red, like that red door she's leaning against, it's going to bounce a lot of red light back onto her, so I pretty much knew this was going to need to be either a black and white or a duo-tone, like you see above. This shot is all about the shadows, which is why I put the light behind her, but we're going to need some post-processing to make it as dark as we want it. As far as the lighting goes, what we're aiming for is that rim light along the edges of her hair, shoulders, arms, and dress, so keep the power of the flash pretty low. If you turn the power of the flash up too high, it will bounce off of everything and overlight it so you'll lose all those nice, dark shadow areas.

POST-PROCESSING: To make the shot more dramatic, in Lightroom's Develop module (or Camera Raw), I darkened the overall exposure by dragging the Exposure slider to the left quite a bit. To make the lighting brighter, I dragged the Highlights slider to the right quite a bit, as well. Then, I converted the image to black and white (by clicking on Black & White at the top right of the Basic panel; in Camera Raw, turn on the Convert to Grayscale checkbox in the HSL/Grayscale panel) and applied a duotone look in the Split Toning panel by increasing just the Shadows Saturation slider to 20 and Hue slider to 32. I also used the Adjustment Brush to brighten her face a little bit, darken the bouquet some, and darken the far-right side of the wall (it was reflecting too much of the light). Does that seem like a lot? It's really not, but I did a video for you anyway. It's on the book's companion webpage, mentioned in the book's introduction.

Go Super-Wide for an Epic Feel

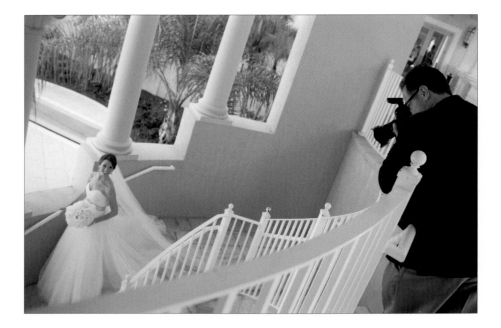

BEHIND THE SCENES: It was the middle of the day before we left for the church and we scouted for some shooting locations for the bridal portrait that weren't out in the direct sunlight. We found this beautiful staircase (actually the entrance to the hotel's spa, as it turns out). Since she was inside the stair area here, she was shielded from the sun. I positioned myself up high, shooting down, so I could see the bride and the elegant-looking columns behind her, as well.

CAMERA SETTINGS: We were using available light and, in that case, I shoot in aperture priority mode (where I choose the f-stop and the camera automatically chooses a shutter speed it thinks will make a decent exposure, and it's usually right). Normally, I would use a higher-numbered f-stop, like f/8 or f/11, but despite how it looks here, the lighting was actually fairly low in this shade, so I lowered my f-stop to f/2.8. The background didn't actually go out of focus here because I was shooting a wide-angle lens, so even though I'm at f/2.8, I'm not zoomed in tight (I'm way out wide) and everything will pretty much be in focus throughout. Perhaps not as sharp as at a higher f-stop, but I was able to keep my ISO at 100 (the cleanest setting) and still get 1/125 of a second shutter speed so the shot wouldn't be blurry because of movement while hand-holding the shot.

Final Image

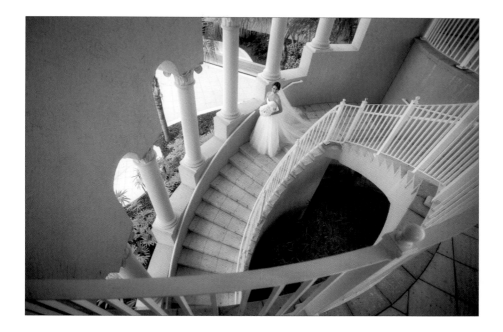

THOUGHT PROCESS: The idea here was to go for the "epic" wedding shot, which means the bride is swept away in the beautiful surroundings. To get that look, I chose a super-wide-angle lens—a 16–35mm f/2.8 lens. The key when using a super-wide-angle lens like this is to keep your subject from getting too close to the sides of the image because it will normally distort them and stretch them so they look much wider. Not flattering, and so far I haven't ever had a single bride request to look stretched wider and distorted. To make it look even bigger and more epic, I climbed up two steps on a LadderKart. That way, I could include the railing right in front of me and create more depth (see page 141 from part 2 of this book series for more on the awesomely handy Conair Travel Smart LadderKart).

POST-PROCESSING: To focus the light more toward the center of the image, I darkened the edges all the way around the photo just a tiny bit using the Post Crop Vignetting feature found in the Effects panel in Lightroom's Develop module (or Camera Raw): just drag the Amount slider to the left a little bit and you'll see the edges darken all the way around. It usually just needs a touch, but it adds a lot.

The Lens Flare Look

BEHIND THE SCENES: This was taken during the reception (I know, duh!), and I positioned myself so I'm shooting directly into the colored light that's aimed at the dance floor—a sure recipe for getting lens flare. The light was constantly changing color, and even moving (it was motorized), so I would pick an area, kind of camp out there, and try to catch the bride and groom in between the other guests out dancing alongside them. You can see the lens flare creating a ring over my shoulder (camera left) in the behind-the-scenes shot above. This technique just takes a little patience because, even though you're aiming directly at a light shining right in your direction, it still doesn't flare every time. You'll get a bunch with the effect, and a bunch without it, as well, but that's not a bad thing. At least you'll have both to choose from.

CAMERA SETTINGS: The technique I used was to lock focus on my subjects (the bride and groom) by holding the shutter button halfway down, and then reposition myself so the light was aiming straight at me. When I saw it start to flare, I pressed the shutter button the rest of the way down to take the shot, knowing that it would be in focus because I had already locked the focus on the bride/groom before aiming my lens at the light. I used an 85mm lens, and just the existing room light at f/1.2. Even at that wide-open of an f-stop (the lowest f-stop I've ever used in my life), my ISO was still 2500. My shutter speed was probably a bit higher than I really needed at 1/250 of a second, but they were moving (dancing) and I wanted to make sure it would freeze their movement.

Final Image

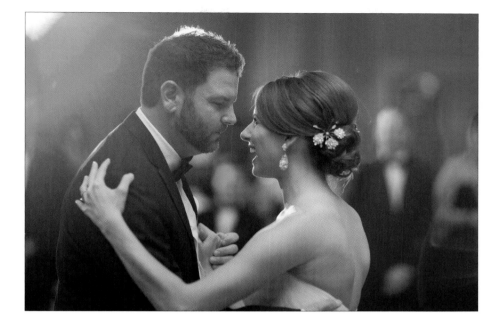

THOUGHT PROCESS: While this lens flare look drives some traditional photographers crazy, a lot of today's brides love it and request it (not by name, of course, but in sample images they provide the photographer). In fact, I know of photographers who have scoured eBay searching for older used lenses (these older lenses don't have a special nano-coating added to reduce lens flare, so that makes creating a lens flare look that much easier). Another thing that makes creating lens flare looks easier is to simply remove your lens hood (if you have one on, take it off). They are designed to help you avoid lens flare and, once again, that's not your goal. Your goal is to accentuate it (don't shoot the messenger). I took this shot at f/1.2 because of the low light, but a happy by-product is that it puts the background way out of focus, which helps give the bride/groom visual separation from the background. Just one thing to keep in mind: when you shoot at f-stops like f/1.2 and f/1.4, your focus is really critical. Lock your focus (hold the shutter button down halfway) when you're directly over the subject's eye that's closest to you.

POST-PROCESSING: In-camera lens flare effects tend to create a flat, hazy look, so you might want to add some contrast back into the image by dragging the Contrast slider to the right in the Basic panel in Lightroom's Develop module (or Camera Raw).

Controlling What You See in the Frame

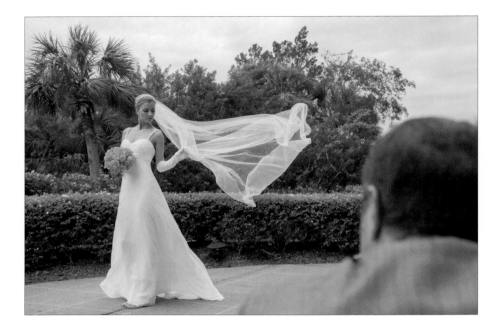

BEHIND THE SCENES: This was taken at a hotel, in an area where they hold outdoor events (cocktail parties, receptions, etc.). This is a natural-light shot, so you pretty much just see me and the bride. However, one thing we were able to do that made a big difference in this shot was to use a really long veil. I wish the idea was mine, but at an industry tradeshow party years ago I overheard a photographer say, "Give me a long veil and I'll give you magic," and man was he ever right! (I would love to give credit to the photographer, but I didn't know who he was. Still don't, but he was right on the money.)

CAMERA SETTINGS: My goal for most outdoor shots is to put the background as out of focus as possible, so I'm going to: (a) zoom in tight, and (b) use the lowest-numbered f-stop my lens will allow (in this case, f/2.8). You can see it's a very cloudy day (thankfully), and the clouds in the sky are acting as a giant softbox and keeping the harsh light away, so I didn't have to do anything to try to make the natural sunlight soft (there's a word for this: luck). It's not really super-bright outside, but at a wide-open f-stop like f/2.8, I was able to get my shutter speed to 1/500 of a second, which is fast enough to be able to hand-hold the camera without worrying about movement and a blurry shot.

Final Image

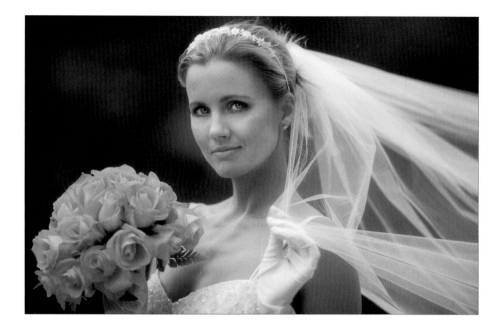

THOUGHT PROCESS: There's a kind of busy, and not particularly attractive, background behind her. So, I tried to position myself so I was aimed at a less-busy part of the background and, if you look at the production photo on the opposite page, you can see I'm squatting down quite a bit to help me find a better background area, as well. Even though it's going to be blurry (courtesy of the f/2.8 f-stop), I still want as little going on behind her as possible. Since I will be blurring the background so much, the bigger picture is this: we get to choose what makes it into our frame, and it's our job to eliminate distractions in and around our subject (or they get lost in all the visual noise). I zoomed in tight like this to: (1) simplify the background, (2) create a direct connection with the viewer by making her very large in the frame, while leaving enough room that you can see the veil blowing in the wind, and (3) avoid the hedge and the walkway where she's standing, and make the image really about her, the bouquet, her veil, and nothing else.

POST-PROCESSING: Mostly portrait retouching for this shot: smoothing out her skin and adding some light to her eyes (our bride has deep-set eye sockets and that creates a lot of shadows, so I had to lighten that area using the Adjustment Brush found both in Lightroom's Develop module and in Camera Raw). The other adjustment was warming up the white balance a little, so her dress looks white (the original looked a little blue because I shot in the shade of the clouds).

Chapter Six

Shooting Travel Like a Pro

Recipes That Make Them Want to Visit That Place Right Now

How do you feel about adding more pressure to your travel plans? I'm talking serious stress even beyond the potential nightmare of being assigned a middle seat in coach for a 10-hour flight, or having to connect to the Internet at dial-up speeds, or sitting next to someone on the plane who is eating a foot-long Coney dog and bag of Doritos. Yes, I'm talking about the intense pressure to come back with photos from your trip that conform to the mental expectations of all your friends and relatives who have seen the incredible amount of gear you own, which in their minds equates to you coming back from your trip and literally blowing their minds with *National Geographic*-quality travel shots. Well, my friends, I'm here to do one thing and one thing only, and that is to alleviate your stress through a simple time-tested method. If you want *National Geographic*-style photos, it starts with actually subscribing to *National Geographic*, but don't subscribe to the print version, get the digital tablet version (for iPad and Android tablets). Then, when you see the type of image on their pages that you'd like to be taking, blow it up large on the screen, take a screen capture of that shot, crop it so all you see is the picture itself, and then email yourself that photo and save it to your camera roll. Repeat for about two dozen photos from a few different issues. Do you see where I'm going with this? Right! This way, you have no photo stress whatsoever. In fact, why even lug all that camera gear in the first place, right? Heck, why even read this chapter or this book, for that matter? Whoa, now cowboy…let's not get carried away here.

Hiding Tourists, Cars, Buses, etc.

BEHIND THE SCENES: This shot was taken in the heart of Rome, Italy. I was standing in a small park across the street from what is locally known as the "typewriter" (its official name is Altare della Patria [Altar of the Fatherland], and I've also heard it referred to as the "wedding cake"). No matter what you call it, or what time of day you're standing in front of it, the view will pretty much always have cars, buses, scooters, and tourists right in front of it.

CAMERA SETTINGS: For travel photography, I'm generally a "one body, one lens" guy (I've tried it both ways—also taking tons of gear, lugging it all over, and switching lenses all day—and I've found that no matter which lens I have on at a particular time, it's always the wrong one). My go-to full-frame lens for travel now is a 28–300mm f/3.5–6.3 (the equivalent for a cropped sensor lens would be an 18–200mm f/3.5–5.6). Nikon makes a great 28–300mm. It's small, not too heavy, surprisingly sharp, and the street price is right around $1,050. Canon makes a 28–300mm, as well, but it's very heavy (3.7 lbs), it's very large, and it's very expensive (street price around $2,700). This is why I use the Tamron 28–300mm f/3.5–6.3 (available for Canon, Nikon, and Sony), which is very lightweight (1.3 lbs), reasonably sharp (not as sharp as the Nikon or Canon, but not terrible), and its street price is only around $630. In the final image, I'm zoomed out wide at 35mm, and I'm at f/6.3 at a shutter speed of 1/100 of a second (it was kind of overcast). My ISO was at 100.

Final Image

THOUGHT PROCESS: Using Photoshop to somehow clone all those cars and buses out of the way would be a nightmare, because you'd have to rebuild a lot of the front of the building. So, instead, try this: get down really low. This is exactly what I did here. This totally changes your perspective and field of view, and uses the foreground grass to hide stuff like cars and buses. There was a very short fence in place to keep people from walking on the grass, so I stuck my camera body between the rungs of the fence and positioned it just above the grass (so you wouldn't see blades of grass in front of my lens), and then took the shot. Composition is a bit of a guessing game when you're shooting down this low, so I turned on Live View so I could see what I was shooting on the back LCD monitor. Once I had it pretty close, I switched off Live View and took the shot you see above. It took me a few shots to get it right, but that's okay—the film is free, right? By the way, you can use this same trick shooting your kid's sporting events to hide the outfield fence on a baseball field, or the empty stands on a soccer field, or to hide anything in your line of sight when standing.

POST-PROCESSING: Not much to do on this shot—just added some contrast and sharpening, and used the Shadows slider to open up the shadows in the building a bit (just drag it to the right in either Lightroom's Develop module or in Camera Raw). While this makes for a good example, it doesn't make a really great shot, especially with that scaffolding on the left side of the building. Want to see how to get rid of stuff like that? Watch the video I made to show you how on the book's companion webpage (mentioned in the book's introduction).

There's a Picture in There Somewhere

BEHIND THE SCENES: This was taken inside Jackalope, one of the awesome gift shops in Santa Fe, New Mexico. I took my students there a few years ago during a workshop at the Santa Fe Photographic Workshops campus. It made such an impression, I went back again this year. Lots to shoot indoors and out, and the place is very camera friendly.

CAMERA SETTINGS: I used my same go-to travel setup here (the one I talked about a couple pages ago—one camera body and my go-to travel lens, the Tamron 28–300mm f/3.5–6.3). For the final image, I'm zoomed in reasonably tight at 200mm and, at that zoom amount, my f-stop could only go as low as f/5.6. (Remember: this is a variable aperture lens, so when I shoot wide, at 28mm, my f-stop can go as low as f/3.5 but as I zoom in tighter, that number is forced to go up. In this case, at 200mm it increased to f/5.6. If I zoomed in even tighter, it would be at f/6.3.) Because we were indoors, I had to bump up the ISO to 400 to get my shutter speed to 1/60 of a second (that's about the minimum most folks can hand-hold a shot and still have it nice and sharp. Any slower and your image would be a little blurry). So, to sum up, I'm at f/5.6, at 1/60 of a second shutter speed, at 400 ISO. The behind-the-scenes shot above was shot at 28mm (wide angle), so I could get my f-stop down to f/3.5, and that increased my shutter speed to 1/640 of a second—plenty of speed to get a sharp shot. So, while it's nice and sharp, it's just a "meh" shot, which is why I needed to zoom in to make something out of it.

Final Image

THOUGHT PROCESS: We've all been in these situations before where you see all this cool stuff in one place, but it's so busy or crowded (like at an indoor market or busy city square) that it's hard to think there's even a shot there. In situations like this, it helps to remember that we don't have to show everything we see in front of us—we can pick and choose what winds up in the frame. We can literally use our camera to cut this giant, busy, messy scene into small visual chunks that fit in our frame. That way, we can keep the distractions to a minimum. In this case, I really liked the colors on this one particular vase on a shelf alongside other gifts for sale in the shop. By zooming in tight, we only reveal what's in our frame—which, in this case, was just this one vase—as if it were all alone. If I had moved even an inch to the right, you would have seen the price tag of the butterfly carving behind it. So, while I'm composing the shot, I'm moving a few inches in either direction to see which one gives the least distracting image, and this was my favorite of the ones I took. Besides the color, what drew me to shooting it in the first place was the soft, diffused light from the skylights above (pretty rare in gift shops, I'd have to say). Now that I've mentioned how you can visually chop a scene like this into little pieces inside your frame, go back and look at that image on the facing page, and you'll see how many good shooting opportunities are actually there.

POST-PROCESSING: I increased the Contrast amount in Lightroom's Develop module (or Camera Raw), and then I darkened the outside edges by dragging the Post Crop Vignetting Amount slider to the left in the Effects panel. That's pretty much it.

Moving to Hide Distracting Stuff

BEHIND THE SCENES: This was taken on the island of Santorini, Greece, which is famous for its whitewashed buildings and beautiful blue accent colors. There's a distracting light post and a small fence in the bottom-right corner here, and there's a telephone pole, wires, and some other distracting junk near the top left (both are circled in red here). I had my lens zoomed out a little, to 70mm, for this shot. I could have gone wider, but then there would've been other distracting things in the frame, like air conditioning units and messy looking chairs and other distracting junk.

CAMERA SETTINGS: This was taken with a 28–300mm f/3.5–5.6 lens at f/8. It was a bright, sunny day, so at 200 ISO, my shutter speed was 1/1600 of a second.

Final Image

THOUGHT PROCESS: I think one of the best things you can do for your travel shots is to keep them "clean" and keep any distracting things in the frame to a minimum. That's what I was trying to do here. You can see that the ship has moved from the right side of the bell tower to the left side, but of course the ship itself didn't move—I did. I walked a few feet up and down the street overlooking this church trying to find a spot where I could frame the image without seeing the telephone pole and wires on the left and the black light post and fence on the right. I walked just far enough that it visually put the ship on the left side of the bell tower. This shot is literally taken just a few feet from where the first shot was taken, yet look at the difference in hiding the distracting elements. Personally, I liked it better with the ship on the right side of the bell tower, but sometimes you have to make a trade off. In this case, the cleaner, less-cluttered shot won out.

POST-PROCESSING: You don't need to do much to a bright, sunny, daylight shot like this. I just increased the Contrast amount a bit in Lightroom's Develop module (or Camera Raw) and sharpened it. *Note:* I sharpen *every* photo, so if I didn't mention it in one of the recipes here in the book, just know that every photo gets sharpened, normally using Photoshop's Unsharp Mask filter. My favorite settings for travel photos? Amount: 120%, Radius: 1.0, Threshold: 3.

Finding Simplicity in a Busy Outdoor Scene

BEHIND THE SCENES: This was taken in Malmö, Sweden, just across a long bridge linking Copenhagen, Denmark, to Sweden. We made the drive (and paid the most expensive bridge toll of my entire life—I believe it was in the $50 range) to shoot a famous high-rise building that I didn't know even existed until someone mentioned on Twitter that I should try to shoot it. The building is called the "Turning Torso," and you can see it in the top left of the image here, climbing up above the shopping/entertainment and living area built up around it along this cute harbor. This wide-angle shot is kind of "snapshotty"—I took it to help me remember what it was like there. But, outside of that, there's not a lot going on artistically in the image. I'm sure it looks much like everybody else's shot who was standing right beside me when I took this from the pier.

CAMERA SETTINGS: Same lens as usual—the 28–300mm f/3.5–5.6—and I'm zoomed out as wide as I can go at 28mm. I chose f/11 for my f-stop, so the Turning Torso in the background would be sharp and in focus, just like the condos in the foreground. It's a bright, sunny day, so my ISO is 200 and my shutter speed is 1/500 of a second.

Final Image

THOUGHT PROCESS: As I walked around the small harbor, I spotted the very modern-looking condo on the far left of the image on the facing page (the one where you see the Turning Torso rising above it). What drew me to find this shot within all that busyness that is the harbor is the fact that I looked up and saw this very clean, very modern, just simple-looking white building against a blue, cloudless sky. The window, and that fact that you see through to the window on the other side, sealed the deal for me that there was a decent shot somewhere. So, I stood in the harbor with my lens zoomed in to 122mm. Not that tight in, but I was fairly close to the building by this time, and I wanted to make sure I left plenty of blue sky to the left of the building. That empty area is called "white space" or "negative space," and since it's essentially empty, what it does is draws the viewer's eye directly toward your subject (in this case, the condo window).

POST-PROCESSING: I added a little Vibrance to the image using the Vibrance slider in Lightroom's Develop module (or Camera Raw), which made the already blue sky a little bluer. Just drag that slider to the right a little bit and you're there.

Shoot the Details Instead

BEHIND THE SCENES: Here's a shot from Istanbul, Turkey, of the famous Sultan Ahmed Cami Mosque, also known as the "Blue Mosque," taken just before sunset. The problem with capturing something so large like this is that you're surrounded by distracting stuff—everything from tourists to street lamps—which makes it really hard to capture this, or nearly any large structure, unless you're up very high shooting down on it.

CAMERA SETTINGS: I shot with a 70–200mm f/2.8 lens zoomed in to 135mm. My f-stop was f/5.6 and my shutter speed was 1/15 of a second, so I was on a tripod. My ISO was 200 ISO (the lowest, cleanest ISO for the camera body I was using).

Final Image

THOUGHT PROCESS: In my Shoot Like a Pro seminar tour (which is based on this series of books), I talk about how challenging it is shooting things like the exteriors of cathedrals, theaters, opera houses, and the like, because they're not usually all by themselves on a flat, unobstructed piece of land. They're usually downtown, and they're usually surrounded by either construction/restoration equipment (think construction cranes, barriers, and fences) or local businesses with signs, power lines, and such. It makes capturing a clean, unobstructed shot of these large structures really tough. That's why I recommend zooming in and focusing on just one important part of the structure, like I did above. I also waited until the sun had gone down. This was taken 1 hour and 11 minutes after the shot you see on the facing page, which also means I had to shoot on a tripod because the light was so low (there was no way I could get to the 1/60 of a second or faster shutter speed I would need to hand-hold this shot). By only showing part of the structure, you're bringing the viewer something they wouldn't see if they were just standing there. Plus, zooming in tight on an important detail area is a very powerful and dynamic way to present a large structure like this.

POST-PROCESSING: Just three main things: (1) The mosque is backlit, so I dragged the Shadows slider in Lightroom's Develop module (or Camera Raw) to the right a bit to bring out detail in the shadows. (2) To enhance the texture, I dragged the Clarity slider to the right, and then (3) I dragged the Tint slider to the right toward magenta to make the sky color more interesting.

The Waiting Game Gamble

BEHIND THE SCENES: This shot was taken during a guided tour of Beijing's Forbidden City. Just a natural light shot. As you might imagine, the Forbidden City is packed full of tourists. You're seeing just a tiny hint of that here because there are literally thousands visiting the grounds at any given time, which makes it a challenge to get any shots without them in every frame.

CAMERA SETTINGS: To put the background out of focus, I shot this at f/2.8 and I was using my 70–200mm f/2.8 lens zoomed in to 140mm in the final image (this was taken a few years ago when I carried more than one lens. Besides this lens, I was carrying a wide-angle zoom, as well). Even though I was in the shade (for the most part), at f/2.8 I was able to get a shutter speed of 1/1600 of a second. My ISO was set at the cleanest native ISO for that full-frame camera body, which was 200 ISO.

Final Image

THOUGHT PROCESS: Once I had passed through this opening, I looked back to see a family with their grandfather in a wheelchair, and they had positioned him facing the courtyard while they were looking at something to the left of him. I thought to myself, "Man, this would make a powerful shot if there was no one else in the frame." The problem was there were still family members around him and some tourists walking through, as well. So, I just decided to wait and see if I got lucky. I leaned against the red door you can see on the far right of the frame, put the camera up to my eye, and composed the shot the way I would want it (leaving lots of negative space to his right, so your eye is drawn immediately to him). Then I just stood there, leaning and waiting, hoping that his family might walk out of my frame for even just a moment. Within about 5 or 6 minutes of waiting, sure enough, they all stepped off the left side of the frame, leaving him alone for just a few seconds. I was already framed up, in position, so all I had to do was press the shutter button and I got it. Two seconds later, here came more tourists, and then the family came back, but I already had the shot. This "waiting game" is certainly a gamble and, in this case, I got lucky—they did walk away and there was a slight pause in the non-stop parade of tourists. But, all I had to lose was time. Well, the tour group did go on ahead without me, and I was the last one back to the tour bus, but that's another story.

POST-PROCESSING: Just added a little contrast using Lightroom's Develop module's (or Camera Raw's) Contrast slider, and a little sharpening using the Unsharp Mask filter in Photoshop.

Zooming to Hide Distractions

BEHIND THE SCENES: Here, we have two guards, manning their post in Beijing's Tiananmen Square, with a backdrop of the main entrance of the Forbidden City (they do a flag-raising ceremony here each day). There are a lot of problems with this photo, including the fact that the guard on the left looks somewhat distracted and, of course, the fire extinguisher isn't adding a lot to the shot. There are also a lot of cars and buses between the guards and the Forbidden City entrance across the street. All of these things are competing for your attention when this shot is really just about the guard on the podium.

CAMERA SETTINGS: For the final image on the facing page, I was using a 70–200mm f/2.8 lens zoomed all the way in to 200mm to put the background as out of focus as I could. (*Note:* I had to walk a few feet backward to be able to frame the shot with lots of negative space on the right side of him.) For the same reason, my f-stop was f/2.8. My shutter speed, even this late in the day, was 1/1600 of a second (thanks to using such a wide-open f-stop like f/2.8). My ISO was set at the cleanest native ISO for that full-frame camera body, which was 200 ISO.

Final Image

THOUGHT PROCESS: By zooming in tight when you have distracting objects in the frame (like a fire extinguisher or a bored guard), you can eliminate a lot of distractions in your image and simplify it, which generally makes it stronger. In this particular case, one of the benefits of zooming in was that I was able to frame the subject so it looks like he's under the ever-watchful eye of Chairman Mao Zedong across the street. The fact that the guard appears to be glancing a suspicious look helps sell the story even more (though capturing his suspicious look was just plain luck). By putting the background out of focus, it visually separates the guard from the busy background, and by composing the image with all that negative space to the right of him, it helps draw your eye directly to him. It makes for a much more dynamic image all around.

POST-PROCESSING: Just two things: I used Photoshop's Clone Stamp tool to remove some distracting things from the background, including red cones and part of a truck on the edge of the frame. I also sharpened the image using Photoshop's Unsharp Mask filter, but as I mentioned earlier, I sharpen every single image, so that second part is a given.

Changing Time and Perspective

BEHIND THE SCENES: This is a photo of a gift shop in the Vatican Museums in Rome, Italy (I know, Vatican City is technically its own sovereign city within the borders of Rome; no need to write in. LOL!). At the end of your tour, you're left in a gift shop and you leave by winding your way down this beautiful staircase. If you search on Google for this stairway, you'll find lots of shots of it. But, nearly all the shots have lots of tourists winding down that staircase, which isn't surprising since the Vatican is one of the most-visited museums in the world, welcoming more than 5 million visitors per year (yikes!). However, I wanted to get a shot of it without any tourists or other distractions.

CAMERA SETTINGS: Although there seems to be a lot of natural light, there's not nearly as much as you'd like. For the image on the next page, I set my f-stop to f/3.5 and, even at that, I had to raise my ISO to 1600 to get my shutter speed up high enough (to just 1/60 of a second) to get a sharp, crisp hand-held shot. Because I generally shoot travel with a 28–300mm f/3.5–5.6 lens, that's what I had with me. But, since I knew I would be shooting a lot of cathedral interiors in Rome, I also brought a wider lens. Even though I rarely used it (and only carried it with me once the entire trip), it paid off here as this shot was taken at 16mm (the lens was a 16–35mm f/2.8).

Final Image

THOUGHT PROCESS: There are really only two ways to get a shot of this stairwell without it being full of tourists (well, without having to resort to a lot of Photoshop work anyway), and that's to either get there really early (before anyone makes it to the gift shop), or at the very end of the day, but you run the risk of having security force you to leave as the place is closing. Doing research before a trip like this is critical. I had learned that if you arrange a private tour, not only do you skip the incredibly long lines, but they also let you into the Vatican an hour before the general public (and the massive crowds). So, as soon as we started, I saw the gift shop off in the distance and asked the tour guide if I could run over there and grab a few shots. Once there, the flat perspective you see on the facing page is just that—flat. But, if you change your perspective and lean over the railing (like I did here), you get this beautiful view of the entire staircase winding its way down. I had to hold the camera with my arms stretched out, so I shot in burst mode. That way, even if a shot or two wasn't perfectly in focus, at least one of them probably would be. I also hedged my bets by shooting there for about 10 minutes, from different angles all around the gift shop, trying different amounts of zoom, and I wound up with the shot you see above.

POST-PROCESSING: I did three things in Lightroom's Develop module (you can also do these in Camera Raw): (1) I darkened the edges all the way around by dragging the Post Crop Vignetting Amount slider, in the Effects panel, to the left a bit. (2) I increased the Vibrance amount a little to bring out the blue at the bottom of the stairs and the orange light on the stairs. (3) I added contrast using mostly the Contrast slider, but I added a little bit of Clarity (which adds midtone contrast), as well.

Another Trick for Hiding Tourists

BEHIND THE SCENES: This is Sainte-Chapelle in Paris, France. It's one of the most amazing churches I've ever seen because it has these tall, amazing, stained glass windows on all sides, all the way around the entire church. Everything below the stained glass is gold leaf, and the whole place is just stunning. It's also very small and, as such, it's always very crowded, and like almost any church, theater, opera house, or hall in Europe, it's also under restoration—you can see scaffolding along the entire left wall above. Believe it or not, I can deal with that, but the tourists are a different problem and that's what this recipe is about: avoiding the tourists.

CAMERA SETTINGS: For the final shot, I used a 14–24mm f/2.8 lens and took the shot at 14mm. Even at f/2.8, and at 800 ISO, I could only get my shutter speed to 1/20 of a second. That is *very* risky for hand-holding a shot (no tripods allowed here) and, in all honesty, I should have increased my ISO to get my shutter speed above 1/60 of a second. I can only imagine the reason I didn't raise my ISO was I just simply wasn't paying enough attention (I was seriously blown away at seeing this church and very distracted with what was standing before me—I really hadn't expected it would be so amazing in person). So, I attribute the fact that I got a sharp shot at 1/20 of a second to a steady hand and a lot of luck, because my hand-holding just usually isn't that steady.

Final Image

THOUGHT PROCESS: I can't tell you how many times I've shown this shot to someone who has been to Sainte-Chapelle and they said, "How in the world did you get this shot without the place being packed with people?" Now, I mention in the previous recipe about getting there before all the tourists do. But, that doesn't always work because often, when they first open the doors in the morning, waiting behind those doors is a wall of tourists. It just depends on how early it opens, and the earlier it opens, the better chance you'll have that there won't be as many tourists in line that early. However, that's not the trick I used to get this shot, which was taken just moments after the shot on the previous page was taken. The trick is simply to raise the camera high enough that you're looking just over the tops of the heads of the tourists. They're all still there, but I composed the shot aiming upward—just over their heads. If I lowered my lens barrel even a half-inch, you'd see the tops of their heads. I've used this trick again and again over the years and it works like a charm. You'd think viewers would say, "Where's the bottom of the church?" but not a single one has (only when I tell them the trick do they realize the floor is missing).

POST-PROCESSING: This shot has a *lot* of post-production because (1) it's an HDR shot, so I had to combine three images into one. And, (2) I had to select the right half of the photo in Photoshop, copy it onto its own layer, flip it horizontally, and then drag it over the scaffolding to hide it. I did a video tutorial to show you how it's done (I posted this, and other post-production tutorials, on the book's companion webpage mentioned in the book's introduction).

Shooting the Food

BEHIND THE SCENES: This was taken at an outdoor cafe (well, it's not an outdoor cafe per se—there's plenty of seating indoors, but I asked to sit outdoors), right along the Seine River and just behind Notre Dame, in Paris. It's a simple setting, and I took a wide shot to show you the regular view of a tasty French dish. Hey! Where's the wine?

CAMERA SETTINGS: For the final shot you see on the facing page, I was using my trusty 28–300mm f/3.5–5.6 zoom lens, and I zoomed in tight to 135mm (I was pretty darn close to the dish, so at 135mm I was really in tight). I used the widest (smallest numbered) aperture I could, which in this case was f/5.6. My ISO was set to 1600, since it was a cloudy, rainy day, but that was actually higher than I needed because my shutter speed was 1/500 of a second. So, I could have come down to maybe as low as 400 ISO and still had at least 1/60 of a second. Lowering that ISO would have given me a cleaner image (noise-wise), but as it is, you really don't see any noise to speak of (and I didn't run any noise reduction plug-ins or anything).

Final Image

THOUGHT PROCESS: I have a simple recipe for shooting food while on vacation, and it pretty much works every time. It starts with (1) asking to either sit outside or to sit by a window. If you can't do either, the rest isn't going to work because when it comes to food, the lighting is critical, and it needs to be natural light. I'm not saying it's impossible to get a decent food shot inside the restaurant with their tungsten lighting, but it sure is a lot harder because there are usually multiple light sources and weird shadows and color problems. So, if you can either sit outside or at a window, the rest is simple. (2) Set your f-stop to your lowest (widest) possible setting (in my case, I could only go as low as f/5.6, but if you can get to f/4, or even f/2.8, it will look even better). (3) Your goal is not to shoot the entire plate of food—just shoot a portion of it (just like with a big building, only shoot the detail). So, stand up, and then zoom in really tight on one area of the dish (as seen here). It's okay to cut off the ends of the dish—just get in really tight. This will put the front of your food in focus, and the back of the food out of focus. At the same time, when you're zoomed in tight like this, it puts the foreground closest to you out of focus, as well. Perfect! (4) Now, tilt your camera at a 45° angle to the left or right (your choice) and take the shot. So, to recap: sit outside or by a window; set your f-stop wide open; stand and zoom in tight; then, tilt and fire!

POST-PROCESSING: Not much to do here. I just added a little contrast and sharpening. Why do I always add contrast after the fact? Because I shoot in RAW mode, which means it turns the in-camera contrast off. So, the photos look flat without me adding some contrast in Lightroom's Develop module (or Camera Raw) after the fact. If you shoot in JPEG mode, the camera adds contrast automatically.

Going on a Stakeout

BEHIND THE SCENES: The photo above was taken at 8:14 p.m. in a very busy part of Montmartre—a popular artist's colony near the Basilica of Sacré-Coeur, overlooking Paris. Behind this non-stop parade of tourists is a charming little bistro surrounded by a cobble-stone street (and a popular photo spot, although I had never shot it before. In fact, I didn't even know it was there, even though I had visited Montmartre many times before. Don't know how I never got back to this spot, but somehow I hadn't until a friend took me there).

CAMERA SETTINGS: The image you see on the facing page was taken with a 14–24mm f/2.8 super-wide-angle lens at 15mm (why 15mm? I'm sure I accidentally nudged the barrel at some point and moved it from 14mm to 15mm. It happens). Since this was at night, my shutter needed to be open much longer than the 1/60 of a second I use for hand-holding shots, so I had to put my camera on a tripod to keep it steady. My shutter speed wound up being 1/6 of a second (way slower than I could possibly hand-hold my camera). Since I was on a tripod, I could use my lowest, cleanest ISO, which was 200 ISO. My f-stop was f/2.8 (probably should have used a higher f-stop—maybe f/11—which would have left my shutter open longer, but might have resulted in a deeper focus. Honestly, though, with a wide-angle lens like this, even at f/2.8 you can see everything's pretty much in focus throughout the picture, so I don't sweat it as much).

Final Image

THOUGHT PROCESS: The photo above was taken at 9:36 p.m. that same night (about an hour and 20 minutes after the first one was taken). Waiting until just after the bistro had closed (so all its lights were still on) and all the other tourists had gone away really paid off. In that hour and 20 minutes, we went and grabbed a bite to eat and then came back to that exact same location, knowing that it would now be pretty much empty. I still had to wait about 10 minutes for a moment where the streets were fully empty (there were still a few tourists making their way home from dinner, and if you look on the far right, you can see a few in line getting a crêpe for the road). I wanted to use the cobblestone street as my foreground, so I got my tripod down as low as I could get it (I splayed out the legs as far as they would go). Then, to keep the camera perfectly still, instead of pressing the shutter button with my hand (which could cause a tiny bit of movement in the camera), I used a cable release to take the shot. That way, my hand never touched the camera, and the shot would be super-sharp.

POST-PROCESSING: The big thing I did here was to add a *lot* of clarity, using the Clarity slider in Lightroom's Develop module (or in Camera Raw). Dragging it to the right enhances the texture in the image, making the cobblestones appear shiny. Then, I got the Adjustment Brush and painted over the cobblestones with the Contrast set to 100 (full power) to make them even shinier, which helped the reflections stand out in the cobblestones even more.

Chapter Seven
Shooting Landscapes & Nature Like a Pro

Recipes for Making the Great Outdoors Look Great

Wait a minute, this is some kind of scam because nature and landscapes are the same thing! Au contraire (said the guy who doesn't actually speak French, though I do adore french fries, or pommes de terre frites, as my non-French friends who want to sound French say when ordering fries at McDonald's), when it comes to photography, nature and landscape are actually two very distinct things. For example, landscape shots are photos of your yard right after you've cut the grass and your hedges have been neatly trimmed, whereas nature shots are usually photos of bees. I am not making this up. Well, maybe the first part, but if you were to Google the term "nature," you know what would come up in the search results? Me neither. So, I'm going to go to Google myself right now and type in "nature," and then when the results appear, I'm going to click on the Images link, and I'll bet I get a bunch of close-up of photos of bees. Here we go (heading to Google.com now. Typing. [insert typing on keyboard sound effect here]). Ah ha! I mean… uh oh. It's not bees. It's a tiger, then a bunch of landscape shots (and not of your yard, probably because you haven't trimmed your hedges). Wait! Wait! I scrolled down on the results page and found a ladybug and some butterflies. Does that count? No? Really? Well, crud, I guess this is a scam after all. Well, if I were you, I'd still read this chapter since you've already paid for the book, unless of course you shoplifted this book, in which case you can pretend this chapter is called "Booked and Fingerprinted."

Shooting Streams

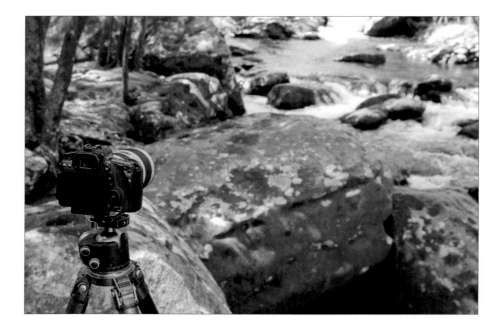

BEHIND THE SCENES: We're in the Great Smoky Mountains National Park and we're set up on a rock that sticks out into a stream, with our camera mounted on a tripod.

CAMERA SETTINGS: I'm using a 70–200mm f/2.8 lens, zoomed in to 110mm. My f-stop is f/32 and that puts my shutter speed at 1.3 seconds. Now, f/32 probably isn't the sharpest f-stop on my camera (and that's being kind—some of the f-stops at the far end of the range experience a thing called "lens diffraction," so they aren't generally as sharp as f-stops like f/8 or f/11), but in this case I was happy to trade a little sharpness to get a longer shutter speed (more on that in a moment).

Final Image

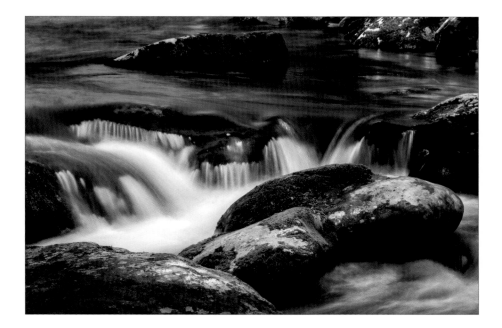

THOUGHT PROCESS: When we're shooting a stream like this, our goal is to keep our shutter open long enough for the water to become smooth and silky, like you see here (water that's frozen in mid-air by a high-shutter speed is one of the Seven Deadly Sins of Landscape Photography). So, how do we keep our shutter open long enough to get this silky water effect? First, look for parts of the stream that aren't out in direct sunlight. I look for parts where there are clouds overhead blocking the direct sun. That was the case here: this part of the stream was under cloud cover most of the time, but the sun did peek out a few times so I had to take a break from shooting until it tucked back behind a cloud. Secondly, set your f-stop to the highest number your lens will allow—on the lens I was using, it was f/32 which, along with the clouds, helped me keep the shutter open 1.3 seconds for the shot you see above. The water is *pretty* silky, but the longer you can keep it open, the smoother and silkier it will get. If you wanted to keep it open even longer, you could add a polarizing filter (see page 152). It darkens the scene, usually by a stop or two, and that keeps your shutter open longer, so using one will get you even silkier water than you see here. If you need silkier water yet, then you can go all the way to a neutral density filter (called an ND filter, for short). We'll talk about them next, in "Shooting Waterfalls," but just know that you can use them here, as well.

POST-PROCESSING: I added contrast in Lightroom's Develop module (or Camera Raw) and darkened the edges all the way around by going to the Effects panel and, in the Post Crop Vignetting section, dragging the Amount slider to the left to –9. Lastly, I applied the Nik Color Efex Pro plug-in's Tonal Contrast filter using the default settings.

Shooting Waterfalls

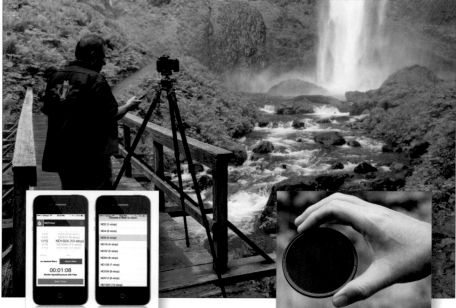

NICOLE S. YOUNG

BEHIND THE SCENES: I'm making a long exposure here (to create that silky water), so even though it's during the day, I'm on a tripod and using a cable release to fire my shutter button. The red light on the back of the camera is on because this behind-the-scenes shot was taken during the time the shutter was open.

CAMERA SETTINGS: The final image was taken with a 16–35mm f/2.8 lens zoomed all the way out at 16mm. My f-stop was f/22 so I could keep the shutter open as long as possible, but I added a 3-stop ND (neutral density) filter to my lens (seen in the inset on the right above) to keep my shutter open even longer (more on this on the facing page). In this case, the sun was behind the waterfall (just lucky), so I was able to get a pretty decent, silky water effect just setting my f-stop to f/22 without any filter at all because it made my shutter speed 2.5 seconds long, which isn't bad. But, once I added the 3-stop ND filter to my lens, it increased my shutter speed to 15 seconds, which made the water much silkier and smoother, so it was totally worth doing. My ISO was 100 (I used the lowest possible ISO not only because I was on a tripod, but because it was my least-sensitive-to-light ISO, so it also forced the shutter to stay open longer).

Final Image

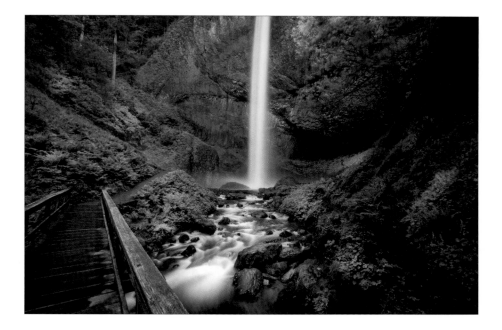

THOUGHT PROCESS: Our goal here is pretty much the same as when shooting streams: keep the shutter open long enough for the water to flow, giving us that really silky water look. Usually, if we shoot in direct daylight, just using a high f-stop (anywhere from f/22 to f/32) alone won't keep the shutter open long enough. Instead, we use an ND filter to darken the scene, so our shutter can stay open longer and still make a proper exposure. ND filters come in different darkness amounts, ranging from 2 stops to 10 stops, but if you need the scene even darker, you can "stack" a second filter on top of the first one (you might use a 10-stop filter, and then a 2-stop on top. You'll be surprised at how much that second 2- or 3-stop filter adds to your shutter speed length). How do you know how long to keep your shutter open? You use an app. I use ND Timer (by Three60, available for IOS; shown in the inset on the left on the facing page). It tells you exactly how long to leave your shutter open (even if you stack filters), plus it has a built-in timer, and it's just 99¢. Although my camera was able to autofocus with the 3-stop ND filter on, if you use an 8-stop or 10-stop (or you stack), it's so dark, your camera won't be able to auto-focus. So, focus first with autofocus turned on (before you put the filter on), then switch your focus to manual (right on the lens), and put the filter(s) on.

POST-PROCESSING: I did four things in Lightroom or Camera Raw (I created a video of it all for you, which you'll find on the book's companion webpage, mentioned in the book's introduction): (1) increased the Contrast amount, (2) added Post Crop Vignetting, (3) increased the Clarity amount to bring out the detail, and (4) used the Adjustment Brush to brighten some of the highlight areas in the grass and bushes.

Photographing Animals

BEHIND THE SCENES: I'm shooting outdoors here in a local zoo using a long lens (this is becoming really popular with wildlife photographers, and most zoos allow you to bring in a long lens and, in many cases, even tripods).

CAMERA SETTINGS: The final image on the facing page was taken with a 200–400mm f/4 lens with a 1.4 tele-extender to get in even closer. With that, I'm zoomed in to 506mm on a full-frame camera body. I'm using a monopod to help steady my lens. My f-stop is f/5.6 (the lowest f-stop I can choose with a tele-extender added to my f/4 lens—with the tele-extender, you lose 1 stop of light). My shutter speed is 1/400 of a second at 1250 ISO (I could have lowered my ISO down to 200 or even lower and still probably had enough shutter speed to have the shot be really sharp, especially since my lens was held up with a monopod). If you don't have this long a lens, you can rent some really long lenses from LensProToGo (www.lensprotogo.com) or BorrowLenses (www.borrowlenses.com). I've used both in the past—they're great, and have an incredible selection of long lenses to rent.

Final Image

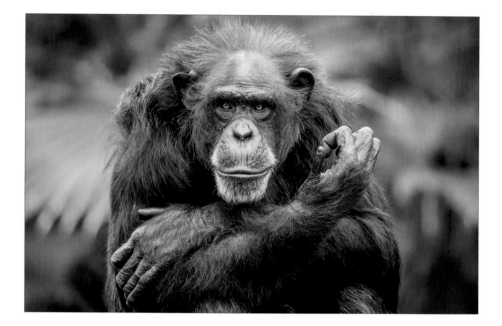

THOUGHT PROCESS: The goal when you're shooting in a zoo is, of course, to frame the image so you can't actually tell it was shot in a zoo. This is often more challenging than it sounds because, while you may have an unobstructed view of the animal (like I do on the facing page), the background behind the animal is usually either an ugly fence or an obviously man-made enclosure, or it just looks very different from their actual natural habitat. One way around this is just to be very aware of the background as you're composing your shot. This can get really frustrating because, of course, the animal won't always be in a location within their environment that lets you get the shot with a decent background behind him. It requires a lot of patience, and you might have to walk away without getting a shot you'd show anyone, because the animal just stays in one location, or is too far away, or stays in an area with an ugly background. You can try shooting from a different angle, which might improve the background, but at the same time the animal might never look in your direction. The patience part of this is really key. Another way around this is to zoom in tight and shoot wide open (using the lowest f-stop your lens will allow), which puts the background out of focus, like you see above.

POST-PROCESSING: I increased the contrast a bit in Lightroom's Develop module (or Camera Raw; pretty standard for me). Then, in the Effects panel, under Post Crop Vignetting, I dragged the Amount slider to –11 to darken the edges of the image just a tiny bit. Lastly, like every image, I sharpened it using Photoshop's Unsharp Mask filter.

Shooting in Daylight

BEHIND THE SCENES: Here you're seeing a before/after of a shot taken during the day (I usually don't shoot landscapes in the middle of the day—only around dawn or dusk—but since you get the most impact from a circular polarizer during the day, I shot these at around 5:40 p.m., when sunset was just after 8:00 p.m.). This before/after is actually a side-by-side of two images (the shot taken without the circular polarizer on the left, and the one with it on the right), both open in Photoshop at the same time (if you have two images open in Photoshop, and you go under the Window menu, under Arrange, and choose 2-up Vertical, it gives you this side-by-side layout onscreen).

CAMERA SETTINGS: This was taken using a 16–35mm f/2.8 lens, zoomed in to 30mm. I'm at f/22 (a popular f-stop to choose for landscapes where you want everything in focus from front to back). My ISO is 100 and my shutter speed was just 1/10 of a second, so I'm on a tripod, using a cable release, to keep my camera as still as possible for the sharpest possible image. One reason my shutter speed is so slow is that it's late in the day, and you lose around a stop-and-a-half to two stops of light by adding a polarizing filter in front of your lens.

Final Image

THOUGHT PROCESS: Although we usually think of using a circular polarizer to get better, more colorful, more saturated skies when we're shooting during the day, a polarizer does more than just help the sky (take a look at the after shot on the facing page, and you can see the effect the polarizer has on the entire image). Adding a polarizer is kind of like adding a pair of polarized sunglasses in front of your lens: it makes almost everything look better in bright daylight. The thing that trips up a lot of folks using a polarizing filter is that the amount of the effect changes pretty dramatically depending on your position in relation to the sun itself. It can either have a huge effect (which mostly happens when you're at a 90° angle to the sun), or little to no effect if you're aiming anywhere else, especially if you're aiming at the setting sun. Also, once the polarizer is on your lens, you'll need to slowly rotate the front of the filter to control the strength and position of it, so make sure you rotate as you're looking through the viewfinder (you'll see how it affects the scene as you rotate it). One thing to keep an eye out for: if you use a polarizer on a wide-angle lens, like I did here, be careful when positioning the darkening in the sky (while rotating the front of the filter) because you can wind up with an uneven effect, with part of the sky being darkened and part of it not being darkened nearly as much.

POST-PROCESSING: Nothing much. Just added some contrast in Lightroom's Develop module (or Camera Raw), and of course sharpening (every image gets sharpened).

Starbright Sun Effect

BEHIND THE SCENES: Shooting landscape shots where you see the sun in the image is getting more and more popular, and that's exactly what you're seeing in the shot above: me aiming at those huge rock-like boulder thingies (that's their official technical name) with the sun clearly in the shot.

CAMERA SETTINGS: For the final image (on the facing page), I'm using a 16–35mm lens at 16mm, so I'm as wide out as it will go. I'm at f/22, which is a particularly popular f-stop for landscape photography, but we're using it for a different reason here (more on that on the next page). Although I'm hand-holding here, in most cases when shooting land-scape images, I'd be on a tripod because I'd normally be shooting in lower light (around dawn or sunset). Since the sun was still bright in the sky, I figured I could hand-hold this one and get away with it, but at 100 ISO and at f/22. Without raising my ISO, I was only at 1/60 of a second, so that was as slow a shutter speed as I could actually get away with and still get a steady shot. About five minutes later, it probably would have been too late and my shutter speed would have fallen to 1/30 and my shot probably would have been a little soft.

Final Image

THOUGHT PROCESS: If I was on the edge of having too slow a shutter speed, why didn't I just lower my f-stop, which would have raised my shutter speed? It's because f/22 is a magic number when it comes to creating those starbright beams of light coming off the sun (you still get them to some extent at f/18, but not like you do at f/22). Take a look at the sun over in the behind-the-scenes shot on the facing page. That's how the sun would normally appear in photos where it's right there in the shot. That was taken at f/8 and the sun's beams really have no definition—it's just a big, fuzzy ball of light. Now look at the 14 well-defined starbrights (one common name for them) coming off the sun in this photo above (the fact that you can count 14 starbrights just shows how well defined they are). Of course, you can buy screw-on filters that will help with this effect, but if all you have to do is dial in f/22 before you take the shot, why not try that instead?

POST-PROCESSING: The rocks are backlit, so in Lightroom's Develop module (or Camera Raw), I dragged the Shadows slider to the right to bring out details in those rocks. I also lowered the Highlights amount quite a bit (to −68) to help lower the brightness of the sun and make those starbrights stand out even more. I increased the Clarity amount to bring out more texture in the rocks, and lastly, I dragged the Vibrance slider to the right quite a bit (to +73) to make the sky richer and more blue.

Zoo Photography, Part 2

BEHIND THE SCENES: Our subject is perched on a branch inside an enclosed aviary at a local zoo. I'm up high in a stand that gives you a "bird's-eye view" (sorry, couldn't help myself) of the area.

CAMERA SETTINGS: The final image on the facing page was taken with a 200–400mm f/4 lens at f/5.6 on a full-frame camera, but I'm zoomed in to just 280mm (the bird just isn't that far away). If you use a cropped-sensor camera, you wouldn't need nearly as long a lens since that crop factor works in your favor, bringing you at least 40% to 60% closer (depending on your make and model, a 70–200mm lens would get you just as close if not closer). My shutter speed is 1/640 of a second at 1250 ISO (I could have lowered my ISO down to 400 and still probably had enough shutter speed to have the shot be really sharp).

Final Image

THOUGHT PROCESS: With any wildlife photo, it's essential to get the eye sharp and in focus, and that was fairly darn easy with the bird just perched there on a branch not far from me. I'd prefer not to be shooting up or down at a bird, if possible, so I got down as low as I could to get the shot you see above. I was only shooting up a tiny bit (I'm standing in the shot you see to the left, but to get this image I did wind up kneeling and resting my lens on the railing in front of me). The challenge, once again, was hiding the fence that surrounded the aviary so you couldn't tell it was taken inside one, and by zooming in tight and using a wide-open f-stop (like f/5.6, in this case), I was able to blur the background enough so you can't see the fence or the unappealing area surrounding the bird. Also, make sure you take a look at everything in the frame before you take the shot—there were lots of little distracting branches and twigs that were sticking into the shot when I first framed it up, so I tried moving a foot or so in either direction until I could find an angle where I could get this fairly clean view.

POST-PROCESSING: In Lightroom's Develop module (or Camera Raw), I dragged the Contrast slider to the right. Then, I went to the Effects panel, under Post Crop Vignetting, and dragged the Amount slider to –11 to darken the edges of the image just a tiny bit. Lastly, like every image, I sharpened it using Photoshop's Unsharp Mask filter (I used quite a heavy amount of sharpening here: Amount 90, Radius 1.5, Threshold 0).

Photographing in an Aquarium

BEHIND THE SCENES: I'm in an aquarium, shooting down low with my lens pressed directly against the glass.

CAMERA SETTINGS: I'm using my 70–200mm f/2.8 lens again (zoomed all the way out to 75mm), and I'm at f/2.8 because the light in most aquariums is really low, so I need as much light coming in as possible to get my shutter speed high enough to freeze the moving fish. Unfortunately, in most cases, that won't be enough alone to freeze their movement and get a really sharp shot. To freeze a moving object, ideally you'd have your shutter speed at 1/1000 of a second or faster. If it's a slow-moving object (like this fairly slow-moving fish), it's not a problem, but if you can get to 1/1000 of a second or faster, then the blurring problem from the movement of the fish goes away completely. In this case, by raising my ISO to 1600, I got my shutter speed all the way up to 1/1250 of a second so I could freeze even a fast-moving fish.

Final Image

THOUGHT PROCESS: Outside of adjusting your shutter speed to freeze the movement of the fish, the big thing you have to work at avoiding are the reflections in the glass. The best way I've found to do this is to go online and buy a rubber lens hood for your lens (B&H Photo has a rubber lens hood that fits my 70–200mm lens starting at around $15). That way, you can put your lens right against the glass itself and that rubber lens hood blocks out any reflections. If you look at the image at the top right of the facing page, you can see my lens hood is right up against the glass (and with the rubber lens hood, you don't have to worry about scratching your lens or the glass in the aquarium, which is helpful to show if/when the aquarium security guard comes by).

POST-PROCESSING: Shots taken through thick glass or Plexiglas like this are almost always going to look a bit flat, so you're usually going to have to add a lot of contrast to combat that. I really cranked the contrast for this shot, and I also used the Lightroom Develop module's (or Camera Raw's) Adjustment Brush to brighten the fish itself, since he was so close to the glass he was kind of backlit. Also, you're going to have to adjust the white balance for most underwater shots—I used the White Balance Selector tool (in Lightroom; or White Balance tool in Camera Raw) and clicked it on rocks that I could tell should be a neutral color. Of course, you could click it on a nearby shark (snicker). You might have to click around the image a few times to find a white balance you like, but you will find one.

Shooting Individual Flowers

BEHIND THE SCENES: Here, we're shooting with natural light, but we're under the edge of a roof so we're in the shade. Our flower (a Gerbera daisy) is positioned with a piece of white poster board behind it (we eventually had to use gaffer's tape to tape the poster board to the wall, because even the tiniest bit of wind would blow it over right on the flower). The camera is set at the same height as the flower (which isn't very high). To make framing the shot easier, I used the pop-out LCD screen and Live View mode on this Canon 70D so I could use the screen to frame up the shot without having to get down on my knees.

CAMERA SETTINGS: I'm using a 100mm macro lens for this shoot, my go-to lens for shooting flowers up close, and we're really close in on the final shot. I'm shooting in aperture priority mode at f/22 because the depth of field is so incredibly shallow that, if you shoot at a wider open aperture, it'll be hard to make anything but a little sliver of the flower look in focus. My shutter speed was 1/15 of a second and I'm at 400 ISO, but no worries because when I'm shooting a macro lens, I'm always shooting on a tripod. To minimize camera movement, I'm using the camera's built-in self-timer (my backup plan when I forget to bring my cable release—it fires the shutter for me 10 seconds after I press the button, so there's no movement from me pressing the shutter button after 10 seconds have passed).

Final Image

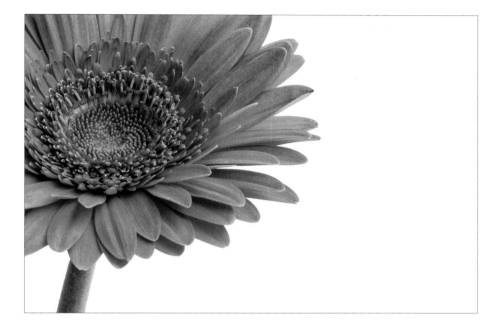

THOUGHT PROCESS: First, you need a great flower to shoot, and that means being picky about which one you choose to shoot. In the same garden, you'll find individual flowers that look ratty, with brown spots and missing petals, and you'll find some that are almost perfect. Be picky about which one you choose to shoot. In my case, we simply went to a local florist and bought three "cash-and-carry" daises for literally just a couple of bucks, but even then, we had to look at a lot before we found this decent one (we couldn't find a near-perfect one in the entire batch). The white poster board you can get from Walgreens. What's nice is that you can use that poster board on-location in a garden: just position it about 6 or 8 inches behind the flower you're trying to photograph (this actually works better than it sounds, so give it a try). We already covered shooting on a tripod for close-up macro shots, and using something to trigger the shutter to minimize movement, and we're shooting at f/22 to increase our depth of field since macro lenses have such a shallow depth of field. However, you can extend that depth of field a bit more if you keep the sensor pretty much flat, so you're aiming directly at the flower at the same height, not aiming down at it. This extends that depth of field and lets you have more of the flower in focus, like you see here.

POST-PROCESSING: I added contrast in Lightroom's Develop module (or Camera Raw), then used Photoshop's Clone Stamp tool to remove little specks and anything else that looked yucky on the petals.

Adding Water Drops to Flowers

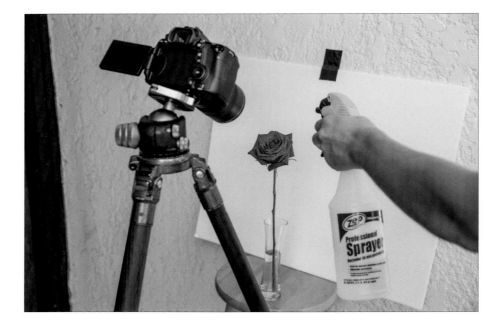

BEHIND THE SCENES: To get water on the petals, we're simply using a spray bottle with water. There are all sorts of mixtures you can concoct to make the water bead up and have bigger drops (like using glycerine, water and milk, sugar, etc.), but I just use regular ol' water. You don't want big sprays of water, just squeeze the trigger a little bit and, of course, the more drops you want, the more times you pull the trigger.

CAMERA SETTINGS: Once again, I'm using a 100mm macro lens with my f-stop at f/22, so I could keep as much depth of field as possible. My shutter speed is 1/15 of a second, which is why I'm on a tripod (but I'm always on a tripod when I shoot a macro lens because any tiny, little movement will create a really blurry image).

Final Image

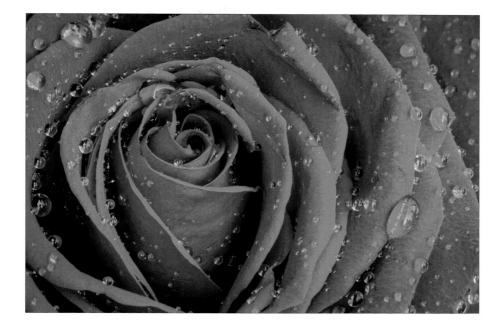

THOUGHT PROCESS: If you look at the production photo on the facing page, you can see that I'm shooting down on the flower, rather than shooting it straight on. This means that even at an f-stop like f/16 or higher (again, I'm at f/22), my depth of field (the area in focus) will be very shallow—shallower than if I had kept the camera's plane of focus straight, so it was aiming right at the flower (as seen in the previous flower recipe). Keeping it straight like that gives you a greater depth of field (more of the flower will be in focus), but I was able to get away with aiming down here because the part of the flower that I was shooting is pretty flat to begin with. If I needed more of the flower in focus, I could have bent the stem of the flower, so rather than facing upward, it would be facing straight forward. Then, I could've lowered my tripod until the camera was aiming straight at the flower, keeping the camera's sensor parallel to the flower, which creates a wider depth of field.

POST-PROCESSING: I increased the contrast a bit in Lightroom's Develop module (or Camera Raw; pretty standard for me). Then, in the Effects panel, under Post Crop Vignetting, I dragged the Amount slider to –9 to darken the edges of the image just a tiny bit all the way around.

Shooting the Moon

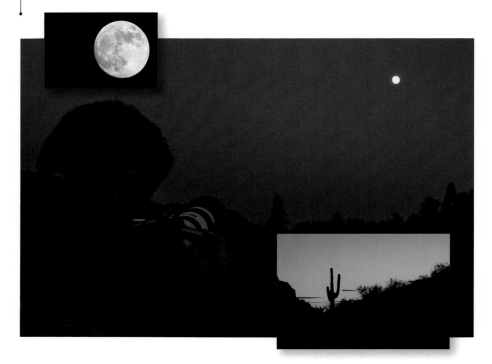

BEHIND THE SCENES: Since taking a shot of the moon is going to require shooting in really low light, we're on a tripod and we're using a cable release to minimize any camera movement while the shutter is open.

CAMERA SETTINGS: For the shot of the moon, I'm using my 70–200mm f/2.8 lens, zoomed all the way in to 200mm. Switch your camera to shoot in manual mode and dial in f/11 as your f-stop and 1/250 of a second as your shutter speed (even though you could "technically" hand-hold the shot, at that fast a shutter speed you're going to get a sharper result on a tripod, so I would definitely go that route). By the way, you want to get the moon as large as possible in your frame, so the longer the lens you can use for this, the better. As I said, I used a 70–200mm for this shot of the moon on a full moon night (check http://stardate.org/nightsky/moon to find out when the next full moon will be), but if you have a tele-extender or a longer lens, use that to get a larger-size moon in your frame. You want it to fill as much of your frame as possible—you can always shrink it down later if you want, but you don't want to have to make it larger or you'll lose quality. Also, zoom in tight, so you just see the moon in your frame and nothing else—you want a clear moon on a black background, that's it.

Final Image

THOUGHT PROCESS: The whole "shoot in manual mode at f/11 at 1/250 of a second" is actually a recipe that seems to work about every time. I wish I had invented it, but it has been around for a while and that's simply because it works. However, because of the brightness of the moon, it's really hard to create one single image where you have a cityscape or landscape where both the moon and the landscape are properly exposed (normally, the moon will appear as a white glowing ball without any detail, so if you see a shot where the moon has detail, you know they pulled off some type of camera or Photoshop trick to make that happen). Back in the traditional film days, to get the moon properly exposed in a photo, you'd have to do a double-exposure—combining two different images into one frame (you'd literally take one shot, rewind the film one frame, and shoot another shot onto that same frame). Some of today's digital cameras have the ability to do double-exposures, so you'd take the landscape shot (for this land-scape, it was f/10 and 1/90 of a second shutter speed at 400 ISO), then you'd turn on the double-exposure feature and change your settings to f/11 at 1/250 of a second, and then shoot the moon on the same frame. Or, you can do what I did: shoot the landscape, then take a second shot of the moon using the settings I mentioned, and use Photoshop to quickly combine the two (believe it or not, this is easier).

POST-PROCESSING: I made the sky a little more yellow, and then I added the moon. Don't worry, I made a video tutorial for you showing you the process (it's simple). You can find it on the book's companion webpage (mentioned in the book's introduction).

Chapter Eight
Shooting Other Stuff Like a Pro

Photo Recipes for All That Other Stuff That We Shoot

What do you call things that you don't have an exact name for? Oh, that's easy. That's "stuff." For example, if you're out with a friend shooting, and your friend says, "Hey, take a shot of that stuff over there," you know exactly what they mean and you turn and nail the shot. Now, imagine that same scenario, but you can't use that amazing catchall term and, instead, you have to try to describe it. Your friend turns to you and says, "Hey, take a shot of that over there?" You say, "Where?" They say, "Over there! That area over to your right." You say, "I don't see it." Your friend says, "Oh my gosh, it's right over there." You have no idea what they're talking about so, of course, you miss the once-in-a-lifetime shot of a killer whale jumping fully and completely up out of the water, chasing a fully grown male seal who somehow manages to avoid the razor-sharp teeth of the graceful mammal, and you're just standing there as the whale watches hopelessly as his catch of the day escapes into the icy waters below your inflatable Zodiac chase boat. If your friend had just said, "Take a shot of that stuff," you'd be walking up to the podium right about now to accept your World Press Photo award (Best of Show) for the image you titled, "The One That Got Away," and just as the flashes of the press on hand are firing, and you're lifting the heavy crystal award over your head and waving to your breathtakingly handsome husband and two perfect kids (one boy, one girl), and you're daydreaming about the new full-frame body you're going to buy with your $10,000 Best of Show check, your cell phone rings. It's *National Geographic*, and you're about to explode with excitement until you hear that it's actually one of their lawyers, and they want to talk to you about some screen captures you have on your tablet. See, that's the kind of "stuff" I'm talking 'bout!

Product Photography

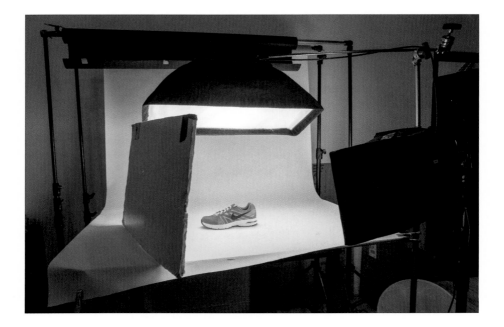

BEHIND THE SCENES: Don't let the setup here fool you, this is just a simple two-light setup and both lights are using the exact same, inexpensive softbox—a 1x3' Westcott strip bank (they run around $150 each at B&H Photo). The lights themselves are my go-to lights for product photography—Spiderlite TD6s, also made by Westcott (they're continuous lights, not flashes; more on these on the facing page). My goal was simply to light the sneaker as evenly as possible, and I used a modified product lighting setup I learned from commercial photographer Jim DiVitale. Having one softbox behind the product and aiming forward covers the top of the shoe and some of that light wraps around to the front, as well (the softbox is a much larger light source compared to the size of the sneaker, so the light spills around it), but just that light alone leaves the side facing the camera a little shadowy. Technically, I could fix that in Lightroom (or Camera Raw) by using the Adjustment Brush and just painting over that area to brighten the exposure, but I wanted to get it right in-camera.

CAMERA SETTINGS: The only downside of these lights, compared to strobes, is that they don't put out as much light, so you'll usually have to shoot on a tripod. I'm shooting with my 70–200mm f/2.8 at 110mm. My f-stop was f/8 (to keep lots of sharpness throughout) and my shutter speed was 1/15 of a second (hence, the whole shooting on a tripod thing—that's too slow to hand-hold). My ISO was just 100, so I could have cranked it up to around 400 probably to get enough shutter speed to hand-hold if I didn't want to be on a tripod.

Final Image

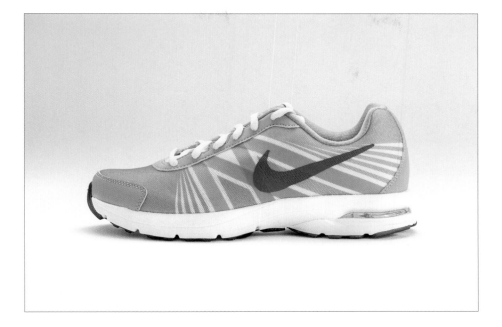

THOUGHT PROCESS: I mentioned that these lights aren't flashes, they're continuous lights, so they're always on. They are very bright, they're daylight balanced, and they use specially designed fluorescent bulbs, so they don't really emit any heat. The advantage of these "always on" lights is "what you see is what you get." Positioning the lights is so much easier—as you move a light, you see the result right as you're moving it. It's really perfect for product photography like this (no flash triggers, no modeling lights, no guessing game)—it couldn't be easier. Plus, they're cheaper than most decent flashes or strobes (or even Nikon or Canon hot-shoe flashes, which are around $550 each, whereas the West-cott TD6s are in the $450 range).

POST-PROCESSING: I brightened the overall exposure a bit in Lightroom's Develop module (or Camera Raw), and I increased the contrast a bit, as well. And, of course, I sharpened the image quite a bit using Photoshop's Unsharp Mask filter, using these settings: Amount 90, Radius 1.5, Threshold 0.

Car Detail Shots

BEHIND THE SCENES: Here, it's another strip bank (I love these things). This particular one is made by Elinchrom, and my assistant, Brad Moore, is aiming it to the right of the front wheel of a Mercedes-AMG on display. He is holding the softbox at a 90° angle to where I'm shooting from, which is lying down on the ground to the left side of the wheel (as seen in the inset. Luckily, it was a really clean floor—when you're shooting cars, it's usually not). We're using a portable Elinchrom flash unit (called a Ranger Quadra, which is a small flash with a battery pack, so you can take it on location).

CAMERA SETTINGS: For close-up car detail shots like the final you see on the facing page, I'm usually using a 24–70mm f/2.8 lens, and my f-stop is f/22 pretty much every single time (we'll look at my f/22 on the facing page). My ISO is 200 and my shutter speed is 1/100 of a second.

Final Image

THOUGHT PROCESS: I learned this technique from UK-based automotive photographer Tim Wallace, and the first time I tried it, I just couldn't believe how well it works. It's based on the fact that if you shoot at f/22 with a strobe like this, the light will fall off to black as soon as the light from the flash runs out. So, even though I took this shot in a very brightly lit airplane hangar, the light immediately falls off to black. It's really pretty amazing. So, what you're seeing in the shot, for the most part, is the reflection of the tall, thin softbox in the metal rim. Its tall, thin shape (although you'll wind up turning it wide when you're shooting different parts of the car) is really perfect for creating beautiful highlights and reflections in the paint, windows, hood, fenders—you name it. So, it's actually an amazingly simple setup: one flash with a 1x3' softbox (or if you can spring for it, get the next larger size, which is around 2x5', which will come in handy for lighting a larger area), and then you set your f-stop at f/22. You'll be amazed. The rest of the time you'll spend just trying different angles (my basic setup is to treat the light like I'm playing billiards: aim in from one side, set up the light at a 90° angle on the other side, and the light bounces off like a billiard ball does when it hits the rail—right back at you).

POST-PROCESSING: In Lightroom's Develop module (or Camera Raw), I increased the Shadows amount a tiny bit, added lots of clarity to enhance the detail and make it a little shinier, and then removed all the little specks, dust spots, and junk with Photoshop's Clone Stamp tool. Pretty easy stuff.

Panning to Show Movement

PETE COLLINS

BEHIND THE SCENES: In this shot, we're trackside at an Indy race shooting a 200–400mm f/4 lens (sometimes supported by a monopod). I usually have ear protection on because those cars are louder than a screaming toddler on a red-eye (I had them off here), and I have a Hoodman Loupe around my neck, which I use to view my LCD screen on the back of my camera when I'm out in the direct sun. I'm also shooting from a kinda low perspective (with my elbows leaning on the edge of the box) to make the cars look bigger and more aggressive.

CAMERA SETTINGS: Again, I'm using a 200–400mm lens, but I'm only zoomed to 280mm. My ISO is 100 (it was a bright, sunny day), and my shutter speed is a slow 1/50 of a second. At that slow of a shutter speed, my shot would be way, way overexposed unless I used an f-stop that let in just a little bit of light, and the one that made my exposure look closest was f/22. Not my usual f-stop for action sports, but I'm not trying to freeze the action, I'm trying to show motion (more on that on the next page).

Final Image

THOUGHT PROCESS: With sports action photos, I'm usually trying to get my shutter speed to at least 1/1000 of a second because that will freeze the motion of the car (or the athlete). However, when you're shooting from the side of the track like this, you can clearly see the wheels and, from a viewer's perspective, the wheels shouldn't be frozen (like the car is parked on the track), they should be spinning, like you see here. To get that wheel spin, and the overall sense of motion created by the blurred background behind the car, you have to choose a really slow shutter speed and pan along with the car (I try to get my center focus point right on the driver's helmet because if that part isn't in focus, the shot's going in the trash). What creates that blurred background is your body motion. Basically, you're trying to smoothly swivel your hips and move right along with the car as it zooms by, firing in high-speed continuous mode the whole time. You'll definitely wind up with a lot of frames that are way too blurry to use, but within that set of maybe 10 to 15 frames, there will usually be one that is really sharp, and we're just looking for that "one" right? Right! So, don't let it bum you out if there are a bunch of blurry ones—just try to get one out of every burst. It'll take a little practice, but within a few minutes, you'll start to have bursts where you have one or two, and that is a big win!

POST-PROCESSING: In Lightroom's Develop module (or Camera Raw), I increased the contrast by dragging the slider to the right, and, of course, I sharpened the image (as always) using Photoshop's Unsharp Mask Filter.

Shooting Action

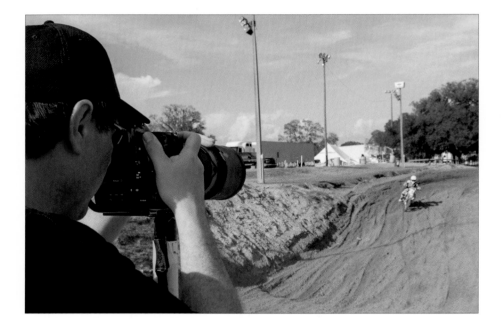

BEHIND THE SCENES: We're on a motocross track, here (I know, duh), and I'm shooting practice runs (this isn't an actual race or I wouldn't be standing this close to the track). I'm using a long lens with a monopod, and it's a pretty bright, sunny day.

CAMERA SETTINGS: I'm using a 300mm lens on a full-frame body, and my f-stop is f/2.8, so the background is nice and blurry. My ISO is set at 200 (the lowest, cleanest ISO available on the particular camera body I was using), and my shutter speed is 1/1600 of a second.

Final Image

THOUGHT PROCESS: There are three things we need to do to get a shot like this: (1) We've got to freeze the motion so the shot is absolutely crisp and clean, and to do that we need at least 1/1000 of a second shutter speed (again, I was at 1/1600 for this shot). Luckily, on a bright, sunny day that's usually no problem at all, especially when we're using an f-stop like f/2.8, which helps us (2) put the background behind the rider out of focus, which separates him from the background (this is what we want). But, let's get back to that freezing-the-motion thing. There is something to watch out for here, and that is your angle when you're freezing motion with a car, bike, or motorcycle. If you shoot any of these from the side of the track where you can see their wheels, this faster shutter speed will literally freeze their wheels like they're parked. You can get away with this if you're shooting them pretty much straight on, like we are here, but if you can see the sides of the wheels, they should be spinning, which means you have to use a dramatically slower shutter speed and use a panning technique, so you see the motion of the wheels (see the previous recipe with the Indy car). (3) The third thing (and this is a biggie) is framing the shot so you don't see distracting stuff in the background, and that was a real challenge here with light poles and trailers and junk in the background. Just keeping the background in mind while shooting makes a difference.

POST-PROCESSING: In Lightroom's Develop module (or Camera Raw), I added contrast and clarity (the clarity really makes that flying dirt stand out) and, of course, I sharpened it in Photoshop with the Unsharp Mask filter using these settings: Amount 120, Radius 1.0, Threshold 0.

It's All About Composition

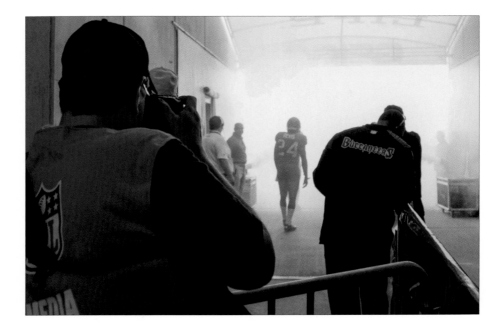

BEHIND THE SCENES: This is behind the scenes at a football game, before the players take the field. The players come out through CO_2 smoke cannons (although this is a pro game, they do the same thing at the local high school here, where the players come through an inflatable tunnel, but they use fire extinguishers instead of CO_2 cannons).

CAMERA SETTINGS: This is shot with a 70–200mm f/2.8 lens zoomed all the way in at 200mm. My f-stop is at f/2.8, and I'm at an ISO of 1000. That put my shutter speed way higher than I actually needed. I only needed 1/1000 of a second, but I got 1/6400 of a second, so I could have lowered it a lot.

Final Image

THOUGHT PROCESS: Framing is what this type of shot is all about. You can see from the behind-the-scenes shot on the facing page that there are people standing all around in a busy environment, but our job as a photographer is to frame up just the piece of it that we want our viewers to see. We don't want them to see the two guys standing on the left, or the guy in front of me to the right, or the railing just a foot to the right edge of the frame. We have that choice when we frame up the shot. Also, he's going to run out right down the middle of the entryway, but we usually don't want our subject right in the center (dead center is dead awful). Just remember, we're in charge of the framing, and to create a more dynamic image, we can compose the shot so he's off to one side or the other in our frame, even though he's standing in the center. So, basically, this shot is about composition and luck, in that he happened to look down before he ran out. Maybe he was meditating or maybe he was looking to see if his shoe was untied before he took the field, but either way, it was luck that he did it while I was framed up to shoot it.

POST-PROCESSING: In Lightroom's Develop module (or Camera Raw), I added some contrast, and of course sharpened the image, but what makes this shot is applying a tonal contrast effect using a plug-in (both OnOne Software's Perfect Photo Suite plug-in and the Google Nik Collection's Color Efex Pro plug-in have really great Tonal Contrast filters—more on these in Chapter 9). However, I did apply the effect to a duplicate of the Background layer in Photoshop, and then I lowered the Opacity of that layer, so you only see a little of the effect and not the full amount.

On-Location Product Shoot

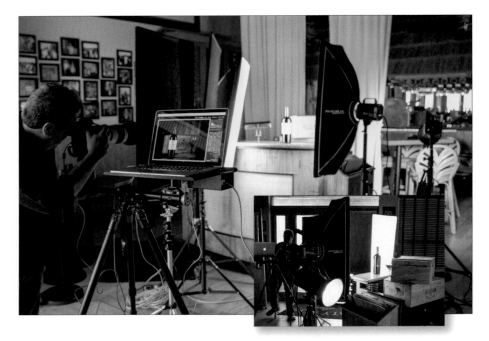

BEHIND THE SCENES: I asked a local restaurant if they would mind if we came in before they opened so we could do a shoot for a wine based in California. They didn't know who I was, but I guess because we asked nicely they said, "Sure, come on in." The reason I wanted to shoot in this particular restaurant was that it had wine crates placed all over the restaurant as decoration, and I wanted to use them as background props. Here, we're using the hostess stand just inside the front doors of the restaurant as our shooting table. I shot it because it had a reflective marble countertop. I'm using three lights in total: There are two flashes lighting the bottle—one on each side and a little bit in front, aiming at each other—that have 1x3' tall strip bank softboxes. The third light is literally aimed at the background with no softbox attached (seen in the inset). I wasn't planning to use a third light, but it was so dark behind the wine crates that it just went to black and started looking like a studio shoot with a black background, so we aimed a light at the background with a very low power setting just to get some light back there. Lastly, those big black squares (next to the light on the left) are there to block the natural light coming in through the restaurant's front doors and keep it from hitting the bottle.

CAMERA SETTINGS: I was using my go-to lens, the 70–200mm f/2.8, zoomed in to 135mm. My f-stop was f/2.8 (so the background would be soft), my shutter speed was 1/125 of a second (pretty standard for flash shots), and my ISO was 200.

Final Image

THOUGHT PROCESS: Choosing the lighting for this job was pretty easy because when you're shooting wine bottles, the go-to softboxes to use are those tall, thin strip banks because they create those long, thin, white highlights you see on both sides of the bottle. I chose to use two strip banks (one on either side, which is why you see two long vertical highlights on the bottle), but it's also very popular to use only one strip bank and just have one tall highlight on the bottle. It's strictly a personal choice, but since I didn't know which one the client would want, I shot all the setups I did that day using both, and then just one, so they'd have a choice. As for positioning the lights, the farther forward your lights are from the front of the bottle, the closer to the center of the bottle those highlights will appear. If you want them more off to the edges of the bottle, move the lights back to where they're almost behind the bottle a little bit.

POST-PROCESSING: When I looked at the final shot, the name of the wine on the label was just a little dark, so in Lightroom's Develop module (or Camera Raw), I used the Radial Filter to put a circle of light right over the name (just click-and-drag out an oval, position it over the name, then click on the Inside radio button, so the slider you move affects just what's inside that oval. Then, drag the Exposure slider a little bit to the right. You can also increase the Feather amount to make the transition from light to dark very subtle). Lastly, I added a slight darkening to the edges all the way around by going to the Effects panel, under Post Crop Vignetting, and dragging the Amount slider to –9.

Lighting Pets

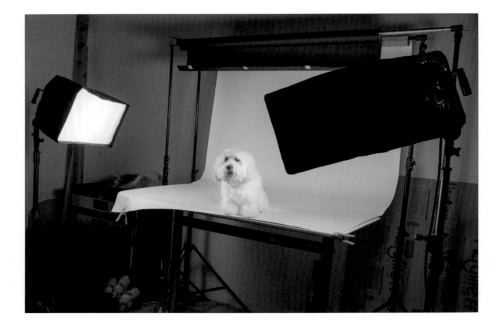

BEHIND THE SCENES: Behold the wonder and majesty that is Maggie the Wonder Dog, our beloved family dog (she's a Coton de Tulear and just a really sweet doggie. In fact, she's sitting here beside me on the couch as I write this, hoping that somehow I will suddenly get up and bring her a treat. She's probably due for one for being our model). I'm using continuous lights here: Westcott Spiderlite TD6s with 1x3' strip banks, one on either side and a bit in front. The advantage of using these continuous lights is, since they're always on, they don't flash, and since they don't flash, they don't freak out dogs or cats, which is a big plus. We're using a 5'-wide roll of white seamless paper for our backdrop.

CAMERA SETTINGS: Since continuous lights aren't as bright as flashes, I'm shooting on a tripod at f/8. I'm at 1/160 of a second and 1600 ISO (I wanted a little faster shutter speed in case she moved a bit). I'm using a 70–200mm f/2.8 lens zoomed in to 140mm.

Final Image

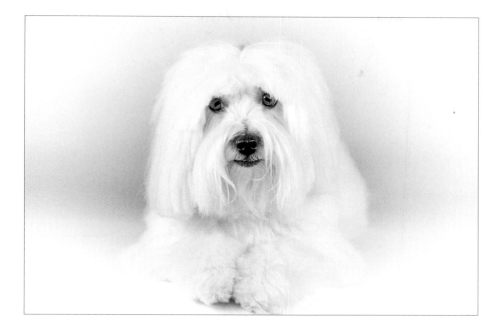

THOUGHT PROCESS: If you look at the behind-the-scenes shot on the facing page, you can see we have Maggie TWD up on a table. For photographing small pets, this table idea can be really handy because it makes it easy to adjust the lights and to primp and fluff the pet. The pet can't wander off to go exploring like they would when they're on the floor, and it's more comfortable for you because you can shoot without having to lie down (for the right perspective, you have to shoot from their height). You do have to be super careful that the pet doesn't freak out and jump or fall off the table, so this won't work for every pet (well, probably every cat, right?). Once you decide whether you want to shoot on the floor or on a table for small pets (like Maggie Doggie), then you'll need to find ways to get their attention, and one way is to use a dog whistle. When they hear the whistle, they perk up, look in your direction, and maybe even tilt their head to the side. If you don't have a dog whistle, don't worry, there's an app for that. The one I use is Dog Whistler Pro (for IOS). It's 99¢ in the App Store, but there are number of different ones to choose from.

POST-PROCESSING: Since I only used two lights, I didn't have one lighting the background to make it solid white, so the background was fairly gray. It looked "okay," but I wanted a white background. So, in Photoshop (or Elements) I created a new blank layer, filled the layer with white, and then used the Eraser tool, with a huge, soft-edged brush, to cut a hole right in the center of that white layer to reveal Maggie on the layer below.

Shooting Cityscapes at Dusk

BEHIND THE SCENES: We're set up on a floating dock across the river from downtown Portland, Oregon, on a good sturdy tripod, and I have a cable release to minimize any camera movement that would happen when I press the shutter button. Since we're shooting at dusk (and after dusk—more on that in a moment), we need to be on a tripod because our exposure will be fairly long (well, certainly longer than we could hand-hold).

CAMERA SETTINGS: I'm using a 16–35mm f/2.8 super-wide-angle zoom lens, zoomed all the way out at 16mm. I chose an f-stop that would put everything pretty much in focus (f/8), and my shutter speed was 1/10 of a second (much slower than I could hand-hold). To even get to 1/10 of a second, I had to raise my ISO to 1600, so there wasn't much light out there at all.

Final Image

THOUGHT PROCESS: What you're seeing above is part camera technique, part patience, and part Photoshop. It's actually two photographs: The first is taken right after the sun goes down, so you get that nice sunset sky (well, there were hardly any clouds in the sky here, so it's not an incredibly dramatic sky like I was hoping for). The problem is that right after sunset, it's still not really dark outside (especially in Portland, where it stays light for quite a while), and so the lights of the city aren't on yet. So, you're going to need to take a second photo about 20 to 30 minutes later—way after sunset. It's pretty dark in the sky now, but by that time, the lights in the city are mostly on and that's what you need for the second image—the city lights (it doesn't matter what the sky looks like for this second shot. This second shot is literally only to capture the city lights). You can't move your tripod or the camera at all—not even a inch—between the "just after sunset" shot and when you take the "city lights" shot. Once you have both, then you're going to take the "just after sunset" photo and add the city lights from the second photo to it in Photoshop (this is a very common technique, and the only way you get that beautiful sky [which we don't really have here] mixed with beautiful city lights before they would actually be turned on).

POST-PROCESSING: You're going to open both images in Photoshop, copy-and-paste the "city lights" shot onto the "just after sunset" shot, add a black layer mask, and paint in white over the buildings and bridge, and the city lights appear. If that sounds confusing, just watch the video tutorial I created on how to do that (then it'll make sense. You can find it on the book's companion webpage, mentioned in the book's introduction).

Shooting a Starry Sky

BEHIND THE SCENES: We're taking a photo at nightfall, so it's a very low-light situation. That's why we're on a tripod and using a cable release, so there's absolutely no movement whatsoever from pressing the shutter button.

CAMERA SETTINGS: For a wide shot of the sky, you're going to need a really-wide-angle lens, like the 16–35mm here, zoomed all the way out (at 16mm, here). Turn your autofocus off on the lens, and manually focus your lens to infinity. You do this one of three ways: (1) If you have a lens that has a Distance Scale window on the top of your lens barrel, rotate the focus ring on your lens until you see the infinity symbol (it looks like the number 8 lying on its side). If your lens doesn't have a Distance Scale window on top, then (2) leave your autofocus on, aim at the moon (or the largest star you can find), or any light (even on the ground) far, far off in the distance, and once it's focused, switch your lens to manual focus. Or (3) use your camera's Live View feature. Press the magnifying glass button to zoom in really tight on your LCD window on the back of your camera, then switch off autofocus and manually focus on the stars. Once focused, then zoom the screen back out to normal. Now, you're focused to infinity. The f-stop here was f/4, with a shutter speed of 15 to 20 seconds max (there's not a whole lot of light up there, so that shutter has to stay open a long time, but if it stays open longer than 20 seconds, you'll start to get star trails from the movement). The ISO was at 3200, which is pretty high, but you can help lessen the high-ISO noise by turning on Long Exposure Noise Reduction. Just know that after your 15- or 20-second exposure, your screen will go black as it takes another 15 seconds for the noise reduction to do its thing.

Final Image

MATT KLOSKOWSKI

THOUGHT PROCESS: As you read on the facing page, the process of taking the picture is actually pretty easy—just some simple steps and settings. The challenging part of shooting stars and/or the Milky Way is finding the right location to take your shot—it has to be a sky with absolutely no light pollution whatsoever (light pollution is any light coming from a city, even one way off in the distance, or light from a neighborhood, or construction site, or any man-made light of any kind). You'll also need a really dark, nearly moonless night— try to shoot near the new moon part of the cycle (other times, the light from the moon is so bright it tends to wash out the stars or Milky Way). In most cases, you'll have to get quite far away from any city or town (literally, an hour or more—if you're in the middle of nowhere, you're probably in the right spot). Also, the Milky Way is only visible from around February to September (though July and August are thought to be the best overall times). Once you've found the right time and location, the rest is easy, but without the right location, you're not going to get the results you're looking for. When shooting stars, like in real estate, it's "location, location, location!"

POST-PROCESSING: Start by increasing the Contrast amount quite a bit, and then you can further increase the brightness of the stars in Lightroom's Develop module (or Camera Raw) by dragging the Highlights slider to the right. Of course, finish things off by applying Photoshop's Unsharp Mask filter.

Chapter Nine

Using Post Like a Pro

Step-by-Step Recipes to Get "The Look"
Using Lightroom and/or Photoshop

Have you ever looked at someone else's photo, maybe a famous photographer, and thought to yourself, "My camera lets me choose the f-stop, shutter speed, and ISO. Which of those three created that desaturated skin tone, those tonal contrast effects, and that three-dimensional look to this image?" If so, then this chapter is for you, because what you'll learn in this chapter is that you can't get those looks "in-camera" since all you really have are f-stops, shutter speed, and ISO. So, the secret to getting those "looks" has to be something else, and quite frankly, it is. It's a special set of controls, buried deep within the menus of most of today's Canon, Nikon, and Sony DSLRs, that are only revealed to a certain number of photographers who, quite frankly, pay a yearly royalty to unlock these secret features and, once they do, they actually have control over four distinct in-camera controls that aren't available to the general public. Here, today, and for the first time ever (well, that I've seen anyway), I'm going to disclose what these extra "paid for" features are as my way of leveling the playing field for all those folks who knew the pros had some advantage, some edge that the average person didn't have, and who had no way of accessing this extra power. These extra four controls are: (1) Spatial, (2) Orthogonal, (3) Retraction, and (4) Expansion, although most pros just use the acronym SORE, as in "you'll be *sore* once you realize I just made this whole thing up." Oh, come on, this late in the book and you don't know by now that these chapter intros are generated by a potent combination of over-the-counter hallucinogenics and a near-lethal dose of complex carbohydrates and sugar normally found only in Kellogg's Honey Smacks breakfast cereal or Mobil 1 Synthetic Motor Oil (whichever comes first)?

Desatured Bleach Bypass Look

TOOLS: This can be done in either Camera Raw (part of Photoshop and Photoshop Elements) or Lightroom's Develop module (it's the same sliders, in the same order, that do the exact same things).

TECHNIQUE: You only need to move three sliders to get this look:

(1) We desaturate the entire image by dragging the Vibrance slider to the left. I don't have an amount I drag it to every time, it just depends on the image. So, just look at the screen while you drag and, when it looks good to you, stop dragging.

(2) Increase the amount of Clarity. Technically, this adds midtone contrast, but what you'll see is that it brings out texture and detail and makes things shinier (like the highlights on her skin, here). You do have to be careful, though, about adding clarity to women's skin because it can make them look bruised and rough. If that happens, just use the Adjustment Brush instead: set all the other sliders to zero and raise the Clarity amount, then just paint over everything but her skin. Problem solved.

(3) Drag the Contrast slider to the right to add more contrast and give it more of that bleach bypass look (it helps darken the sky up a little bit, too!).

Final Image

THE LOOK: This kind of replicates the bleach bypass look that was created in traditional photographic darkrooms and, although the darkroom is gone, this look still lives on and looks great on images where you see a lot of sky, like this one.

OTHER OPTIONS: If you like using plugs-in (I sure do), then here are two that have excellent built-in, one-click, bleach bypass effects, and that work with Photoshop, Lightroom, Elements, or Apple Aperture:

(1) OnOne Software's Perfect Photo Suite (www.ononesoftware.com) comes with a plug-in called Perfect Effects, and it has a Bleach Bypass filter that works really nicely.

(2) The Google Nik Collection's Color Efex Pro plug-in (www.google.com/nikcollection/) has a Bleach Bypass filter that also nails this look in just one click.

High-Contrast Skin Look

TOOLS: This can be done in either Camera Raw (part of Photoshop and Photoshop Elements) or Lightroom's Develop module.

TECHNIQUE: Just a few sliders:

(1) Drag the Clarity slider to the right until the skin looks really textured (here, I dragged it all the way over to +85, but of course how far you drag depends on your subject's skin and how it looks as you drag, so don't get locked into using my number.

(2) Since the Clarity slider increases midtone contrast, it tends to make parts of the image darker and some brighter. I've found that with skin it generally makes it darker, so I usually drag the Shadows slider to the right until the brightness of the face looks normal again (in this case, I dragged to +50).

(3) I also went to the Effects panel and, under Post Crop Vignetting, dragged the Amount slider to the left to darken the edges of the image and put the focus on his face.

Final Image

THE LOOK: What this does is really accentuates the texture in the skin (or texture in anything, for that matter), and that's why you usually see a lot of clarity added mostly to men's skin, because seeing the detail of every little pore and crevice looks great on guys. While there are some cases where you can get away with adding clarity to a woman's skin, it usually isn't very flattering because we generally try to keep women's skin soft, not crisp and detailed. While we used it here on skin, the next time you really want to bring out detail and texture in anything, just crank up the Clarity setting.

OTHER OPTIONS: Here are two plug-ins (for Photoshop, Lightroom, Elements, or Apple Aperture) that both have great clarity-like effects:

(1) OnOne Software's Perfect Photo Suite comes with a plug-in called Perfect Effects that has a Tonal Contrast preset under the Tone Enhancer filter.

(2) The Google Nik Collection's Color Efex Pro plug-in has a Tonal Contrast filter that also looks great, and in its settings, there are presets that vary the degrees of the effect. (The default setting has less of an effect than you see here. The Strong preset is more like what you see above.)

Tone-Mapped HDR Look

TOOLS: This is done here using Photoshop's built-in HDR Pro for Photoshop CS6 or higher. (*Note:* To create an HDR image, you need to start by turning on bracketing in your camera and then take a bracketed set of shots. You need at least three images: one with a normal exposure, one that's 2-stops underexposed, and one that's 2-stops overexposed. You can see the three images in the filmstrip at the bottom of the window here.)

TECHNIQUE: It's a simple technique with two parts:

(1) Select your bracketed images in Lightroom (or Bridge), then go under the Photo menu, under Edit In, and choose Merge to HDR Pro (in Bridge, it's under Tools, under Photoshop). This opens the Merge to HDR Pro window you see above.

(2) Choose the Scott 5 preset at the top right (that's a preset I created that Adobe asked if they could include and, of course, I was delighted). Now, turn on the Edge Smoothness checkbox to soften the effect, and then click OK to merge these three images into one single image.

(3) Duplicate the Background layer, and then apply the Gaussian Blur filter at 50 pixels. Lower the Opacity of this layer (in the top-right corner of the Layers panel) to 50% and change the layer's blend mode (at the top left of the panel) from Normal to Soft Light to add a slight glow to the image. Lastly, add a Levels adjustment and click the Auto button.

Final Image

THE LOOK: This adds an illustrated or surreal look to your images by adding hyper-detail to the entire image (sometimes referred to as the "Harry Potter look").

OTHER OPTIONS: While this technique was done with Photoshop's built-in HDR feature, if you don't have Photoshop, there are two other popular options:

(1) The #1 most-popular software for creating HDR tone-mapped images is Photo-matix Pro from HDRsoft. It's pretty much the software that people who are really serious about HDR use, and it will do everything from realistic to surrealistic (like we see here), but you can push the surreal look farther there than you can with HDR Pro, and that's one reason why it's so popular—you can turn the amp up to 11 (so to speak). You do not have to have Photoshop or Lightroom to use Photo-matix; it can be used as a standalone product.

(2) The Google Nik Collection of plug-ins (for Photoshop, Lightroom, Elements, and Apple Aperture) has a popular HDR plug-in called HDR Efex Pro. (*Note:* This par-ticular plug-in does not work with Photoshop Elements, you have to have the full version of Photoshop.)

Spotlight Effect

TOOLS: This can be done in either Camera Raw (part of Photoshop and Photoshop Elements) or Lightroom's Develop module.

TECHNIQUE: You're going to use the built-in Radial Filter tool for this:

(1) Click on the Radial Filter tool up in the toolbar at the top left of the Camera Raw window (as seen here; or at the top of the right side Panels area in Lightroom's Develop module). Click where you want the center of your spotlight and drag outward. As you drag, an oval will appear showing you the size of your spotlight—keep dragging until it's the size you want it (you can see how far I dragged it above). Now, scroll to the bottom of the panel on the right side and click the Outside radio button, so that changes we make only affect the area outside the oval. Whatever's inside our oval (the nun, in this example) remains untouched.

(2) To darken the area around the nun (so you don't see the other people in the pews around her—I turned off the preview, so you could see them here), click on the – (minus sign) button to the left of the Exposure slider to reset all the other sliders to zero and lower the Exposure to –50. Drag that Exposure slider farther to the left and, as you do, the area around the nun starts to go to black. Her highlights are pretty bright, too, so you may want to click on New, switch to Inside, and lower the Highlights, as well (I did, anyway). Lastly, when you're done, you may want to switch to the Adjustment Brush, lower the Exposure slider there, and paint over the end of the pew (to her right), so it's not so bright.

Final Image

THE LOOK: This effect is great for creating drama and for hiding distracting things in the background. In this case, you could see other people sitting in the pews behind her to the right and it drew your eye away from her and took away from the drama. By using the Radial Filter to greatly darken everything around her, you're able to hide those other people and make a much more dramatic image.

OTHER OPTIONS: You could do this directly in Photoshop (or Elements) if you didn't want to use Camera Raw by duplicating the Background layer, and then changing the layer's blend mode to Multiply, which makes the entire image much darker. Next, click on the Add Layer Mask icon at the bottom of the Layers panel (it's the third icon from the left), which puts a layer mask over the darker layer. Set your Foreground color to black, get the Brush tool (B), choose a really large-sized, soft-edged brush from the Brush Picker up in the Options Bar, and then click once over the nun to reveal the original version of her from the Background layer below this darker layer.

Grungy, Aged Look

©ISTOCK/DAVID M. SCHRADER

TOOLS: This can be done in either Photoshop or Photoshop Elements.

TECHNIQUE: You're going to combine two images into one:

(1) To create this grungy, aged look, you're going to need a paper texture. If you have some really old paper, you could scan it, but I just went to iStock.com, found this royalty-free image for $2, and used it as my paper texture.

(2) Now, in Photoshop (or Elements), use the Move tool (V) to drag-and-drop this old paper image on top of your main image, and then press Command-T (PC: Ctrl-T) to bring up Free Transform. Click-and-drag the corner points outward until your paper texture completely covers your image, then press Return (PC: Enter).

(3) Press Command-U (PC: Ctrl-U) to bring up the Hue/Saturation dialog. Drag the Saturation slider to the left a bit to desaturate the paper image a little, so it's not quite as colorful and looks a bit washed out. Lastly, in the Layers panel, change the layer's blend mode (in the pop-up menu at the top left) from Normal to Multiply, and this blends the paper image in with your main image. Now, lower the Opacity of this layer to around 80%.

Final Image

THE LOOK: We add a texture over the photo, and then desaturate the texture image (old photos didn't generally look as colorful and vibrant as the images we see today, plus they've faded over time). This makes the image look grungy and aged and helps sell the look.

OTHER OPTIONS: Here are a couple ways you can change or vary the look:

(1) Use a different paper texture. If you want a bunch of free paper textures—they are already out there—just do an Internet search for "paper textures," and you'll find links to hundreds of free, ready-to-go papers. A lot of them would work perfectly for this type of effect. Or, try this site, which offers 149 free paper textures: www .demilked.com/free-paper-textures-backgrounds/.

(2) Try different blend modes. Although we used the Multiply blend mode to get this look, each blend mode gives a different look and, depending on the image, you might find a blend mode that works better for your image than Multiply. Here's a tip to quickly toggle through all the layer blend modes, so you can easily see each one (then you can just choose the one that looks best for your image): it's the keyboard shortcut of Shift-+ (plus sign). Once you've clicked on the pop-up menu, press it each time you want to toggle through a different blend mode.

Black & White

TOOLS: This can be done in either Camera Raw (part of Photoshop and Photoshop Elements) or Lightroom's Develop module.

TECHNIQUE: We're going to add a ton of contrast:

(1) In Camera Raw, click on the fourth icon from the left (at the top of the right side panels) to make the HSL/Grayscale panel visible, and then turn on the Convert to Grayscale checkbox to make this a black-and-white image. In Lightroom's Develop module, just click on Black & White at the top right of the Basic panel.

(2) Let's start by setting our white point and black point back in the Basic panel, so we get the widest possible range of contrast (if you have Photoshop CC, it can do this for you automatically—just Shift-double-click directly on the Whites slider, then on the Blacks slider, and it will automatically set both for you). Drag the Whites as far to the right as you can go without having a white triangle appear in the upper-right corner of the histogram, then back it off a bit. Then, drag the Blacks to the left until you see a solid white triangle in the top-left corner of the histogram, then back it off a tiny bit.

(3) Drag the Contrast slider to the right to add more contrast (I dragged it to +54 here) and drag the Clarity slider to the right to increase the midtone contrast (I went to +33). I also dragged the Highlights slider to the left until the sky didn't look solid white.

Final Image

THE LOOK: I've always felt that what makes for a really dynamic-looking black-and-white photo is one that has just a ton of contrast, so that's what I'm going for when I convert an image to black and white. Without that "snap" of contrast, your black-and-white images can really look flat, almost dull. So, make sure you're not shy when you drag the Contrast and Clarity sliders. Also, although I didn't mention it in the technique part on the facing page, every single image I edit gets sharpened. I'm not exaggerating—every single image. For this one, I used Photoshop's Unsharp Mask filter (found under the Filter menu, under Sharpen) with these settings: Amount 120%, Radius 1.0, Threshold 3.

OTHER OPTIONS: While I did this entire black-and-white conversion right in Camera Raw, almost every photographer I know that's seriously into black and white uses a plug-in to do the conversion, and frankly, they all use the same plug-in (as do I—have been for years). It is the go-to tool for black and white like Photomatix is for HDR. Everybody uses it (and it's worth the price of the entire suite to get it. Yes, it's that good). It's the Google Nik Collection's Silver Efex Pro plug-in (for Photoshop, Lightroom, Elements, or Apple Aperture). When you open it, it shows you a default black-and-white conversion and then a long list of thumbnails, each with a different conversion for you to choose from, emulating different darkroom processes and methods. Just click on the one you want and you're done (although you can tweak any preset you'd like).

Realistic HDR Look

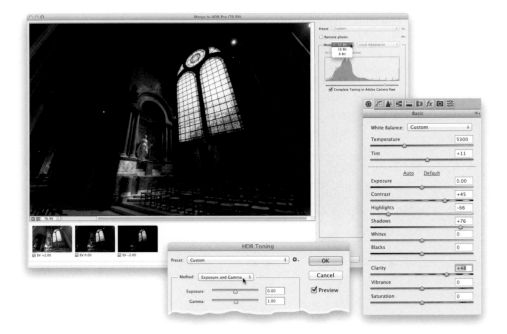

TOOLS: This uses Adobe Photoshop CC and its HDR Pro and Camera Raw. (*Note:* To create an HDR image, you need to start by turning on bracketing in your camera and then take a bracketed set of at least three shots with 2 stops between them.)

TECHNIQUE: You're going to create a 32-bit (super-high-quality) HDR image:

(1) Select your bracketed images in Lightroom (or Bridge), then go under the Photo menu, under Edit In, and choose Merge to HDR Pro (in Bridge, it's under Tools, under Photoshop). This opens the Merge to HDR Pro window. To create a 32-bit HDR file, choose 32-bit from the Mode pop-up menu near the top right. When you do that, you'll see the options change to what you see above. There are no other settings changes you can make here, so click the Tone in ACR button at the bottom right (ACR stands for Adobe Camera Raw, and that's where we'll edit this 32-bit image).

(2) When the image opens in Camera Raw, enter the settings you see in the inset on the right above (basically, you're going to add contrast, reduce the highlights, open up the shadows, and add clarity).

(3) When you're done, click OK. Your image will open in Photoshop as a 32-bit image, but we'll now need to convert it to a standard 8-bit image. So, go under the Image menu, under Mode, and chose 8 Bits/Channel. When it asks, click to Merge the layers, and then the HDR Toning dialog will appear. We don't want to apply tonemapping (or it will look surreal), so from the Method pop-up menu (shown in the inset at the bottom), choose Exposure and Gamma and click OK, and your HDR image will keep its realistic look.

Final Image

THE LOOK: By creating a 32-bit HDR image, you're keeping as much of the quality and tonality in your HDR as possible. You can edit the image in Camera Raw while it's still in this high-quality mode, and by using the Shadows slider coupled with Clarity, you can bring out detail without making the image look surreal or like an illustration. Photoshop does step in at the very last minute (when you're switching from 32-bit back to regular 8-bit mode) and tries to make you think you have to add tonemapping, but by using the tip on the previous page (choosing Exposure and Gamma), you can keep your realistic look intact when you make the conversion.

OTHER OPTIONS: While there are a number of other HDR software packages out there, including ones you can use without Photoshop, as plug-ins for Lightroom or Aperture, or as a standalone, the most popular one is Photomatix Pro from HDRsoft (and it does let you create 32-bit, high-quality, realistic HDR images). When you open your three (or more) bracketed images in Photomatix, you'll choose some settings first and then, if you chose that option, see the Ghost Reduction dialog. Once you're done there, your preview image appears and, in the Adjustments panel, you'll click on Exposure Fusion at the top (rather than the default Tone Mapping) to create a realistic HDR look. I really don't mess with any of the other controls here, although you might want to try the Method presets. I just click the Save and Re-Import or Apply button, and then I do the rest of my editing in Camera Raw (or Lightroom's Develop module) using the same settings I show in the inset on the right side of the facing page.

Creative White Balance

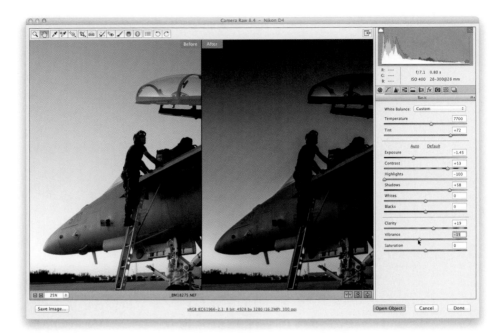

TOOLS: This can be done in either Camera Raw (part of Photoshop and Photoshop Elements) or Lightroom's Develop module.

TECHNIQUE: We darken the exposure, then tweak the White Balance sliders:

(1) To make the image look like it was taken much closer to sunset, we start by lowering the Exposure amount (dragging it to the left) so the image isn't so bright. That helps a lot right there.

(2) To create the sunset colors you want, you use the Temperature and Tint sliders. If you look at the sliders themselves, behind them it shows a gradient and you just drag in the direction of the color you want. To get this look, I dragged the Temperature slider to the right a bit (toward yellow) and the Tint slider to the right quite a bit (toward magenta) for this color combination.

(3) Sometimes, dragging these sliders way over to one side or the other makes the white balance look too vibrant, but you can lower the Vibrance amount (drag the slider to the left) to fix that. I also added a little Clarity, which usually looks great on anything metal.

Final Image

THE LOOK: To get this sunset look, it helps if you shoot late in the day, even if it's a while before sunset. That way, your shadows will be softer, like they would be at sunset, even if the sky isn't nearly as dark as it will be an hour or so later.

OTHER OPTIONS: While there are lots of plug-ins that add color effects, it's so easy to do in Camera Raw or Lightroom (it's just dragging either the Temperature or Tint sliders, or both, until it looks good to you), you don't really need a plug-in.

Blur Vignette

TOOLS: This is done in Photoshop CS6 or higher.

TECHNIQUE: It looks like we're using a plug-in, but it's a built-in Photoshop filter called Iris Blur:

(1) Start in Photoshop by duplicating the Background layer. Then, go under the Filter menu, under Blur, and choose Iris Blur. That brings up the interface you see above, and it puts a big oval on your image with control points all the way around it.

(2) Click-and-drag one of the control points to resize the oval, and if you click inside it, you can drag it around the image to position it where you want it (I positioned it over the gondola). Then, if you put your cursor just outside one of the edge points, it will turn into a two-headed arrow, and you can click-and-drag to rotate the oval (as seen above). The four dots inside the oval control where the transition happens between in-focus and blurry, and you can click-and-drag them in and out. If you click on the round ring in the center and drag around it, it controls the amount of blur (or you can just drag the Blur slider in the Blur Tools panel). When you're done, click OK. Since you applied this to a duplicate of the Background layer, now you can lower the layer's opacity if you think the effect is too intense.

Final Image

THE LOOK: You're going to use this look when you want to focus the viewer's attention, and you'll see it used a lot as a wedding photography effect.

OTHER OPTIONS: Of course, if you don't have Photoshop (and use either Lightroom, Elements, or Apple Aperture), there are plug-in or standalone options, like:

(1) OnOne Software's Perfect Photo Suite. It comes with a plug-in called Perfect Effects, which has a Lens Blur filter. That filter has a Round preset, which works very much like Photoshop's Iris Blur, with the onscreen ovals for positioning, resizing, and such.

(2) The Google Nik Collection's Color Efex Pro plug-in has a Vignette: Blur filter that does the same thing, and while you can choose the center of the blur area, the placement options are not quite as flexible as Photoshop's built-in Iris Blur, but it still does a nice job.

Dodging & Burning

TOOLS: This can be done in either Camera Raw (part of Photoshop and Photoshop Elements) or Lightroom's Develop module.

TECHNIQUE: All we need is Camera Raw's (or Lightroom's) Adjustment Brush:

(1) In Camera Raw, click on the Adjustment Brush up in the toolbar along the top left of the window (in Lightroom's Develop module, it's above the right side Panels area). Now, click the + (plus sign) button to the right of the Exposure slider two times. This sets all the other sliders to zero and increases your Exposure amount to +1.00.

(2) For this particular picture, we're just going to brighten (dodge) areas in the image so it looks like little pools of light are hitting those areas, but you can also darken (burn) any areas you feel are too bright (click the New radio button at the top of the tool's options, and lower the Exposure setting). Scroll to the bottom of the tool's options and turn off the Auto Mask checkbox.

(3) Then, take the brush and just click it once over any highlight areas that you want to be brighter, like you're painting with light. I put arrows on the capture above so you could see where I clicked to make it look like light was hitting those areas. You usually only have to click once, but if it's not bright enough, just click a second time.

Final Image

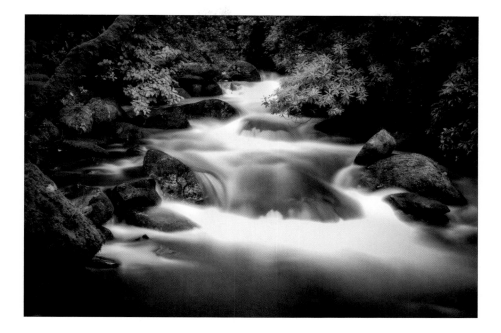

THE LOOK: Dodging-and-burning has been around forever (it was a traditional dark-room technique), and it's used quite a lot today in landscape and travel photography to add pools of light throughout the image, which adds more depth and dimension to the lighting in the image.

OTHER OPTIONS: You can do this directly in Photoshop (or Elements) itself without using Camera Raw. Here's how:

(1) Duplicate the Background layer and, in the Layers panel, change this duplicate layer's blend mode (in the pop-up menu at the top left of the panel) from Normal to Screen. This makes the layer much brighter. Now, Option-click (PC: Alt-click) on the Add Layer Mask icon at the bottom of the Layers panel (it's the third icon from the left), which puts a black mask over the brighter layer (so now everything looks normal again). Set your Foreground color to white, get the Brush tool, choose a medium-sized, soft-edged brush from the Brush Picker up in the Options Bar, and then click once over the areas you want to brighten (like we did with the Adjustment Brush on the facing page), and it reveals that lighter layer just where you clicked, so you get the same look.

Duotone Look

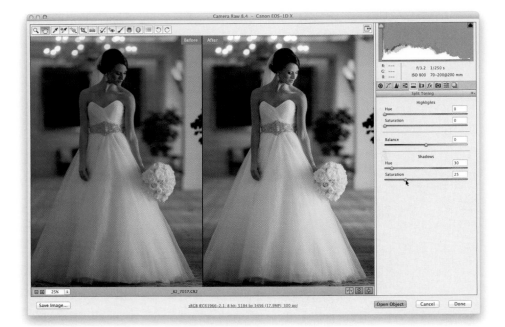

TOOLS: This can be done in either Camera Raw (part of Photoshop and Photoshop Elements) or Lightroom's Develop module.

TECHNIQUE: You're going to convert to black and white, and then add a duotone look:

(1) In Camera Raw, start by clicking on the fourth icon over (at the top of the right side panels) to open the HSL/Grayscale panel. Turn on the checkbox for Convert to Grayscale to make this a black-and-white image. In Lightroom's Develop module, click on Black & White at the top right of the Basic panel.

(2) Now, go to the Split Toning panel (seen above). You're only going to work with the Shadows set of sliders here (we're not going to touch the Balance slider or the Highlights sliders). First, in the Shadows section, drag the Saturation slider over to 25 (as shown here) so you can see the color. Then, drag the Hue slider to the right to choose the color you want for your duotone tint (here, I wanted a brownish looking duotone, so I stopped at 30. The little gradient behind the slider shows you the range of colors available and where to drag to get different colors).

Final Image

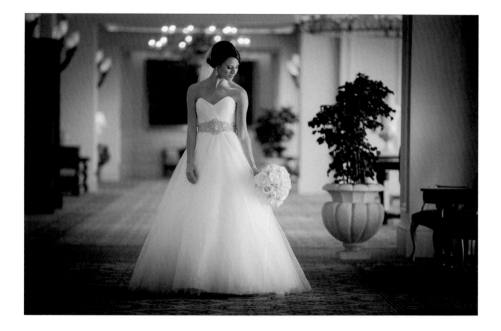

THE LOOK: Duotone and sepia tone looks are very popular in landscape photography, as well as wedding and portrait photography. While you can apply a tint like this to a color photo, the classic look is to first convert to grayscale, and then put a tint (usually warm tones, like browns, yellows, or reds) over the image. The nice thing about applying the duotone using this method is how nicely the image prints (if you're making prints), so there's no need to use Photoshop's built-in (but somewhat complicated) duotone feature to get a good-looking print.

OTHER OPTIONS: There are a number of plug-ins (for Photoshop, Elements, Lightroom, or Apple Aperture) that have built-in duotone or tinting effects. In fact, I think it's harder to find a plug-in that doesn't have them. Here are the two I use most:

(1) OnOne Software's Perfect Photo Suite. It comes with a plug-in called Perfect Effects that has two filters that work well for duotone looks: Antique and Black & White. Scroll through those filters' thumbnail previews and you'll find one-click duotone looks.

(2) The Google Nik Collection's Color Efex Pro plug-in has a Color Stylizer filter whose settings can be adjusted to create a duotone or sepia tone effect. Also, the Collection's Silver Efex Pro plug-in, for creating black-and-white conversions, has some built-in duotone/sepia tone presets.

Index

32-bit HDR images, 200, 201
70-200mm f/2.8 lens, 30, 36

A

about this book, 2–5
action photography
panning movement in, 172–173
setup for shooting, 174–175
Add Layer Mask icon, 195, 207
Adjustment Brush
aquarium photography and, 159
dodging-and-burning with, 206
portrait photography and, 13, 37, 61, 69
product photography and, 168
spotlight effect and, 194
travel photography and, 143
wedding photography and, 113
Adler, Lindsay, 63
Altare della Patria photo, 122–123
animal photography
aquarium photos, 158–159
pet photos, 180–181
zoo photos, 150–151, 156–157
Antique filter, 209
aperture priority mode
flower photography and, 160
natural light portraits and, 20, 21
aperture settings. *See* f-stops
Apollo softbox, 76, 80
apps
Dog Whistler Pro, 181
ND Timer, 149
aquarium photography, 158–159
athletes
dramatic side lighting for, 40–41
edgy lighting for, 56–57
V-flat lighting for, 68–69
Auto Mask checkbox, 206

B

Background layer, 195, 204, 207
background lights, 50, 52, 61, 64

backgrounds
action shots and, 173, 175
hot-shoe flash and, 77
instant black, 88–89
natural light and, 6, 8, 12, 28, 118
separating subjects from, 77, 175
studio lighting for, 50, 52
travel shots and, 132, 135
backlight stands, 52
battery packs, 28, 40
beauty dish, 30, 50
beauty look
simplified setup for, 62–63
two-light setup for, 50–51
wraparound light and, 58–59
Beijing, China, 132–135
bird photography, 156–157
Black & White filter, 209
Black & White option, 113, 198, 208
black background technique, 88–89
black point, 198
black-and-white photos
converting color photos to, 113, 198–199, 208
direct window light for, 17
duotone look for, 113, 208–209
muscular subjects for, 57
plug-in for creating, 17, 57, 99, 199, 209
wedding shots as, 107, 113
Blacks slider, 198
Bleach Bypass filter, 47, 189
bleach bypass look, 188–189
blend modes, 197
Multiply, 195, 196
Screen, 207
Soft Light, 192
BLOWiT Fans, 38, 64
Blur slider, 204
blur vignette, 204–205
blurred backgrounds
action shots with, 173, 175
See also out-of-focus backgrounds
BorrowLenses website, 150
bracketing photos, 192, 200
bridal portraits. *See* wedding photography
Brush tool, 195, 207
Buissink, Joe, 107
burst mode, 137
Buy This Book of Chapter Intros Even Though You Won't Learn Anything **(Kelby),** 4

post-processing examples, 187–209
 black-and-white conversion, 198–199
 blur vignette, 204–205
 creative white balance, 202–203
 desaturated bleach bypass look, 188–189
 dodging & burning, 206–207
 duotone look, 208–209
 grungy, aged look, 196–197
 high-contrast skin look, 190–191
 realistic HDR look, 200–201
 spotlight effect, 194–195
 tone-mapped HDR look, 192–193
product photography
 on-location, 178–179
 studio setup for, 168–169

Q

QuikBox kit, 74, 78, 82, 86

R

Radial Filter tool, 179, 194, 195
Ranger Quadra flash unit, 170
RAW mode, 141
Ray Flash adapter, 38, 39
realistic HDR look, 200–201
reception flash, 104–105
reflections on glass, 159
reflectors
 beauty look using, 51
 filling in shadows with, 42
 outdoor portraits and, 12–13
 V-flat, 38, 68–69
renting lenses, 150
retouching portraits video, 23
rim light, 21, 34, 113
ring flash, 38–39
Rogue 3-in-1 Honeycomb Grid, 76, 95
royalty-free images, 196
rubber lens hood, 159

S

Sainte-Chapelle church, 138–139
sandbags, 10
Santorini, Greece, 126–127
Saturation slider, 31, 196
Scott 5 preset, 192

Screen blend mode, 207
scrims, 11
seamless paper, 32, 180
second shooters, 106–107
self-timer, 160
sepia tone effect, 209
shade
 dappled light vs., 15
 shooting portraits in, 6–7
shadows
 adjusting in post, 123
 filling in, 42–43
 playing up, 46–47
Shadows slider
 car detail photography and, 171
 high-contrast skin look and, 190
 landscape photography and, 155
 travel photography and, 123, 131
sharpening images
 action photography, 173, 175
 animal photography, 151, 157
 black-and-white conversions, 57, 199
 portrait photography, 17, 57, 89
 product photography, 169
 travel photography, 127, 133, 135
 See also Unsharp Mask filter
Shoot Like a Pro seminar tour, 131
shower curtain liner, 18
shutter speeds
 dramatic lighting and, 108, 109
 flash used with lower, 76, 85
 freezing motion using, 106, 175
 hand-held photography and, 124, 154
 instant black background and, 89
 moon photography and, 164
 ND filters and, 148, 149
 polarizing filters and, 152–153
 showing motion using, 172, 173
 starry sky shots and, 184
 studio settings for, 42
side lighting, 40–41
silky water effect, 147, 148–149
Silver Efex Pro, 17, 57, 99, 199, 209
skies
 cityscape image, 183
 shooting starry, 184–185
skin
 desaturating the color of, 31
 high-contrast look for, 190–191

wildlife photography. *See* **animal photography**
window light, 16–19, 22–25
 direct contrasty, 16–17
 flash mixed with, 102–103
 food photography and, 141
 positioning subjects in, 22–25
 softening, 18–19, 24–25
wireless transmitters
 Cactus Triggers, 83
 PocketWizard PlusX, 76, 83
wraparound light
 beauty look with, 58–59
 one-light setup for, 36–37

Z

zoo photography, 150–151, 156–157
zooming
 f-stop settings related to, 124
 hiding distractions by, 134–135
 softening backgrounds by, 6, 14, 77

CHECK OUT
ALL OF THE ACTION WITH THESE
CREATIVE MINDS
(and yes, they do their own stunts)

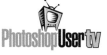